Celebrate St. Nicholas

D1468305

It is the season of celebration and joyous gift-giving, a special time to share with those most precious those things which excites the heart and satisfies the soul.

❉✳❆✳❉

Celebrate with the Decorative Arts Collection as we Celebrate St. Nicholas!

O Holy Night

Jo Sonja Jansen

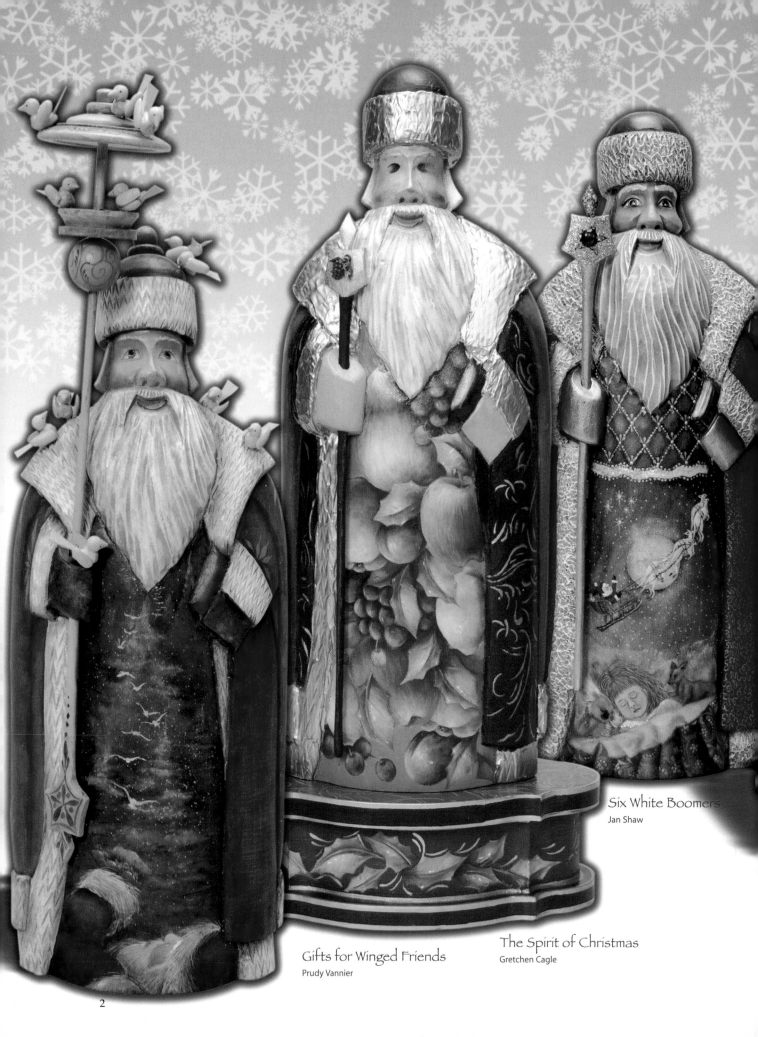

Gifts for Winged Friends
Prudy Vannier

The Spirit of Christmas
Gretchen Cagle

Six White Boomers
Jan Shaw

2

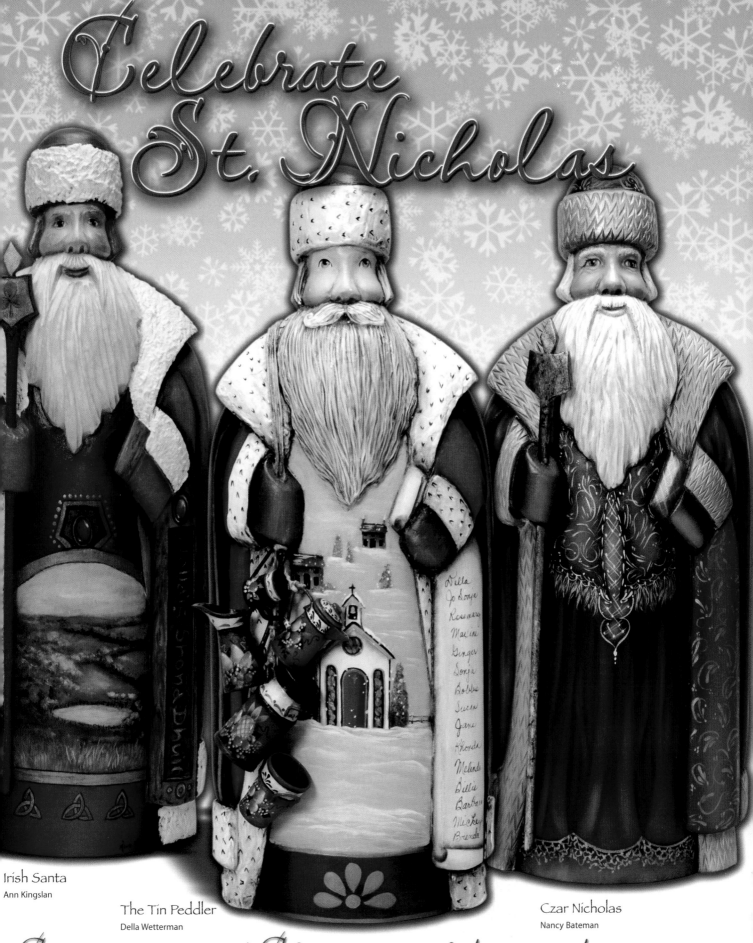

Celebrate St. Nicholas

Irish Santa
Ann Kingslan

The Tin Peddler
Della Wetterman

Czar Nicholas
Nancy Bateman

Create the spirit of Christmas with design and inspiration of artists from around the world.

3

Do you believe?

Eight-year-old Virginia O'Hanlon wrote a letter to the editor of the New York Sun, and the quick response was printed as an unsigned editorial on September 21, 1897. The work of veteran newsman Francis P. Church has since become history's most reprinted newspaper editorial, appearing in part or whole in dozens of languages in books, movies and other editorials.

Dear Editor:
I am 8 years old. Some of my little friends say there is no Santa Claus. Papa says, "If you see it in The Sun it's so." Please tell me the truth; is there a Santa Claus?

Virginia O'Hanlon
115 W. 95th St.

Virginia, your little friends are wrong. They have been affected by the skepticism of a skeptical age. They do not believe except [what] they see. They think that nothing can be which is not comprehensible by their little minds. All minds, Virginia, whether they be men's or children's, are little. In this great universe of ours man is a mere insect, an ant, in his intellect, as compared with the boundless world about him, as measured by the intelligence capable of grasping the whole of truth and knowledge.

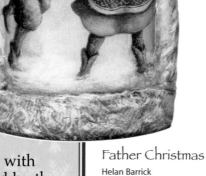

Father Christmas
Helan Barrick

Published & Distributed by

All American Crafts Publishing, Inc
www.allamericancrafts.com

PaintWorks
The Discovery Magazine for Decorative Painters
www.paintworksmag.com

Quick & Easy Painting
www.quickandeasypainting.com

Graphic Design by
Gretchen Cagle Publications, Inc.
PO Box 2104
Claremore, OK 74018-2104

Gretchen Cagle Publications, Inc.

Printed in USA
ISBN 13: 978-0-9789513-4-4
ISBN 10: 0-9789513-4-4
Library of Congress Control Number: 2008926440

Yes, Virginia

There is a Santa Claus! He exists as certainly as love and generosity and devotion exist, and you know that they abound and give to your life its highest beauty and joy. Alas! How dreary would be the world if there were no Santa Claus.

Whatever you call him, Santa, Kris Kringle, St. Nicholas or Father Frost, this book is dedicated to all the artists who have added their talents to the words of Mr. Church thus proving that there is indeed a Santa Claus. The diversity brought to this collection of carved figurines is phenomenal! Each artist was given a raw wooden figure and asked to decorate it. Their variety of interpretations stands as a testimony to the ingenuity of decorative artists the world over.

Because of your belief in the Decorative Arts Collection Museum, we are able to share this gift with everyone who believes!

Andy B. Jones, Director
Decorative Arts Collection Museum
650 Hamilton Avenue SE
Atlanta, GA 30312
404-627-3662
www.decorativeartscollection.org

❄✳❄✳❄

Norwegian Santa
Eldrid Arntzen

Russian Peasant Santa
Heidi England

Decorative Arts Collection Board of Trustees

Peggy Harris, President
Gretchen Cagle, Vice President
Debra Garner, Treasurer

Shea Szachara, Secretary
Toni McGuire, Trustee
Betsy Thomas, Trustee

Celebrate St. Nicholas. Copyright ©2008, The Decorative Arts Collection. All rights reserved. No part of this product may be reproduced in any form unless otherwise stated, in which case reproduction is limited to the use of the purchaser. The written instructions, photographs, designs, projects and patterns are intended for personal, noncommercial use of the retail purchaser and are under federal copyright laws; they are not to be reproduced by any electronic, mechanical or other means, including informational storage or retrieval systems for commercial use. Permission is granted to photocopy patterns for the personal use of the retail purchaser.

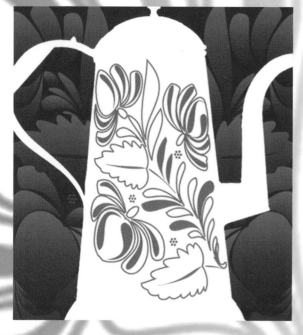

DECORATIVE ARTS COLLECTION

The Decorative Arts Collection has been forward thinking in its strategy from its inception. With a two-pronged approach, a collection has been assembled which showcases both the historic roots and the contemporary direction of decorative painting. The historic portion of the works has outstanding examples of early American painted tin such as the crookneck coffeepot. Other fine pieces illustrate the variety of decorative painting: frakturs, theorems, stenciling, Chippendale painting and pith paintings–to mention a few. Additionally, the Collection features a variety of folk art styles from around the globe and contains a wide diversity of mediums and an incredible assortment of surfaces.

Developing the historic portion of the Collection is an ongoing process with a continuous search for additional fine examples of artwork to augment the current body of works. The resurgence of decorative painting in the late 1940's and 1950's helped to form the foundation of the contemporary collection. The Museum is pleased to have pieces from some of these early painters who shared their knowledge and brought the art form to the masses. These artists developed new techniques and their own unique style of painting. Pioneering artists, such as Peter Hunt and Peter Ompir, inspired many people to take brush in hand and begin painting. In keeping with the DAC mission, one of the primary goals is the continuation of public education about decorative painting and the techniques used to create these masterworks.

Show your support for the Decorative Arts Collection by becoming a Friend of the Museum. For your contribution, you will receive our repleca crookneck coffeepot pin as a token of thanks. Additionally, you will receive four issues of the *Museum News*, a 10% discount on DAC merchandise and free admission to the Museum. The DAC Museum is supported by individuals like you who have a love for decorative painting. Annually renew your support and receive our porcelain renewal pins. See page 160 for more information on becoming a Friend of the Decorative Arts Collection.

Peggy Hobbs
Clematis
Oil on Wood
Late 20th Century

Decorative Arts Collection Museum

PO Box 18028
Atlanta, GA 30316

650 Hamilton Avenue SE
Suite M
Atlanta, GA 30312

(404) 627-3662
www.decorativeartscollection.org

6

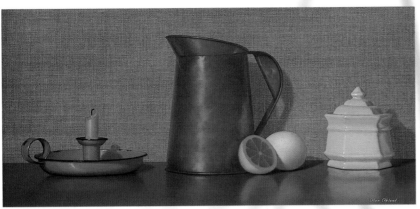

Olav Okland
Still Life
Oil on Linen
Late 20th Century

Gene K Prewitt
Sunshine Seeds
Acrylic on Tin
Late 20th Century

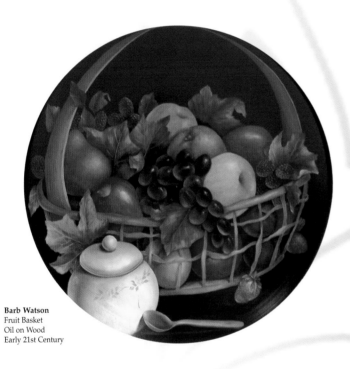

Barb Watson
Fruit Basket
Oil on Wood
Early 21st Century

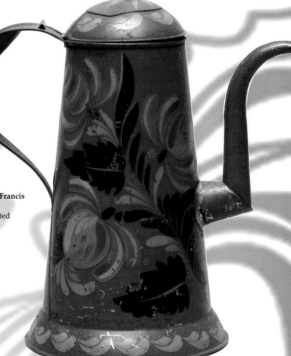

Attributed to Edward Francis
Crookneck Coffeepot
Japan Color on Tinplated
Sheet Iron
1820

Joyce Howard
Folk Art
Acrylic on Wood
Late 20th Century

7

Table Of Contents

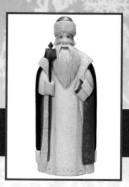
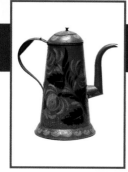
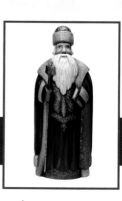

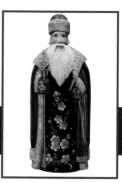
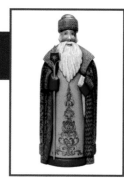
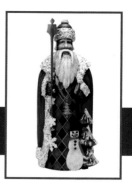

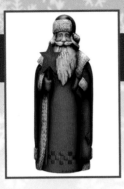

Simply Santa Claus
Maxine Thomas
Page 21

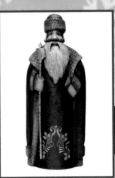

Butterfly Santa
Maureen McNaughton
Page 25

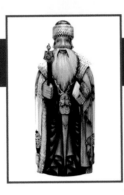

Erté Santa
Golda Rader
Page 22

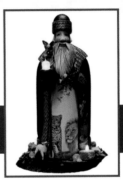
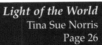

Light of the World
Tina Sue Norris
Page 26

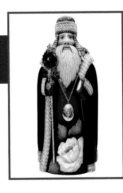

Jeweled Rose Santa
Margot Clark
Page 23

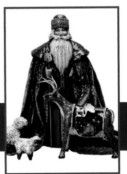

St. Nicholas, *the Bishop of Myra*
Linda Wise
Page 27

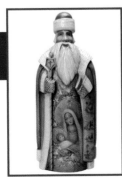

O Holy Night
Jo Sonja Jansen
Page 24

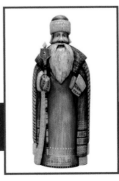
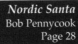

Nordic Santa
Bob Pennycook
Page 28

Table Of Contents

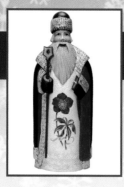
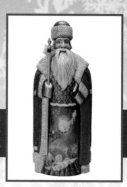
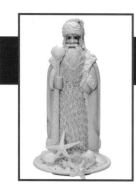
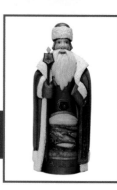
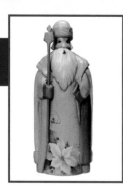
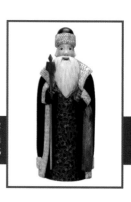
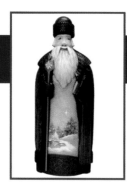
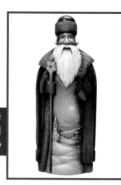

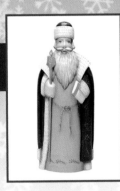

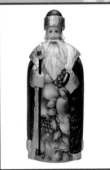

Father Nick
Kaz Iwaski
Page 37

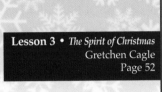

Lesson 3 • *The Spirit of Christmas*
Gretchen Cagle
Page 52

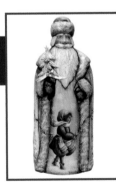

The Tin Peddler
Della Wetterman
Page 38

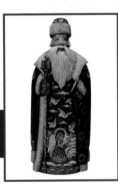

Lesson 4 • *Angel and Doves*
G DeBrekht Artistic Studio
Page 58

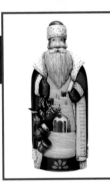

Lesson 1 • *Father Christmas*
Helan Barrick
Page 42

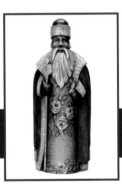

Lesson 5 • *Elegant Santa*
Ginger Edwards
Page 62

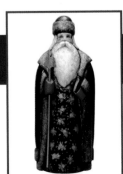

Lesson 2 • *Antique Santa*
Trudy Beard
Page 48

Lesson 6 • *Russian Peasant Santa*
Heidi England
Page 68

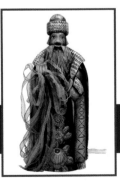

11

Table Of Contents

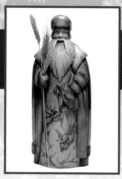
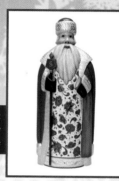
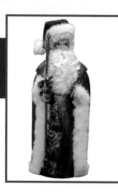
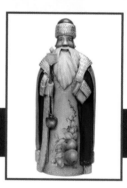
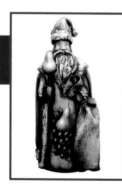
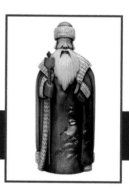
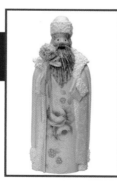
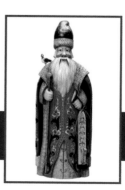

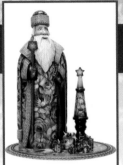
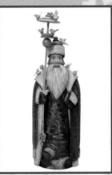
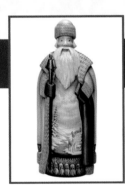
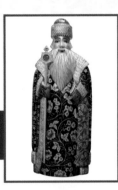
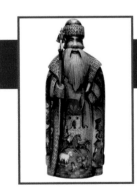

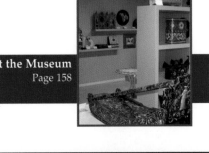
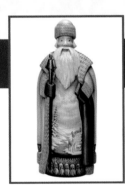

Inspiration . . .
from Plain to Unique

These fabulous St. Nicholas figurines all began as a 14-inch unpainted wooden figure. Each was meticulously hand-carved in Russia by skilled artisans working in traditional Russian folk style. G. DeBrekht of Russia commissioned these figures specifically for the Decorative Arts Collection to present in this innovative collaboration.

Two of the figures shown in this book were painted by Russian artists in the customary ornate mode of their homeland. The other figures were sent to designers around the world for each to interpret in their own unique way.

From the elaboratley embellished work of designers such as Linda Wise and Sharyn Binam or the exquisitely intricate painting of Golda Rader and Heather Redick to the simple perfection of Maxine Thomas and Masayo Kunioka you will be awestruck by the variety and beauty of all the St. Nicholas figurines.

Whether painted with realism or stroke-work or landscapes or animals, be they lavish or simple, the result is a celebration not only of the legend of St. Nicholas, but also a celebration of the beauty and diversity of decorative painting.

❄ ❄ ❄ ❄

St. Nick with Fruit
Andy B Jones
United States

14

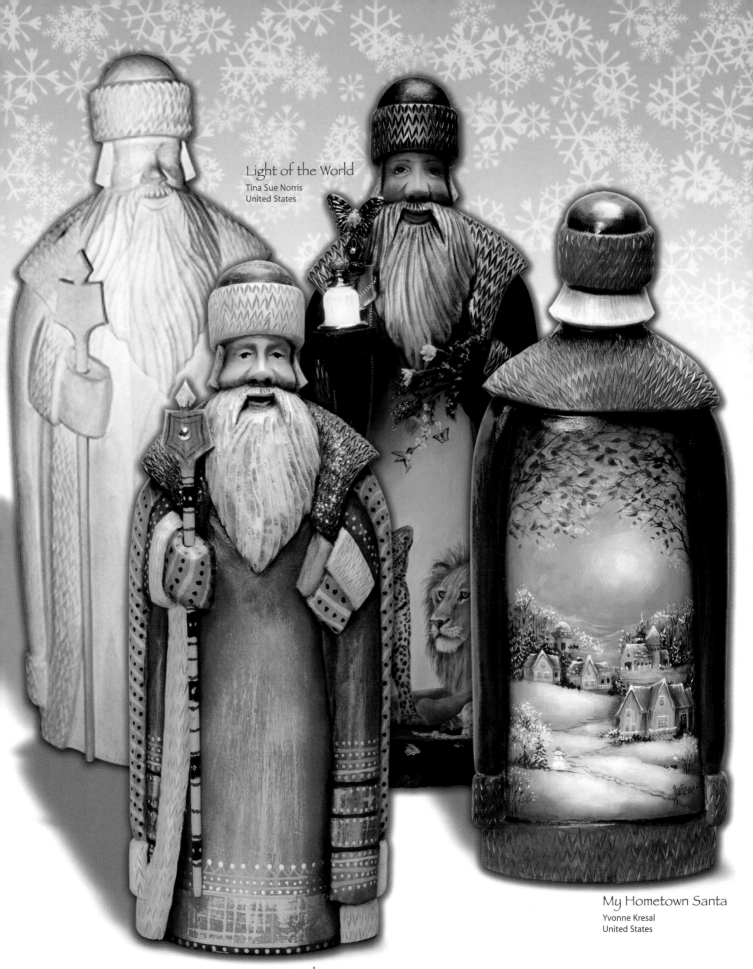

Light of the World
Tina Sue Norris
United States

My Hometown Santa
Yvonne Kresal
United States

Nordic Santa

Bob Pennycook
Canada

15

Norwegian Santa

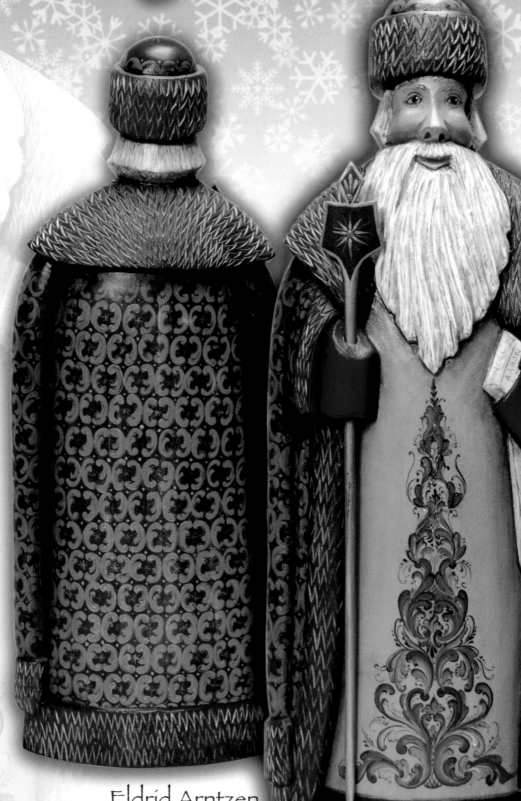

Eldrid Arntzen
United States

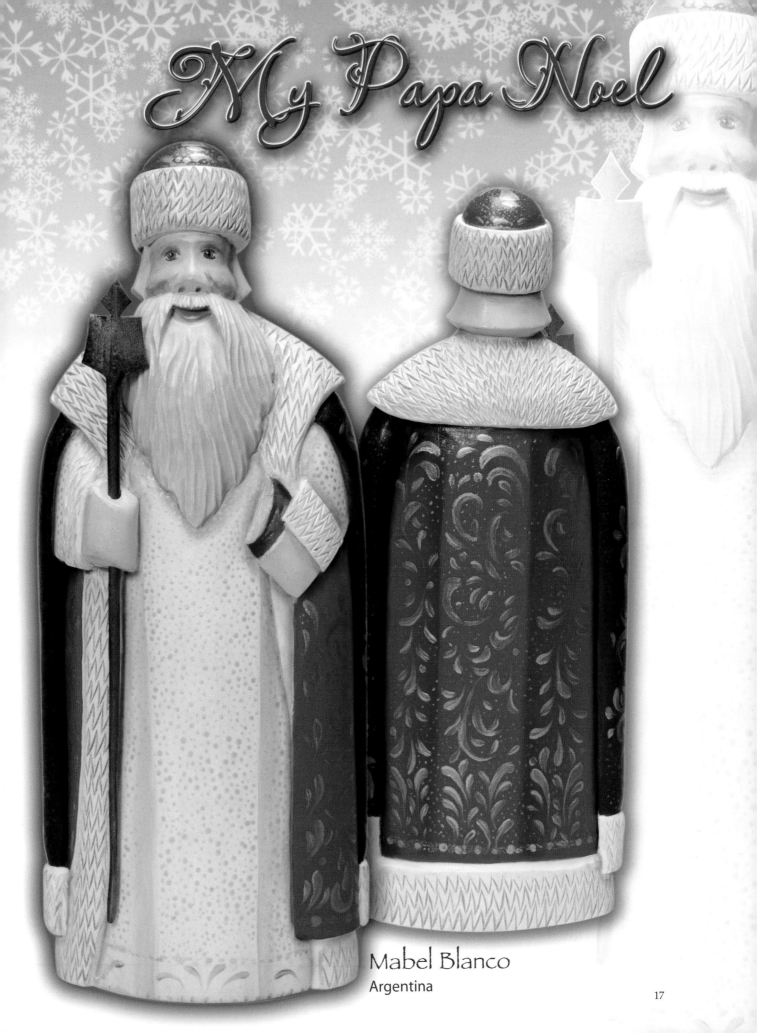

My Papa Noel

Mabel Blanco
Argentina

17

Czar Nicholas

Nancy Bateman
United States

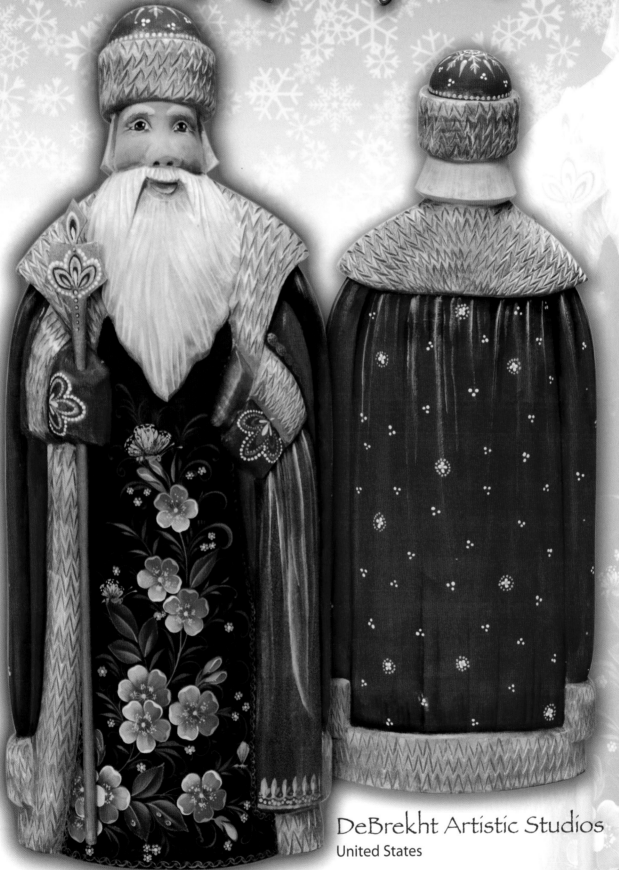

Rose of Russia

DeBrekht Artistic Studios
United States

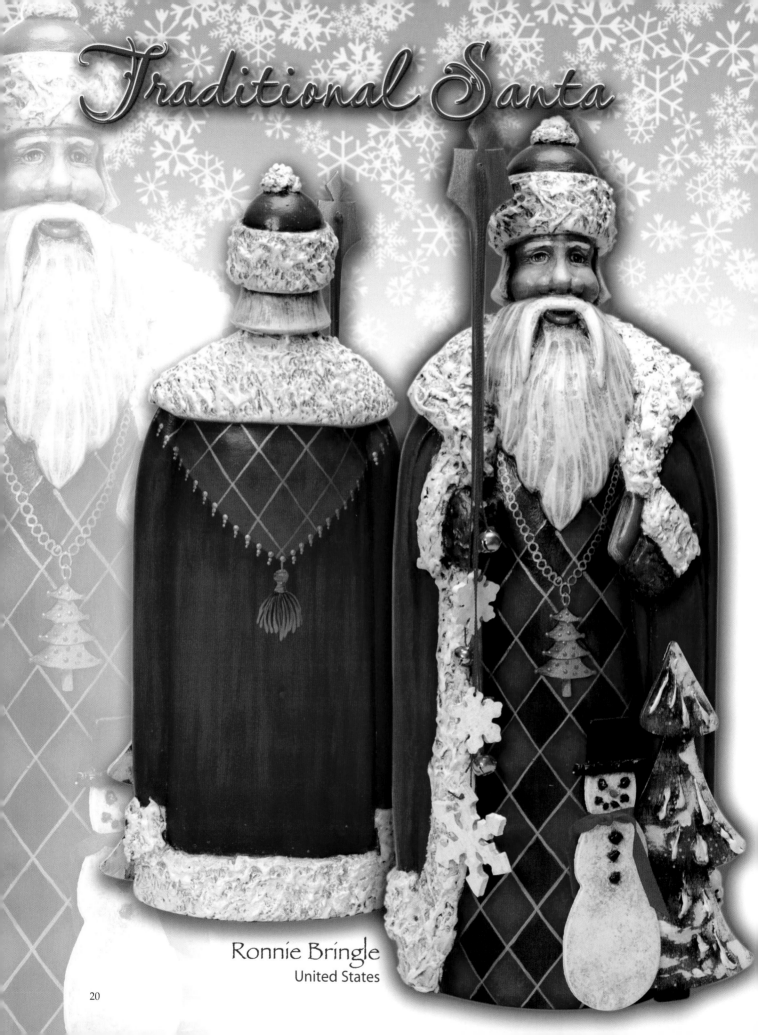

Traditional Santa

Ronnie Bringle
United States

Simply Country Claus

Maxine Thomas
United States

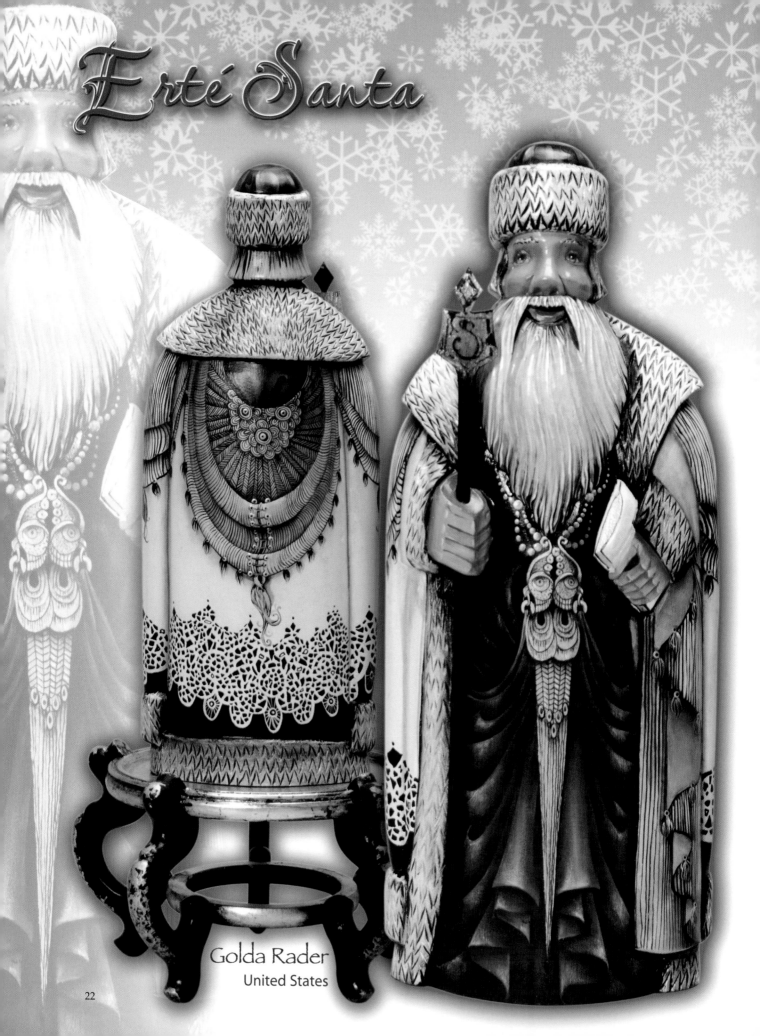

Erté Santa

Golda Rader
United States

Jeweled Rose Santa

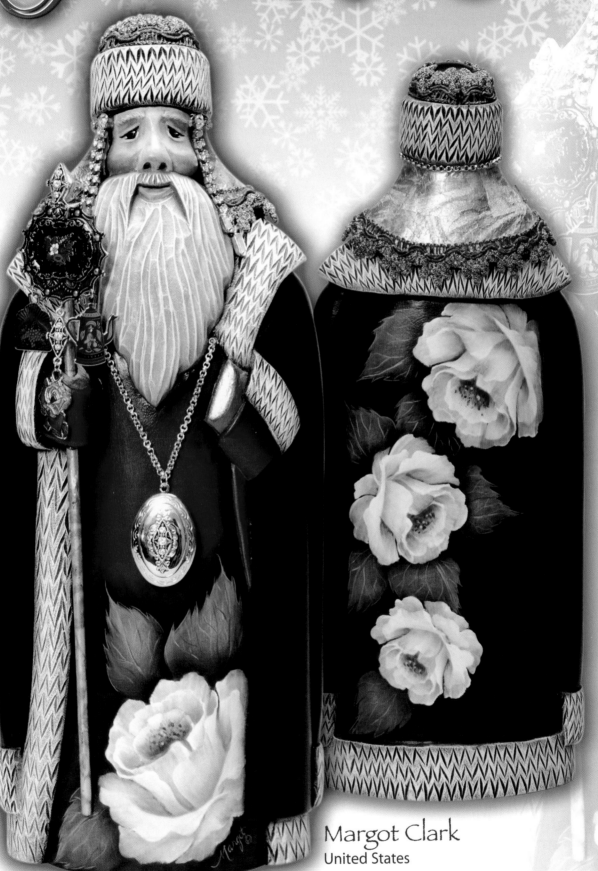

Margot Clark
United States

O Holy Night

In a manger far away our precious Lord and Saviour lay. Angels in the heavens sing, praises to the newborn King.

Jo Sonja Jansen
United States

24

Butterfly Santa

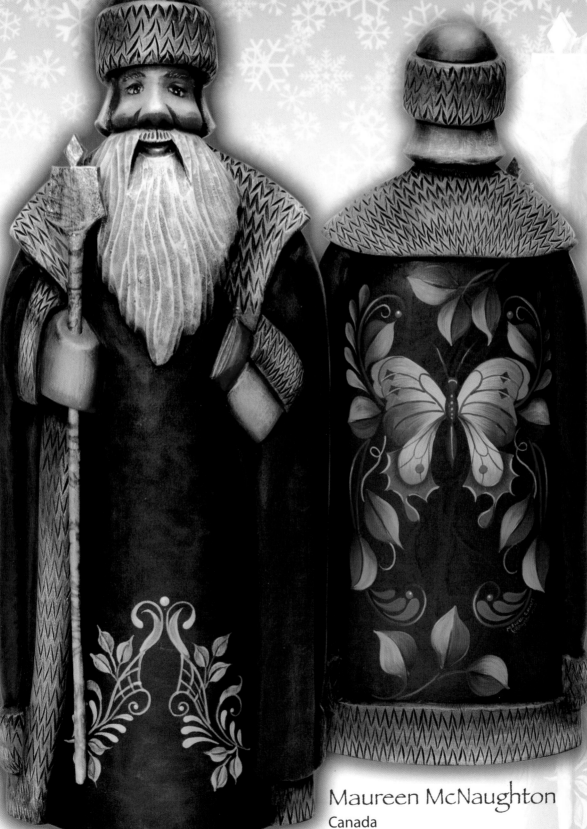

Maureen McNaughton
Canada

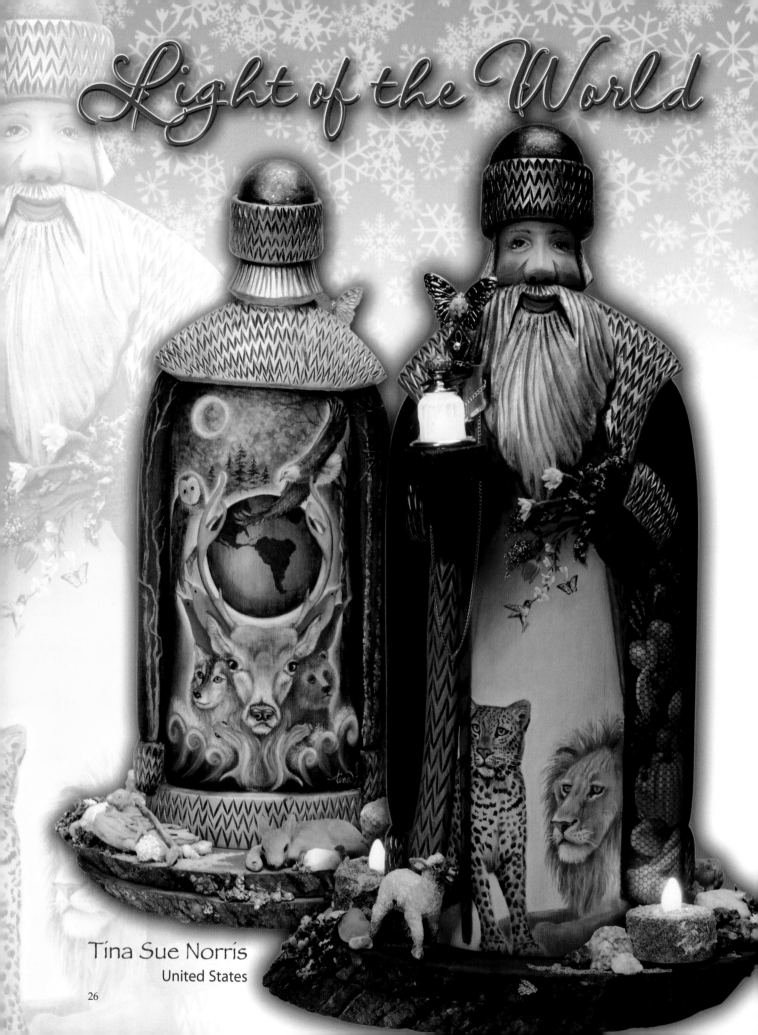

Light of the World

Tina Sue Norris
United States

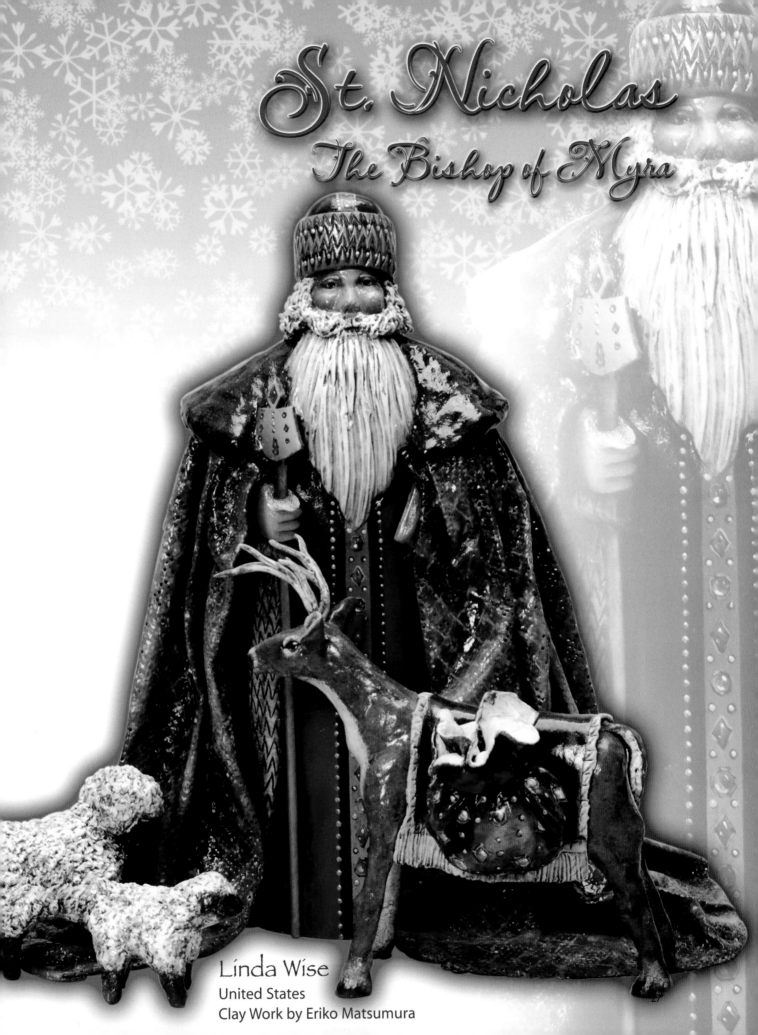

St. Nicholas
The Bishop of Myra

Linda Wise
United States
Clay Work by Eriko Matsumura

Nordic Santa

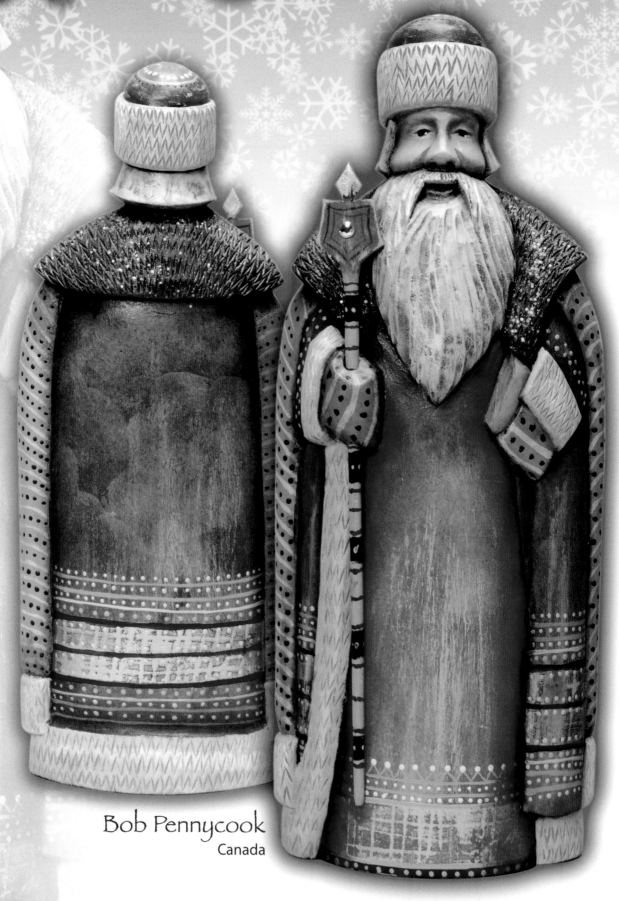

Bob Pennycook
Canada

Holly & Hellebore

Tracy Sims
Australia

Winter White Santa

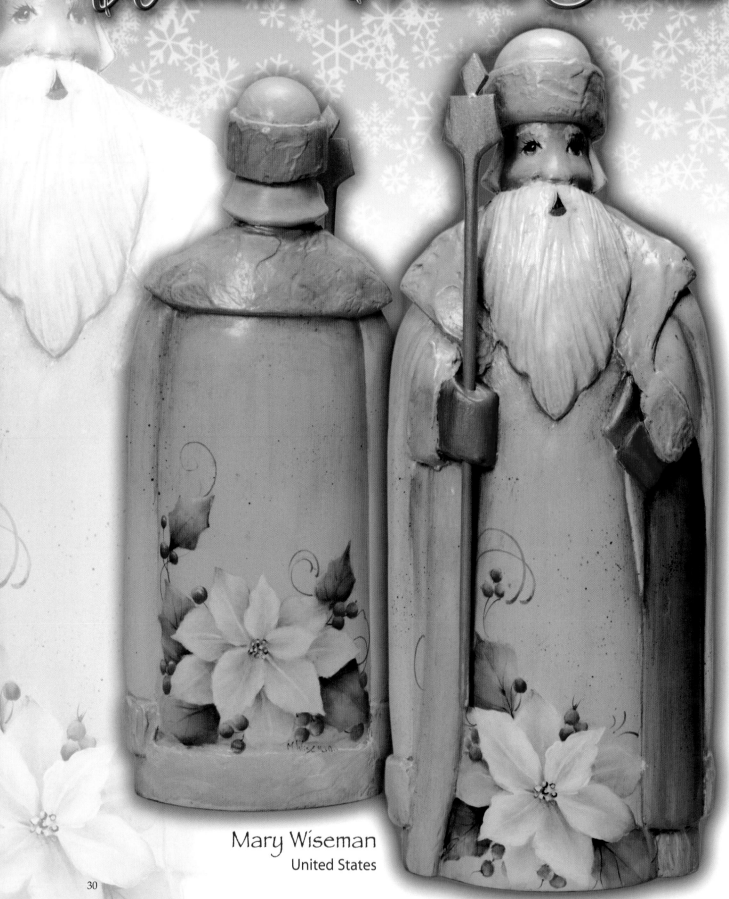

Mary Wiseman
United States

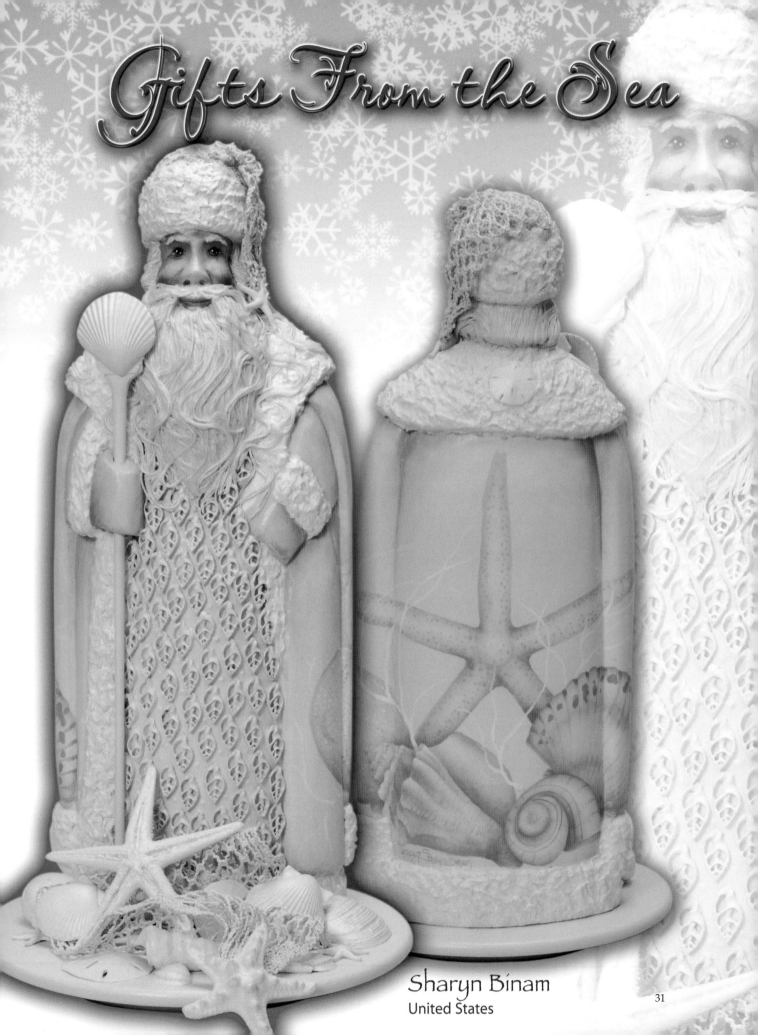

Gifts From the Sea

Sharyn Binam
United States

31

Old World Santa

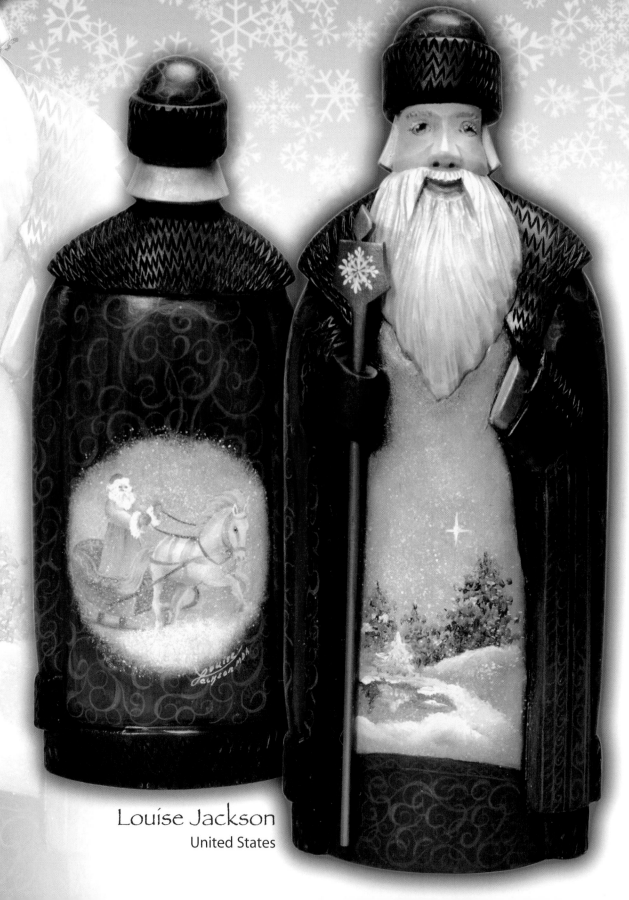

Louise Jackson
United States

Six White Boomers

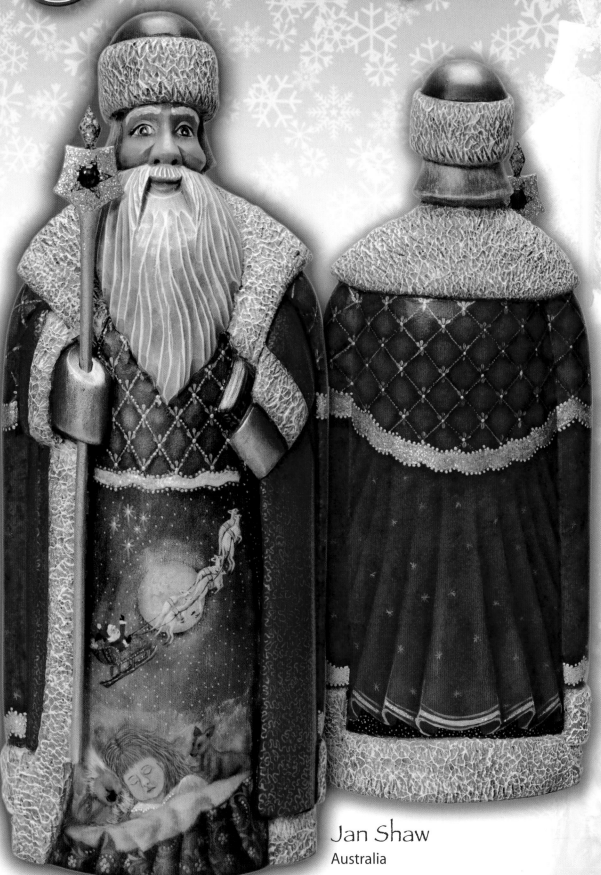

Jan Shaw
Australia

Irish Santa

Ann Kingslan
United States

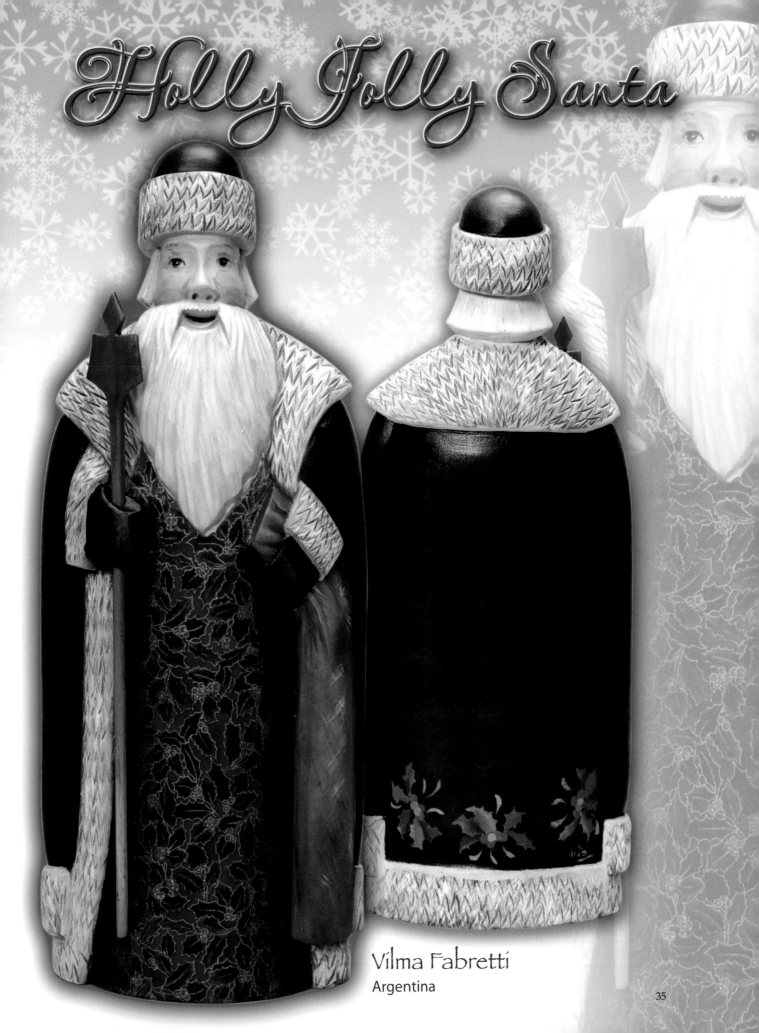

Holly Jolly Santa

Vilma Fabretti
Argentina

My Hometown Santa

Yvonne Kresal
United States

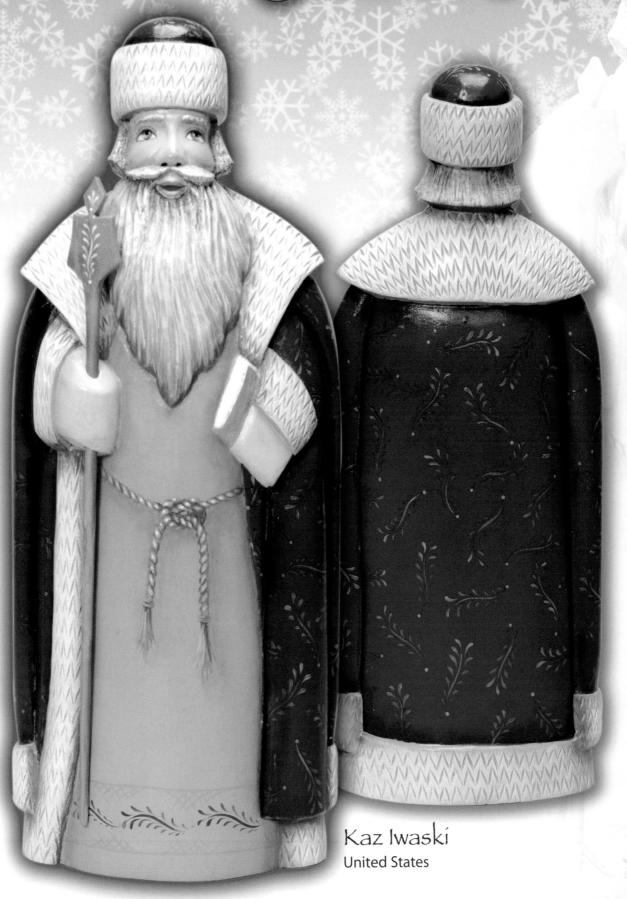

Father Nick

Kaz Iwaski
United States

The Tin Peddler

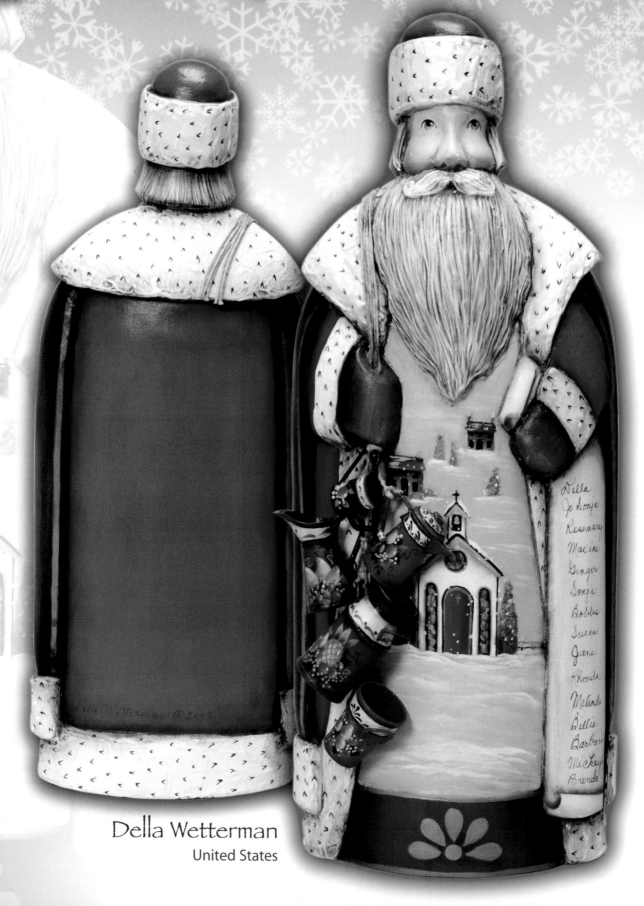

On the scroll:
Della
Jo Sonja
Rosemary
Maxine
Ginger
Sonja
Goldie
Susan
Jane
Rhonda
Melinda
Billie
Barbara
Mickey
Brenda

Della Wetterman
United States

Inspiring . . .
Step-by-Step Lessons

Create & Celebrate
The Spirit of
St. Nicholas
❄

Pick your Favorite Season
whether it
Celebrates the Renewal of
Spring Blossoms,
the Season of the Harvest
or a
Celebration of your Cultural
Heritage.
❄

St. Nicholas
is
A Man of all Seasons

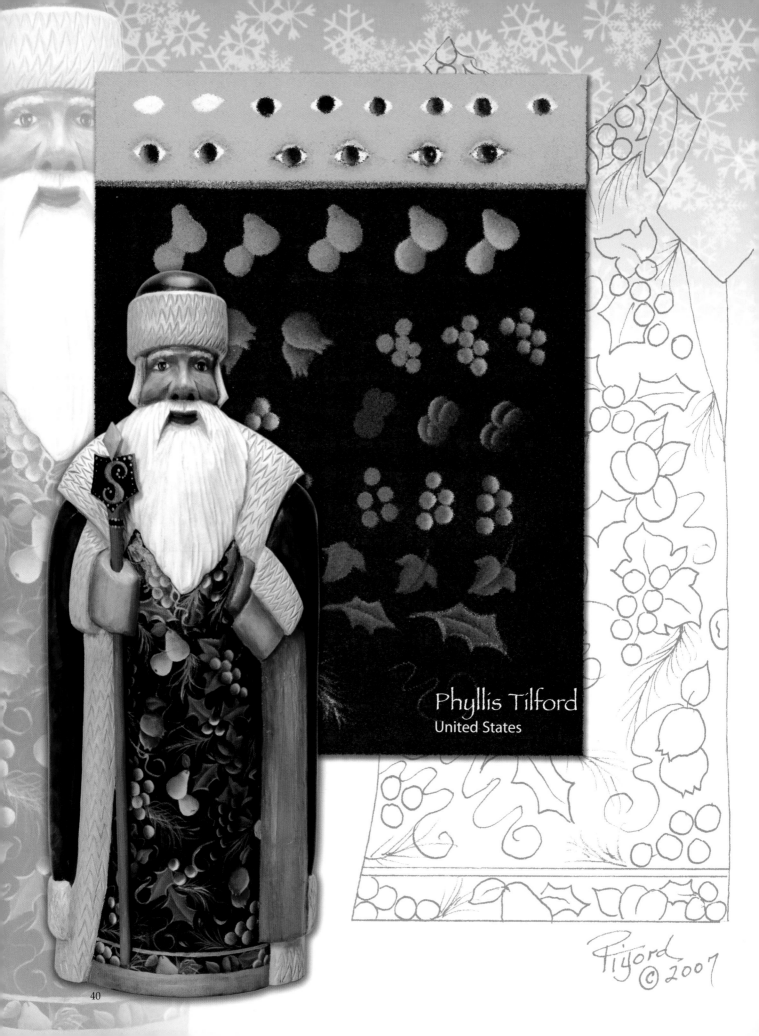

Phyllis Tilford
United States

40

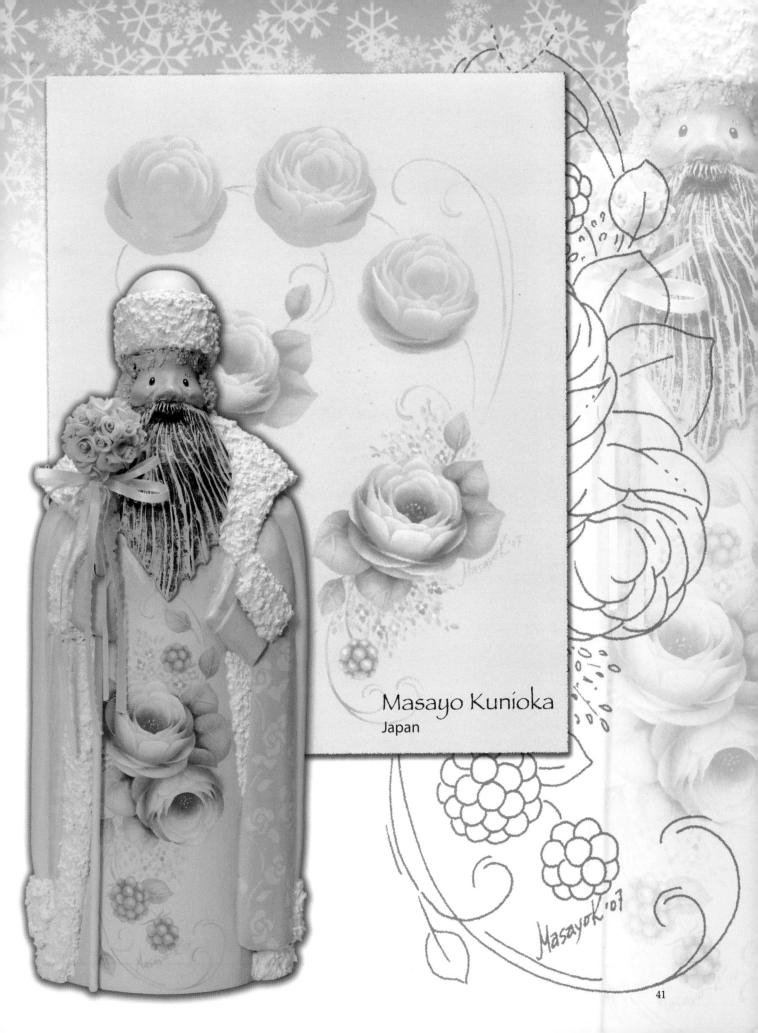

Masayo Kunioka
Japan

Father Christmas

Preparation

Sand the figurine and wipe with a soft cloth.

Molding clay is used to enhance Father Christmas' facial features and to further define selected clothing areas. When adding molding clay to the figure, be sure to apply wood glue to the surface before adding the clay. Use an X-acto knife to cut small pieces of clay. Use toothpicks, small spoons or any other utensil to shape the clay. Do not trace children until after Father Christmas' clothing is painted.

Clay Applications

Face

For the nose, roll a pea-size ball of clay and attach it to the center ball of the nose. Add a smaller roll of clay for sides of nose. Roll a ball of clay for each cheek, then flatten it slightly and apply it to the figurine and smooth into the face. For the eyes, roll small balls of clay and attach them in the center of each eye area. Add a small, flattened roll for the eyebrows. For the lower lip, add a small, curved roll of clay and glue in place. Shape and add the moustache. You may want to add clay to the hair and beard. Use a combing tool to add texture.

Clothing & Christmas Tree

Roll clay 1/8-inch thick and add to gloves and shape thumbs. Add strips to the fur areas using your fingers to smooth it into place. Shape small trees for the sides of the coat.

For the tree in his hand, roll the clay 1/4-inch thick and cut out the tree shape. The tree trunk is cut from the scepter dowel rod. Cut it long enough so that a length of 3 1/2-inches can be pushed halfway up into the tree plus enough additional length to anchor it in Santa's hand. Push the dowel into the tree, then remove it. Add glue in the hole and reinsert the dowel. Cut the star and bird from thin pieces of clay. Let the clay dry completely.

Apply a thin coat of Clear Glaze Medium to the entire figure and let dry. Apply a coat of slightly thinned Unbleached Titanium to the figure. Let dry.

Santa

Face & Lower Lip

Mix Skin Tone Base + Burnt Sienna (3:1). With the #8 shader, base face and lower lip. Let dry. Apply a light coat of Retarder over the face. Shade sides of face, under nose and brows with Burnt Sienna. Darken inside mouth with Burnt Sienna + Purple Madder. Pinken cheeks, nose and lower lip with a little Red Earth. Let dry. Paint eyeballs with Aqua using the #1 liner. Lighten lower portion with Warm White + a little Aqua. Darken the top of the eyeballs with Storm Blue. Add a Raw Umber pupil and a Warm White highlight with the 18/0 liner. Add a fine Burnt Sienna line to shape the top of the eyes. Highlight cheeks, nose and lower lip with Warm White.

Paint the beard, moustache and hair with Nimbus Grey using the #10 shader. Let dry. Highlight with a light brushing of Warm White.

MATERIALS

JO SONJA'S ARTIST ACRYLICS

Warm White, Unbleached Titanium, Smoked Pearl, Skin Tone Base, Naples Yellow Hue, Raw Sienna, Burnt Sienna, Jaune Brilliant, Napthol Red Light, Red Earth, Permanent Alizarine, Purple Madder, Aqua, Sapphire, Storm Blue, Yellow Green, Antique Green, Brilliant Green, Teal Green, Fawn, Nimbus Grey, Raw Umber, Brown Earth, Pale Gold (metallic), Opal Dust (in bottle).

JO SONJA'S MEDIUMS

Retarder, Clear Glaze Medium, Polyurethane Water Base Satin Varnish, Kleister.

ADDITIONAL SUPPLIES

Stencil: Laurie Speltz BCS139 (Snowflakes)
Elmers Wood Glue
Molding clay: Modena Clay or Quick Wood Clay
Combing Tool

BRUSHES

Loew Cornell
- Series 7350-#'s 18/0 and 1
- Series JS Liner-#0
- Series 7300 Shaders-#'s 6, 8, 10, 14
- Series 7150 Wash Glaze-size 3/4-inch
- Series 7500 Filberts-#'s 4, 6, 8
- Series 7850 Deerfoot Stippler-size 3/8-inch

Royal Langnickel Aqualon Wisp
- Series 2931-sizes 1/8-inch, 1/4-inch, 3/8-inch

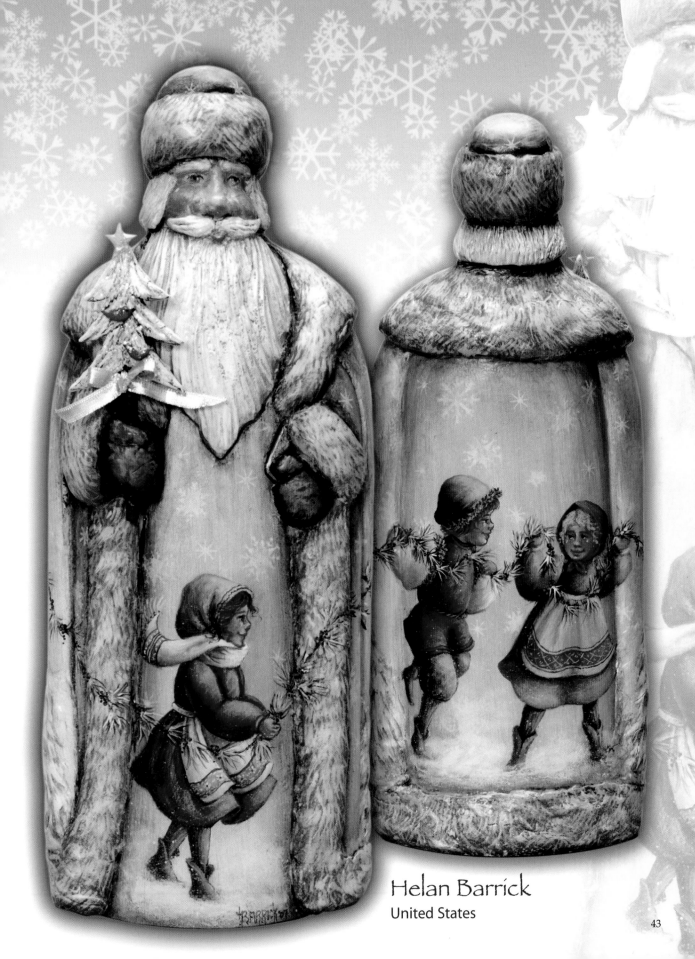

Helan Barrick
United States

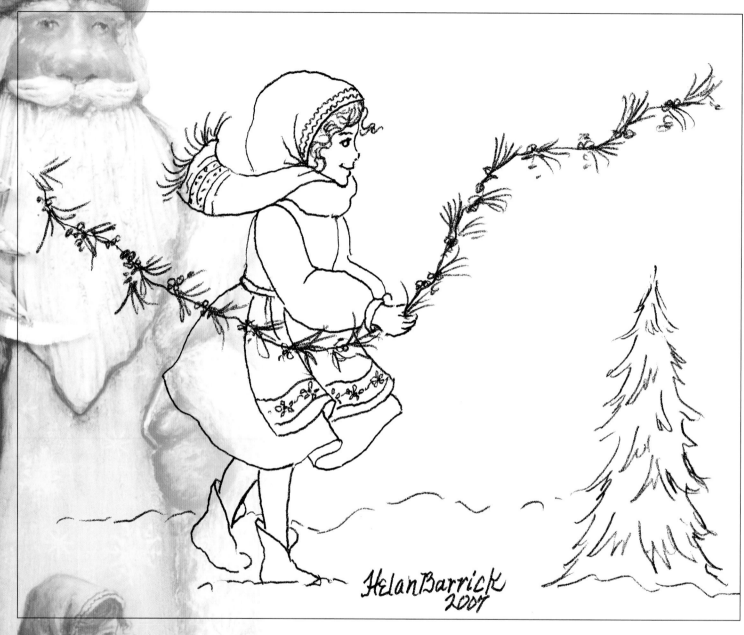

HelanBarrick 2007

Clothing

Coat & Cap: Tint the coat and cap with a thin wash of Storm Blue + a little Raw Umber using the #14 shader. While damp, blot brush and side load with a little Storm Blue + Raw Umber and slightly darken shadow areas next to fur trim and under the beard. Let dry.

Fur: Brush slightly thinned Fawn + Raw Umber over all fur. Let dry. Dampen with retarder and blot lightly. With a

1/4-inch wisp brush, add fur strokes with Smoked Pearl.

Gloves: Base with Teal Green. Highlight with Antique Green + Yellow Green.

Book: Brush Pale Gold over pages. Paint book cover with Purple Madder. Highlight with Napthol Red Light + a little Naples Yellow Hue.

Children

Carefully trace pattern to tracing paper and transfer to the

surface using a stylus and gray transfer paper.

Using the #6 shader, base coat hands and faces with Skin Tone Base. Let dry.

Transfer features carefully and accurately. Go over the transfer lines with fine lines of Burnt Sienna + a little Skin Tone Base. Fill in eyeball color: Burnt Sienna for brown eyes or Aqua for blue eyes. Let dry.

Brush a light coat of retarder

over faces before shading or adding blush tones.

Add Burnt Sienna shading with the #1 round brush along the hairline and side of the nose. Use a dry #4 or #6 filbert to soften color. Let dry. Blush cheeks, lips and lower tip of nose and chin with a tiny bit of Red Earth using the #1 liner brush. Soften color with a dry #4 filbert. If needed, add line work for the top of eye line, the brows, center mouth line and separate the fingers using delicate Burnt Sienna line work. Also add line work where needed at edge of face, hands and fingers.

Brown Hair

Add a thin wash of Burnt Sienna. Let Dry. Add Burnt Sienna + Raw Umber lines using a liner bush and a 1/8-inch wisp brush.

Blonde Hair

Add a Raw Sienna + Raw Umber wash. Let dry. Add line work with Naples Yellow Hue using a liner bush and a 1/8-inch wisp brush.

Clothing

Apply base colors. Let dry. Trace on any necessary pattern lines. Apply a light coat of retarder before adding shading or highlights.

White Clothing

Base with Nimbus Grey. Shade with Sapphire + Raw Umber. Lighten with Warm White. Add trims with thinned colors using Yellow Green + Antique Green, Napthol Red Light + Jaune Brilliant and Warm White.

Green Clothing

Base with Antique Green + a little Unbleached Titanium. Shade with Teal Green + Antique Green. Lighten with Yellow Green + a little Antique Green, then Yellow Green + Naples Yellow Hue.

Red Clothing

Base with Permanent Alizarine + Purple Madder. Lighten with Jaune Brilliant + Napthol Red Light and then further lighten with Jaune Brilliant + Naples Yellow Hue. Fur and rope belts on boy's clothing is Brown Earth. Highlight with Fawn + Naples Yellow Hue using a 1/8-inch wisp brush and a liner brush.

Shoes & Stockings

Base with Raw Umber. Lighten with Fawn.

Garland

Paint a thin Brown Earth line. Add greenery with thinned Teal Green and lighten with Brilliant Green and some Yellow Green. Add berries with dots of Permanent Alizarine and highlight with Napthol Red Light.

Snowflakes

Stencil with Warm White using a stippler brush.

Snow at Bottom

Nimbus Grey. Highlight with Warm White. Spatter with thinned Warm White.

Tree in Boy's Hand

Base Teal Green. The stick is painted Raw Umber. Star is Pale Gold.

Paint birds with Permanent Alizarine. Lighten them with Napthol Red Light + Jaune Brilliant. Add an eye of Storm Blue. Let dry. Brush Opal Dust over tree, star and birds.

Final Finish

Apply a coat of Clear Glaze Medium. Let dry. Apply two coats of Polyurethane Water Base Satin Varnish.

Helan Barrick
2007

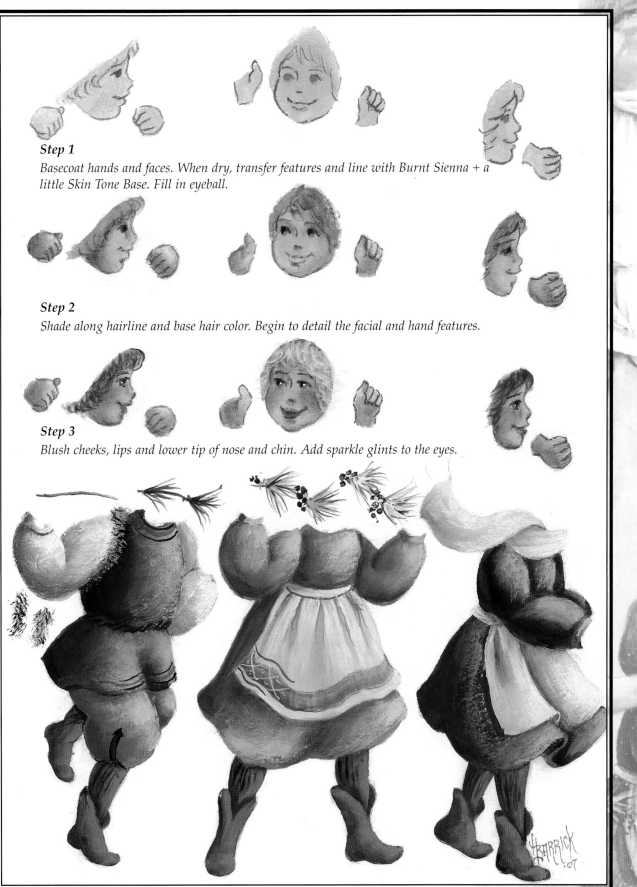

Step 1

Basecoat hands and faces. When dry, transfer features and line with Burnt Sienna + a little Skin Tone Base. Fill in eyeball.

Step 2

Shade along hairline and base hair color. Begin to detail the facial and hand features.

Step 3

Blush cheeks, lips and lower tip of nose and chin. Add sparkle glints to the eyes.

Antique Santa

Preparation

Use wood filler to create fur texture, build up cheeks, nose, eyebrows, hair and to make the beard larger. Allow this to dry overnight.

Face

1. Paint the face with Warm White + Burnt Sienna.

2. Load the liner with Burnt Sienna thinned with water; outline the eyes.

Load #2 flat with Blending Gel, corner load with Burnt Sienna and shade the face all around, above eyes, sides of the nose, under nose and eyebrows.

3. Paint the eyes Warm White, then add iris with Dark Hydrangea and the pupil with Pure Black. Add Warm White highlights.

Wrinkles are painted with the liner and Burnt Sienna thinned with water.

4. Create blush on nose and cheeks with Warm White + a tiny bit of Burnt Sienna and

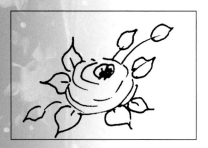

Cardinal Red. Highlight cheeks and nose with Warm White.

Hair & Beard

1. Paint beard, hair, eyebrows and moustache Dove Gray. Load #12 flat with Dove Gray + a bit of Dark Hydrangea; shade around beard, hair, under moustache and eyebrows.

2. Load 3/8-inch Wisp brush with Blending Gel + Warm White. Use the tip of the brush, and long curvy strokes to paint wavy hair and beard.

Robes, Hat & Scepter

1. Apply two coats of Green Forest to robes and hat. Add swirls and dots with Pure Gold.

Add Pure Gold dots to hat. Dry.

2. Apply a transparent glaze with Blending Gel + a small amount of Pure Gold using #12 brush.

3. Paint scepter Pure Gold. Dry. Apply a transparent glaze with Blending Gel + Burnt Carmine + a little Burnt Umber. Wipe away excess.

Gloves

1. Use #8 flat and a brush-mix of Cardinal Red + Fuchsia + Warm White to paint gloves.

2. Highlight gloves and create a velvet-looking texture by patting with the flat side of a #8

3. Tap highlight on moustache and eyebrows with the same brush.

MATERIALS

FOLKART ARTIST'S PIGMENTS

Burnt Carmine, Burnt Sienna, Burnt Umber, Pure Black, Warm White.

FOLKART ACRYLIC COLORS

Cardinal Red, Dark Hydrangea, Dove Gray, Fuchsia, Grass Green, Green Forest, Parchment, Red Violet, Raw Sienna.

MISCELLANEOUS

FolkArt Blending Gel Medium, FolkArt Metallic Pure Gold, stylus, matte polyurethane varnish, wood filler.

BRUSHES

Royal & Langnickel
• Series 4585 #10/0 liner
• Series 4350 #'s 2, 4, 6, 8, 12
• Series 2935 3/8-inch wisp

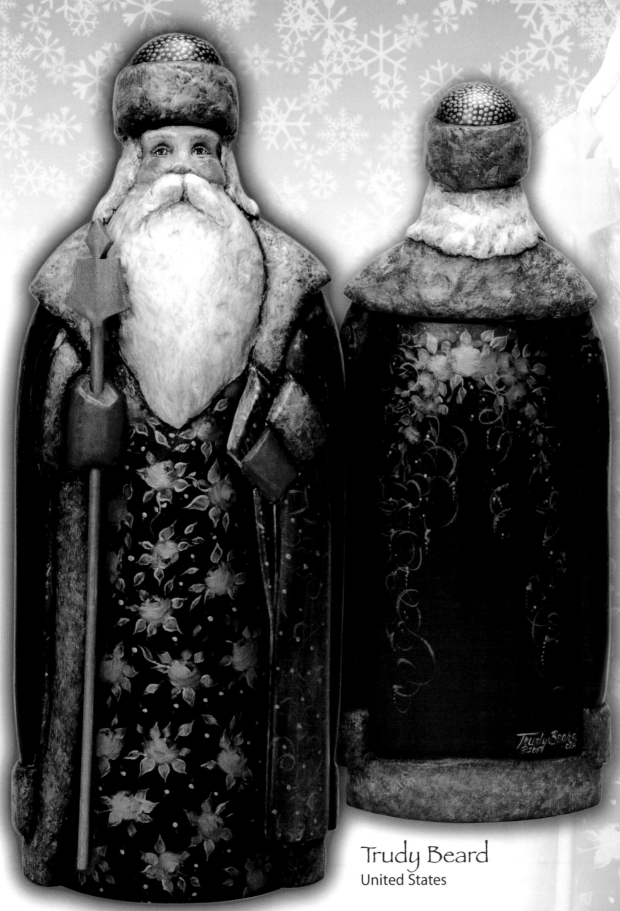

Trudy Beard
United States

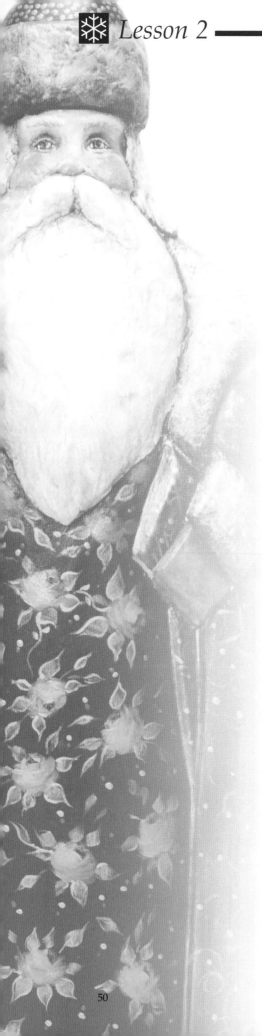

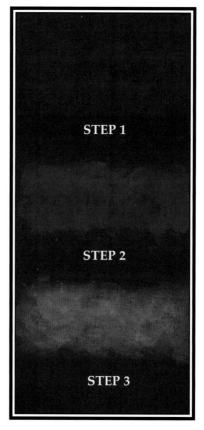

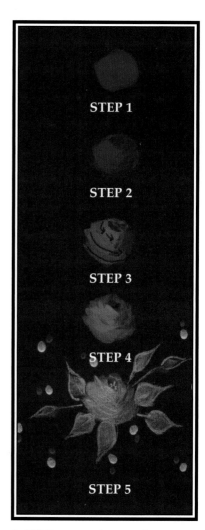

brush loaded with the glove mix + a little Warm White. Dry.

The gloves will be antiqued when everything is painted.

Fur

1. Dab on a mixture of Burnt Umber + Burnt Carmine. Paint one section at a time so you can work wet-on-wet.

2. While undercoat is damp, dab on Raw Sienna + Burnt Umber.

3. Add final highlights while Step 2 is still damp. Highlights are Raw Sienna + a little Parchment.

Roses & Leaves

1. Load #4 flat with Cardinal Red; paint rose shape. Let this dry slightly, reapply Cardinal Red.

2. While second coat of Cardinal Red is damp, shade throat of rose, right side and bottom of rose with Burnt Carmine. Clean brush; squeeze dry.

3. Paint middle values with a brush-mix of Cardinal Red + Fuchsia + a small amount of Warm White. Start with a short flat stroke under the throat of rose. Refer to painted work-sheet.

4. Load same brush with the mix above + a bit more Warm White and highlight the rose.

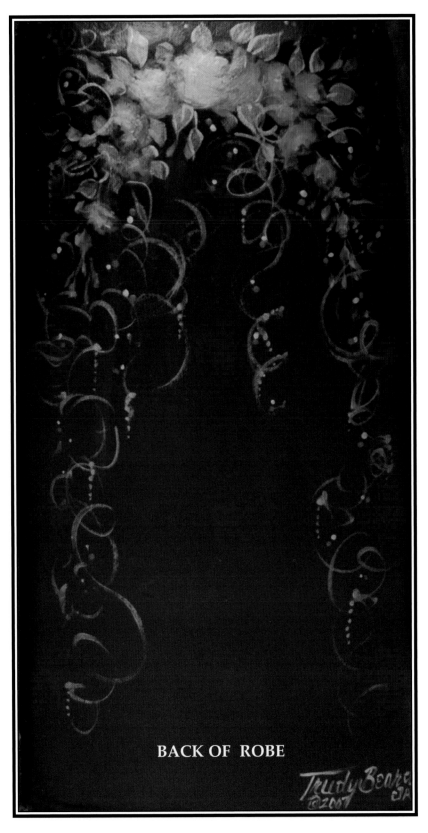

BACK OF ROBE

5. Paint leaves with #4 flat and Pure Gold + a small amount of Grass Green. (The leaves will be slightly transparent).

Outline leaves with thin lines of Pure Gold.

Highlight roses with a transparent glaze of Pure Gold. (Load brush first with Blending Gel, then Pure Gold).

Add tiny Pure Gold dots in throat of rose.

Add Pure Gold dots and Fuchsia dots between roses and leaves. (Use a small stylus to create dots).

Back of Robe

This area is meant to appear as if it is an old heavyweight tapestry fabric woven with elegant roses and trimmed with gold threads.

1. Create an arrangement of roses with smaller roses and buds at each end of the arrangement.

2. Add violet filler flowers with Red Violet and Red Violet + a little Warm White.

3. Add tendrils and dots of Pure Gold.

Finishing

1. Allow everything to dry thoroughly. Antique everything with a mixture of Blending Gel + a little Burnt Carmine + Burnt Umber. Wipe away most of the antiquing mixture, leaving some in the creases.

2. Allow to dry overnight. Apply two light coats of matte finish varnish.

The Spirit of Christmas

Background Preparation

Seal all wood surfaces with wood sealer. When dry, sand with 400 grit sandpaper. Wipe with a tack cloth to remove sanding dust.

Fur Areas on Father Christmas

On all fur areas of the hat and robe, using the palette knife, apply Titanium White artist's (tube) acrylic in short vertical, overlapping strokes as if you were icing a cake. Allow to dry. Apply additional applications in the same manner until these areas look as if they are fur covered.

Acrylic Basecoats

- Face & Hands: Flesh
- Beard, Brows, Moustache & Hair: Grey Sky
- Robe, Hat & Side of Pedestal Box: Ultra Blue Deep
- Gown: Country Blue
- Scarf: Royal Purple highlighted with Deep Periwinkle
- Top & Bottom of Pedestal Box: Royal Purple
- Scepter Handle: Lamp (Ebony) Black

When dry, spray all surfaces with Matte Finish and transfer the pattern detail to the gown using graphite paper.

Fur & Scepter Blade

Using the Krylon 18KT Gold Leafing Pen, cover all fur areas and the scepter blade until opaque. Several applications may be needed to adequately cover the surfaces. Allow to thoroughly dry before handling.

Face

Eyes

Sideload a small flat brush with BLK and paint the eyes with horizontal v-shaped strokes.

Cheeks, Lips & Bridge of Nose

Blush with CS and deepen the lower area of the cheeks and the lower lip with PAC.

Hair & Beard

With a mix of TW+BLK (medium value grey), shade under the hat, the upper area of the beard adjacent to the face and randomly on the remaining beard areas. Using a dirty grey mix of these colors barely define the brows. Highlight front and lower areas of the

MATERIALS

DECOART AMERICANA ACRYLIC COLORS

Avocado, Country Blue, Deep Burgundy, Deep Periwinkle, Grey Sky, Lemonade, Lamp (Ebony) Black, Royal Purple, Ultra Blue Deep, True Red, Hi-Lite Flesh.

PERMALBA ARTISTS ACRYLICS

Titanium White (tube)

WINSOR & NEWTON ARTISTS OIL COLORS

Cadmium Lemon (CL)
Cadmium Orange (CO)
Cadmium Scarlet (CS)
Cadmium Yellow (CY)
Cadmium Yellow Pale (CYP)
Dioxazine Purple (DP)
French Ultramarine (FU)
Ivory Black (BLK)
Oxide of Chromium (OxC)
Naples Yellow Light (NYL)
Permanent Alizarin Crimson (PAC)
Purple Lake (PL)
Purple Madder Alizarin (PMA)
Titanium White (TW)
Yellow Ochre (YO)

KALA KOLINSKY BRUSHES

Series, 5250: #'s 2, 4, 6, 8, 10
Any liner brush with an excellent point.

Brushes are available from Kala Brushes, PO Box 6478, Phrump, NV 89041, (580) 220-9668, www.kalabrush.com.

SIMPLY ELEGANT STENCILS BY REBECCA BAER

Scrollwork Background Stencil (ST101).

Available from From the Hands of the Creator, 13316 Marsh Pike, Hagerstown, MD 21742, (301) 797-1300, www.rebeccabaer.com.

LIBERTY STAIN & VARNISH

Gloss Finish, Matte Finish.

MISCELLANEOUS SUPPLIES

Small pointed palette knife, disposable palette paper, tracing paper, graphite paper, stylus, tack cloth, 400 grit wet/dry sandpaper, wood sealer of your choice, Krylon 18KT Gold Leafing Pen, 1/4-inch stencil brush, grapes with grape leaves fruit charm from the jewelry-making section of your local craft store, small amount of rubbing alcohol for cleaning stencil brushes loaded with paint from the 18KT Gold Leafing Pen.

PEDESTAL BOX

Available from Allen's Woodcrafts, 3020 Dogwood Lane, Sapulpa, OK 74066-9803 , (918) 224-8796.

Gretchen Cagle
United States

hair with TW. Also, apply TW highlights to the brows and randomly on the beard.

Basic Instructions

Work each design element in the order listed going through all steps until directed to allow the painting to dry. When dry, continue as directed.

All colors are brush-mixed and applied sparingly to the element. After applying each application of color, dry-wipe the brush and barely blend between the color breaks before applying the next color. Where more than one shade or highlight color is listed, apply the first color, dry-wipe the brush and blend. The second or third application of color to that area is applied and blended in a smaller area than the previous color applications thus building to a peak of highlight or a depth of shadow that allows some of each previous color application to remain visible.

Pear

Base	CL+small amount OxC
Shade	Base mix+ OxC +BLK
1st Highlight	NYL
2nd Highlight	TW at bottom
Tint	CO
3rd Highlight	TW

If necessary, when dry, strengthen shade and highlight areas. Paint the stem using the pear colors.

Grapes

Base	PMA
Shade	PL in overlaps
1st Highlight	CS bottom area of each grape
2nd Highlight	CO leaving some CS

Allow to dry.

Tint	TW+FU
Glints	CO or TW

Paint grape stems with any yellow green color from the palette.

Leaves

Base	CL+OxC+BLK
Shade	OxC+BLK in overlaps and vein areas
1st Highlight	CL
2nd Highlight	TW
Tint	TW+FU
Glints	TW

Upper Apple

Base	CL+OxC-entire apple. Allow to dry.
Dark	CS
Shade	PAC in lower portion of CS
1st Highlight	TW+PAC below smile
2nd Highlight	TW
Tint	TW+small amount FU

Apply tint at bottom center. Paint the stem using the pear colors.

Lower Apple
(Not Included in Steps)

Dark	PAC
Mid	CS
Light	CO adjacent to leaf
Shade	PAC+PM
Highlight	TW on top of smile. TW+FU on far right side of smile and at the top left of apple.

In the blossom end of the apple, dab a touch of BLK and highlight with any yellow green from the palette.

Oranges

Base	CO
1st Shade	PAC
2nd Shade	PMA in deepest over-laps
1st Highlight	CYP
2nd Highlight	TW
Tint	TW+FU

Apply detail in the blossom end of the orange by dabbing in a bit of BLK and CL.

Lemons

Base	CL
1st Shade	CY
2nd Shade	YO
Highlight	TW
Tint	PAC

Plums

Base	FU+small amount DP
1st Shade	FU+BLK
1st Highlight	TW
2nd Shade	BLK in deepest overlaps
Tint	PAC adjacent to shade

Stenciling Santa & the Pedestal

The top of the pedestal box and the Ultra Blue Deep areas of Santa's robe are stenciled using the paint from the 18KT Gold Leaf Pen applied with the stencil brush.

On the palette, tap the pen in an up and down motion to release a puddle of paint onto the palette. Load a scant amount of the paint onto the stencil brush and then stencil Santa's robe.

Before moving to the pedestal box, clean the stencil with a paper towel wetted with rubbing alcohol. After stenciling the box, using the 18 KT Gold Leaf Pen, carefully outline along the bottom and top edges of the box lid and box bottom.

On the scepter, glue on the tiny grape charm which is painted as follows:
1.) Grapes are based with Deep Burgundy and, while wet, highlighted with True Red.
2.) Leaves painted with Avocado and, while wet, highlighted with Lemonade.

©2007
Gretchen

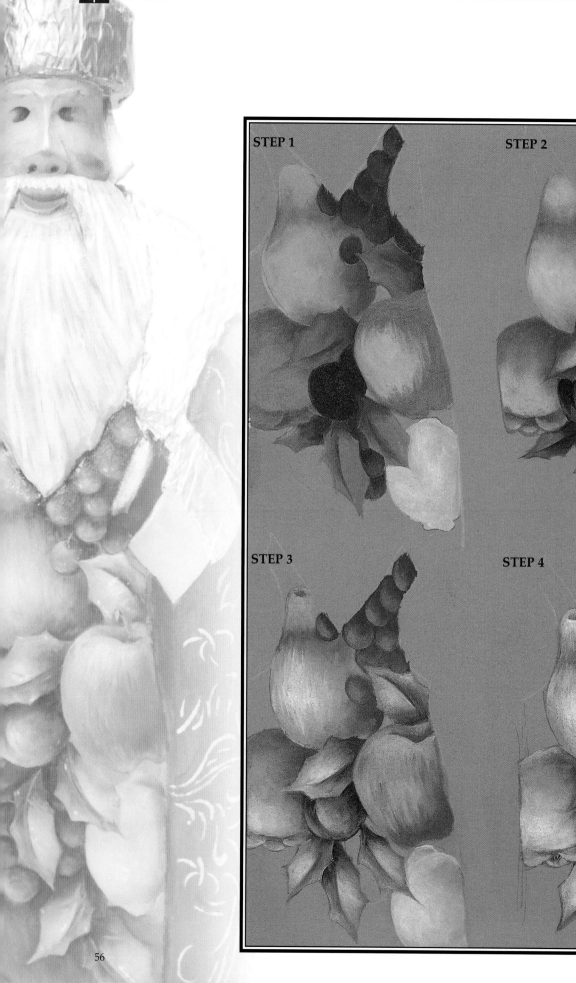

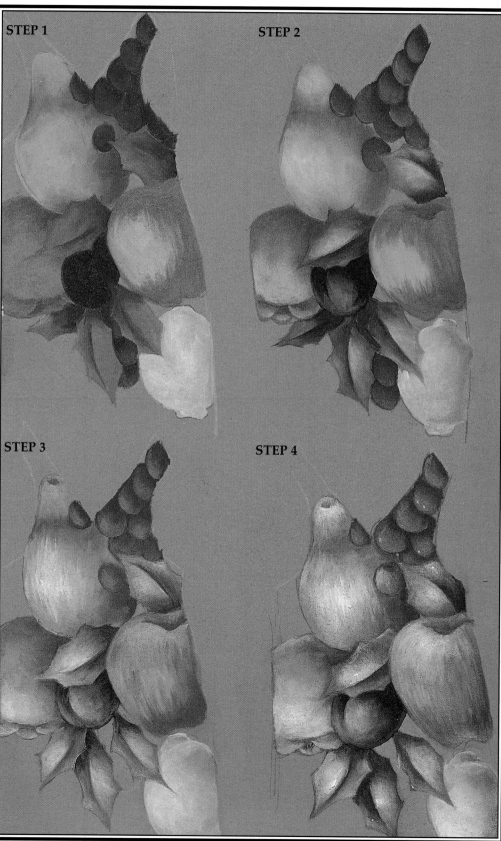

STEP 1

STEP 2

STEP 3

STEP 4

GRETCHEN CAGLE

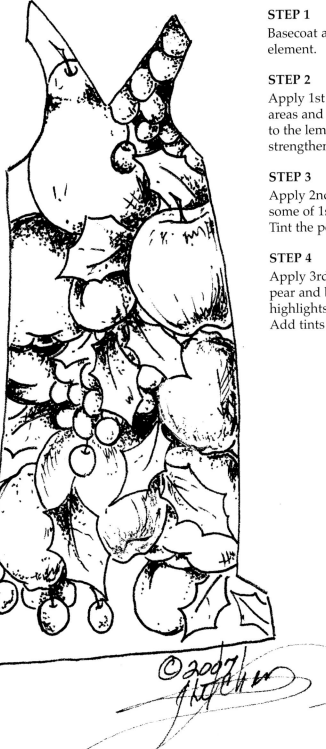

STEP 1

Basecoat and shade each element.

STEP 2

Apply 1st highlight to lightest areas and apply 2nd shade to the lemon. If necessary strengthen other shaded areas.

STEP 3

Apply 2nd highlight leaving some of 1st highlight visible. Tint the pear.

STEP 4

Apply 3rd highlight to the pear and brighten any other highlights that appear too dull. Add tints to all elements.

©2007

Angels & Doves

Preparation

Using tracing paper and, with a pencil, trace all patterns to the Santa. Apply water with brush on the painting areas before painting each area.

Santa's Bag in His Left Hand

Use a #4 brush loaded with Marigold to paint the circle of ornaments. Sideload the brush with Chestnut to shade circle inside round. Use a #3 brush loaded with Geranium to paint flower inside the gold circle.

With a #8 brush, apply the bag with a mix of Vines + Forest Green (2:1). Add a shadow line, using a sideloaded a #8 with a mix Forest Green + Vines (2:1).

For details on the ornament, use Primrose, Soft White and Gold applied with a #1 brush.

Santa's Coat

For basic color, use a #10 brush with a color wash of Claret Rose. Apply shadow line with a mix Claret Rose and Deep Plum (2:1) using a #8 brush. Use #5/0 to add small ornaments on the coat with Gold.

To the fur areas, brush with a little Chestnut pushing it into the v-shaped markings and then dry-brush with Soft White highlights.

Santa's Gloves

Paint using a #4 brush with Geranium. Ornaments on the gloves are applied with Marigold and Vines using a #8 brush. Sideload a #3 brush to shade with a mix of Deep Plum + Chestnut. Use a #1 brush with Deep Plum for C-stroke and outline of the ornament.

The center of the flower is painted with a #1 brush loaded with Primrose. Add points with Gold Dust.

Coat & Sleeve Ornaments

Use a #8 brush to paint base color with Marigold (color wash). Apply the base tone on the main details of the ornament using a #3 brush loaded with Geranium, Vines and Tiger Lily (follow the pattern).

Sideload a #4 brush with Deep Plum to shade ornaments. Use a #1 brush loaded with Deep Plum for the outline and C-strokes of the ornament. Add point with Primrose, Geranium, Gold and Gold Dust using a #5/0.

Use a #8 with Marigold to paint base of the border on the coat. Add green lines with Vines. Use the #1 with Geranium and Deep Plum to outline and add tiny lines. For small triangles, use a # 5/0 with Primrose. For the dots, use the same brush with Soft White and Gold Dust.

Angel & Santa Face

Both faces utilize the background color as the basic flesh tone.

Shade and define the features of the angel with Chestnut and blush the cheeks with a wash of Geranium. Highlight the chin with Soft White.

Santa's face only needs a blush of Geranium.

Eyes: Add Chestnut to shade around the eyes using a #3 brush. Fill in eyeballs with Cornflower. Middle of the eyeballs, upper eyeline and eyelashes are with Charcoal using a #1 brush.

Santa's Staff

Use a #8 with Marigold to paint the staff. Add Chestnut for the shading. Apply Geranium and Vines for base of the ornament using a #3 brush, then add outline of the ornament with Deep Plum loaded onto a #1 brush. With Soft White, Primrose, Gold and Gold Dust, paint small details of the ornament (see picture).

Front of Santa's Gown

Apply sky, starting with Marigold using #8 brush, then blend a mix Cornflower +

MATERIALS

JO SONJA'S CHROMA ACRYLICS

Marigold, Chestnut, Vines, Forest Green, Geranium, Primrose, Soft White, Gold, Claret Rose, Deep Plum, Cornflower, Harbour Blue, Tiger Lily, Charcoal, Mustard Seed, Gold Dust.

ROYAL MAJESTIC BRUSHES
• Rounds: #'s 5/0, 3, 4

ROYAL KOLINSKY ELITE BRUSHES
• Round: #1
• Flat: #'s 8 and 10

MISCELLANEOUS
Tracing paper, transfer paper, pencil, paper towel, cap with water.

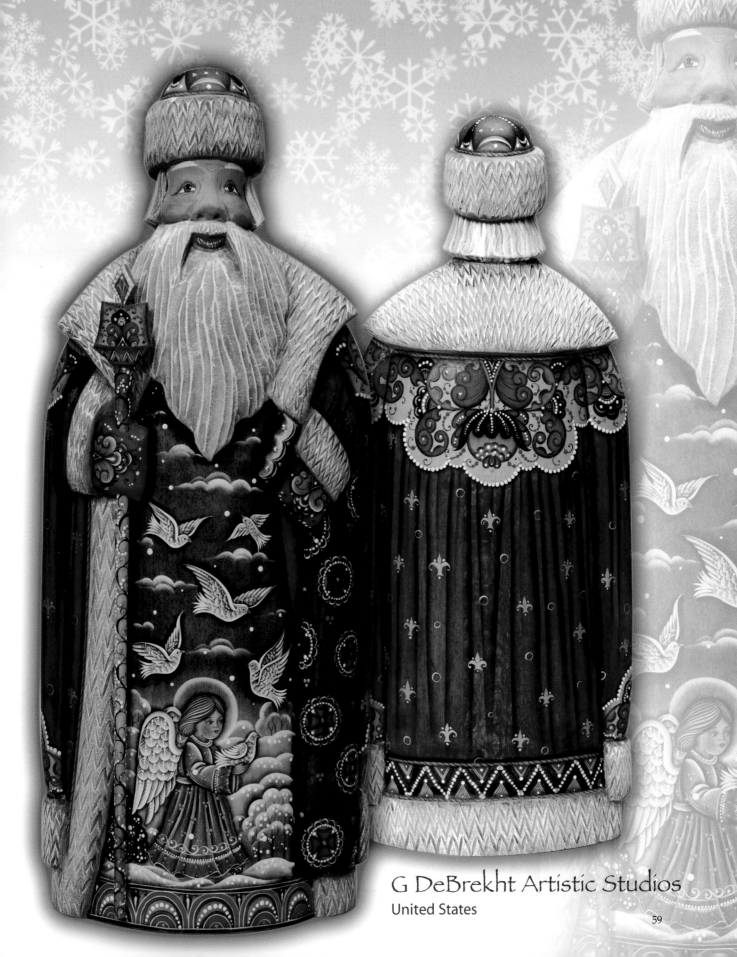

G DeBrekht Artistic Studios
United States

Harbour Blue (2:1) into the sky area. Add the same mix for shading the snow.

Paint the birds and angel wings with Chestnut. For the dress of the angel and the border, apply Mustard Seed; then add Tiger Lily to the elements of the dress and Vines to the tree.

Sideload a #8 brush with a mix of Chestnut + Deep Plum (2:1) and add fine detail shadows of the birds, angels wings and dress. Highlight with Soft White using a #3 brush.

Add Soft White clouds and small trees on the background with a sideloaded #3 brush.

Santa's Hat

Paint with Marigold, then apply the shadow with Chestnut. Add circular ornaments on the hat using a #4 brush loaded with Marigold. Sideload brush with Chestnut to shade circle inside round. Use a #3 brush with Geranium to paint the flower inside the gold circle. For details on the ornament use Primrose, Soft White and Gold applied with a #1 brush.

Hat

Glove, Coat & Sleeve Ornaments

Back of Cape

60

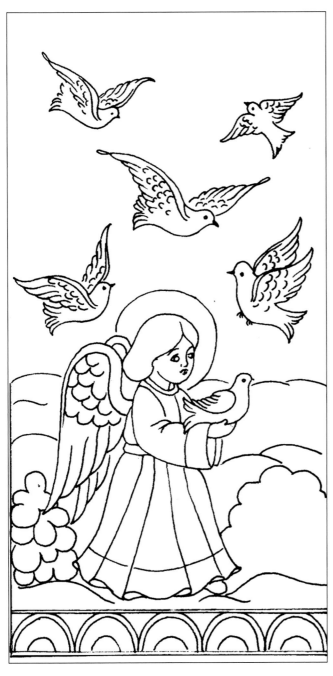

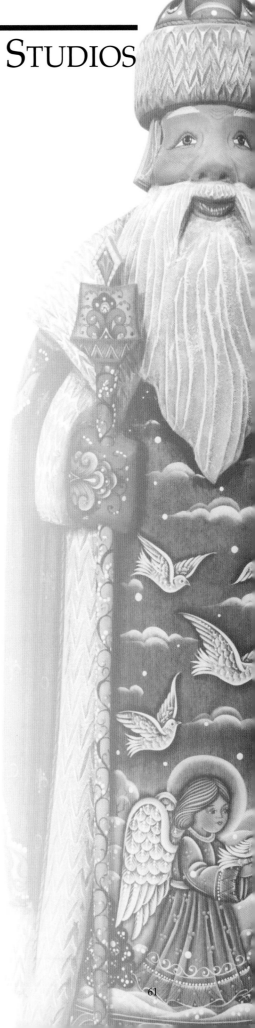

Elegant Santa

Preparation

1. Base paint all sections of the Santa with appropriate colors. Mix a small amount of JW Etc. Sealer with paint for this step.

Face	Skintone
Hat & robe	Rose Pink
Undergarment, fur, hair & moustache	Country Twill
Gift	Lime Yellow + a small amount of Thicket
Bow	Rose Pink
Mittens	Pure Black

While the mitten paint is still wet, brush small amounts of Titanium White in highlight areas and blend. No other attention was given to the mittens.

Paint the staff with Burnt Sienna

Let dry.

2. Finish base painting undergarment. Brush Country Twill over the entire area and while paint is still wet, brush a bit of Vintage White in highlight (center) area and blend. Allow to dry.

Shade. Side load the 1-inch brush with a mixture of Burnt Umber + Thunder Blue (2:1) and stroke color underneath beard, mittens and each side of robe. Blend and then allow to dry.

Add metallic trim to bottom of robe and staff as follows: Measure and mark guidelines across bottom edge of robe. Example has 4 lines. The top line is 2 1/4-inches from the bottom edge. The next line is 1 3/4-inches from bottom edge; the next line is 1 1/4-inches and the final one is 1-inch.

Apply metal leaf adhesive to each marked line using the dagger brush. Use the #1 round brush to make comma strokes using the adhesive. Brush adhesive over all the staff.

Allow adhesive to dry until clear but still sticky, then apply leaf flakes.

Let adhesive continue to dry for several hours, then brush excess leaf from undergarment and staff.

3. Apply texture finish to robe and hat. With a palette knife, mix Raspberry Wine with an equal amount of Floating Medium and a small amount of water to make a transparent glaze.

Working a section at a time, brush the glaze mixture on using a large flat brush. While glaze is still wet, lay plastic wrap onto surface, press firmly, then remove. Continue until all sections are completed. Let dry.

Shade robe and hat. Dampen a large flat brush with water, blot, and then side load with Burnt Carmine for this. Let dry.

The fur trim is completed later.

Gift

Shade box with a small flat brush side loaded with Hauser Green Dark. No highlights were added. The light base color will show through for sufficient highlights.

Shade bow with Raspberry Wine. Highlight Rose Pink + small amounts of Titanium White.

After box is shaded and dry, paint ribbon Rose Pink. Shade ribbon Raspberry Wine. Highlight Rose Pink + small amounts of Titanium White.

Face

Brush a fresh coat of Skintone over face and lower lip, then brush a shading mixture of Burnt Sienna + tiny amounts of Dioxazine Purple onto shaded areas. Blend paints using the Bringle Blender brush in a stippling motion.

Add small amounts of Skintone + a small amount of Vintage White on cheek areas and

MATERIALS

FOLKART ACRYLIC COLORS

Titanium White, Vintage White, Country Twill, Yellow Ochre, Lemonade, Lime Yellow, Thicket, Thunder Blue, Hauser Green Dark, Burnt Sienna, Burnt Umber, Dioxazine Purple, Light Red Oxide, Skintone, Rose Pink, Raspberry Wine, Burnt Carmine, Pure Black.

BETTE BYRD AQUA SABLE BRUSHES

- Round, Series 100: #1
- Flat, Series 200: #'s 20, 16, 12, 6, 4
- Flat, Series 250: 1-inch
- Filbert, Series 600: #'s 4, 2
- Small soft mop
- Dagger, Series 1000: 1/4-inch

BRINGLE BLENDER

- Series 450: #'s 6, 4

MISCELLANEOUS

Lightweight plastic wrap, variegated metal leaf flakes and adhesive from Houston Art, white chalk pencil and clear ruler, palette knife, FolkArt Floating Medium, First Step Sealer by JW Etc.

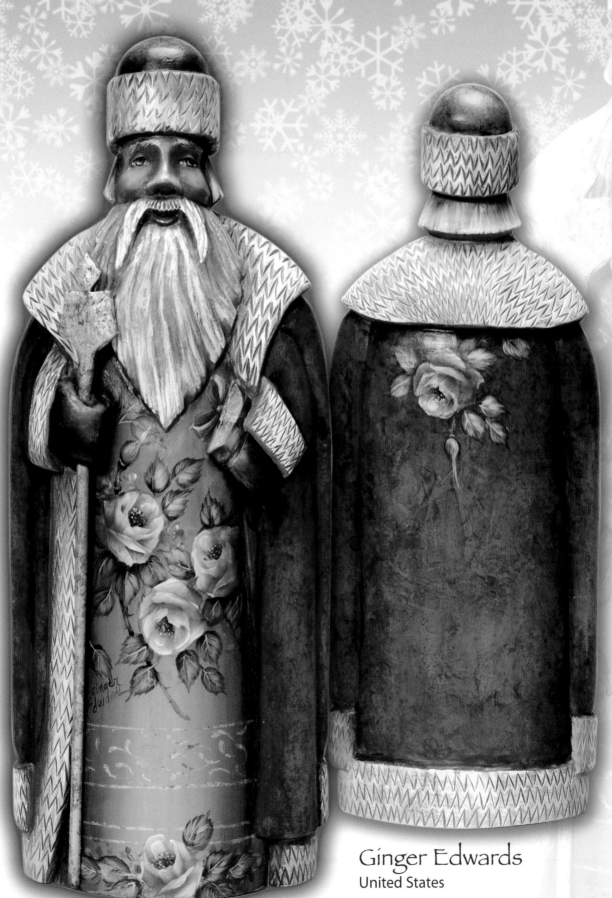

Ginger Edwards
United States

continue blending with the stippling motion. Let dry.

Side load a flat brush with a mixture of Raspberry Wine + small amounts of Light Red Oxide and tint cheeks, lower lip and tip of nose. Let dry.

Paint eyebrows Country Twill darkened with small amounts of Thunder Blue and Burnt Umber. Highlight with Vintage White + Titanium White.

Eyes

Use a liner brush and paint in the order given.

Paint iris Thunder Blue thinned with water. While the paint is still wet, stroke a tiny bit of Titanium White across the bottom of each iris.

Add pupils with Pure Black thinned a bit with water.

On each side of iris, add a bit of Titanium White + Skintone (about equal amounts).

Paint upper lid lines with Burnt Sienna + a bit of Pure Black thinned with water. Add a short line underneath each iris to indicate lower lid line.

Hair, Moustache & Beard

Thin Vintage White to a semi-transparent consistency with water and stroke paint on from tips upwards. While paint is still wet, stroke highlights using Titanium White. Allow to dry, then side load a flat brush (that has been dampened with water) with a mixture of Thunder Blue + Burnt Umber (1:1) and shade hair next to hat. Shade beard underneath lip and moustache.

Add light glints in eyes, top of cheeks, tip of nose and lower lip with tiny dots of Titanium White.

Roses

Paint one rose at a time following the instructions. Study the step-by-step illustrations.

Base: Thin Rose Pink with a bit of water and Floating Medium. While paint is still wet, side load the dirty brush with Raspberry Wine and stroke color inside throat and across bottom of cup.

Establish petals while paint is still wet. Side load the opposite side of brush (from the one having Raspberry Wine) with small amounts of Vintage White. Reload brush as necessary to complete all the petals. Be sure to keep the darker pink values in the brush as you reload.

Shade: Side load a flat brush (appropriate to the size area you are working) with small amounts of Raspberry Wine + a tiny speck of Burnt Umber or Burnt Sienna. Shade inside throat, wherever triangular areas are formed as petals overlap and underneath petal edges to create desired contrast. Let dry.

Tint: Deepen color of rose by brushing on a top coat of Raspberry Wine thinned with water to a transparent consistency. Let dry.

Center: Stipple with small amounts of Burnt Umber + a bit of Raspberry Wine. With a liner, add stamen lines and a few splotches. Let dry. Add highlights among stamen with tips of the bristles of the liner and Yellow Ochre. Add a few dots of Lemonade.

Leaves

Do not base paint leaves on the undergarment. On robe, base paint leaves Country Twill.

Base: Side load a brush equal in size to the width of the leaf with a mix of Thicket + Thunder Blue (1:1). Stroke color across stem end of leaf and next to center vein on one side. Let dry, then side load brush with same mix and stroke paint onto outside edges of leaf. Dry.

Shade: Thicket + Thunder Blue + a tiny speck of Burnt Umber on both sides of center vein.

Tint: Some leaf edges with a mix of Burnt Umber + Burnt Sienna and/or Raspberry Wine. Tap corner of brush onto leaf to create some splotches.

Highlight: Lightly with Lime Yellow. Use a filbert brush for this.

Stems to leaves are painted with the shading mixture. Veins are Lime Yellow.

Fur Trim

Thin a mixture of equal amounts of Thunder Blue + Burnt Umber with water and a bit of Floating Medium to create a transparent color. Brush the mixture on the fur trim to enhance the carved detail, then lightly brush Titanium White on. Use more pant in highlight areas. Let dry, then shade trim if necessary with a flat brush side loaded with a mix of Thunder Blue + Burnt Umber.

Finish the Project

After all paint is dry, brush on a protective coating with your favorite varnish.

GINGER EDWARDS

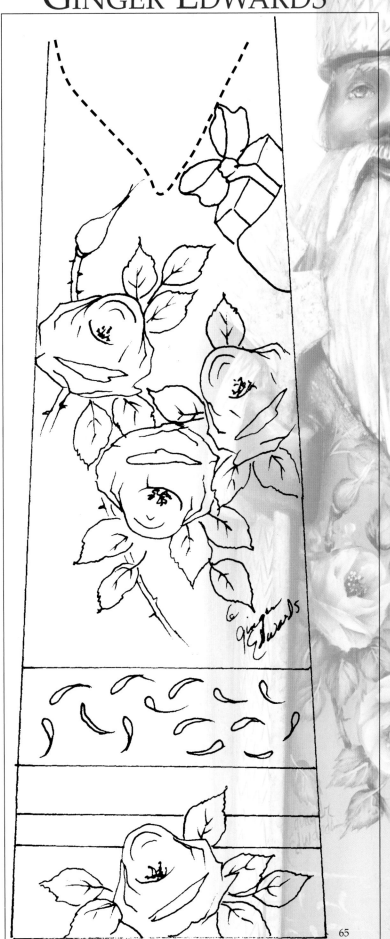

65

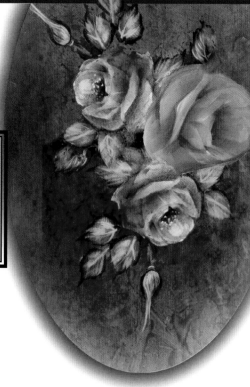

Step 1

Brush thinned base color onto area of rose. Sideload brush to deepen color inside and across bottom of cup.

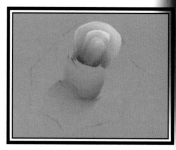

Step 2

Sideload brush (on opposite side of dark) to stroke three petals inside throat.

Step 3

Stroke petals on each side of cup, usually three per side.

Step 4

Two strokes of the brush indicates the front of the cup.

Step 5

An additional two strokes completes the cup.

Step 6

Two strokes of the brush indicates bottom petals.

Step 7

A third stroke directly in front of the cup finishes lower section of petals.

Step 8

The final stroke that completes the rose. When rose is established and dry, deepen shading and color of rose with transparent paint.

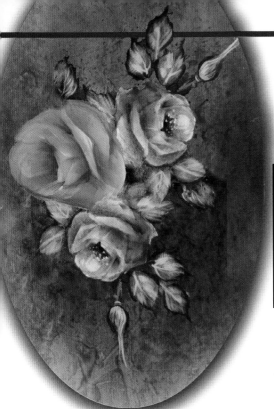

Step 9
Shows all strokes combined creating the rose.

Step 10
After rose is established and dry, deepen shading and rose color with transparent paint.

Step 1
Sideload a flat brush with paint, stroke color across base of rose and next to center vein.

Step 2
When dry, indicate edges of leaves with the same brush sideloaded with paint.

Step 3
Shade each side of center vein with a flat brush sideloaded with paint.

Step 4
Tint some petals edges with a sideload of paint. Tap corner of brush to create splotches.

Step 5
Lightly brush highlights; add stems and veins.

Russian Peasant Santa

A House is Beautiful, Not because of its walls, But because of its Cakes.

Olde Russian Proverb

Preparation

Use the 1-inch square wash brush. Basecoat entire piece with Blackberry. Add touches of Deep Plum and Claret Rose to Santa's hat, sleeves and cape. Stroke, tap and chop for a rough blend.

Santa

Face

Use the #4 filbert to mix Island Sand, Marigold plus touch of Tiger Lily for the flesh color. Add Tiger Lily and Poppy for cheeks. Use Marigold plus a touch of Blackberry for shading. Use a touch of Cornflower to eye area and across the bridge of nose.

Use the #2 short liner to paint the white of the eye Island Sand with a touch of Marigold. The iris is Marigold plus a touch of Blackberry for a soft brown. The pupil and liner is Blackberry. There is a fine Cornflower line just under the eye lid. Use the #0 liner. The red in the inner corners of the eyes is Poppy. Highlight the eyelid with a touch of Island Sand. Also, highlight the white of the eye and the iris using Island Sand and the #0 liner. The laugh lines in the corner of the eyes are a slightly lighter skin tone as well as darker flesh lines. The final accent is Cornflower.

Hair

Use the 3/8-inch oval glaze to mix Island Sand, Harbour Blue and a touch of Tiger Lily for a middle value of grey. Apply and brush very dry to lightly skim over the top of the carving. Let the deep carving work for you. Add lighter grey commas to the hair under the hat.

Fur

Use Island Sand and a dry brush with a light touch. When you first touch the surface, find the highlight areas. As you run out of paint, go to the shaded areas.

Scabbard

Mix a little Mustard Seed and Blackberry to paint the area. Highlight with Rich Gold and shade with a touch of Blackberry. Use the #6 filbert.

Folded Fabric

Use the 3/8-inch oval glaze to mix Sunflower and Marigold. Shade with Marigold and Deep Plum. The accent strokes are Harbour Blue with a touch of Cornflower. Use the #2 short liner.

Santa's Staff

Paint Marigold. Add Mustard Seed plus Island Sand over-stroke commas.

Peasant Lady

Paint her using the 1/4-inch oval glaze brush.

Face

Paint with Island Sand and touch of Marigold. Add Tiger Lily and Poppy for the cheeks and lips. The hair is Marigold and Blackberry. The eyes are Island Sand. Use Marigold and Blackberry mix for a soft brown iris. The pupil is Blackberry. Highlights are Island Sand.

Apron & Blouse

Mix a dirty white by adding Harbour Blue and Tiger Lily to Island Sand. Highlight by adding more Island Sand plus additional diagonal white strokes for a painterly look. The #6 filbert works well for this.

MATERIALS

JO SONJA'S CHROMA ACRYLICS

Poppy, Claret Rose, Deep Plum, Tiger Lily, Marigold, Sunflower, Mustard Seed, Cornflower, Harbour Blue, Island Sand, Blackberry, Rich Gold, Raw Umber.

JO SONJA SURE TOUCH BRUSHES

- Series 1385 Filberts: #'s 2, 4, 6
- Series 1390 Oval Glaze: 1/4-inch and 3/8-inch
- Series 1375 Square Wash: 1-inch
- Series 1350 Round: #4
- Series 1360 Short Liner: #2
- Series 1330 Kolinsky Liner: #0

ADDITIONAL SUPPLIES

Chroma

Clear Glazing Medium, Cherry Wood Stain Gel, Retarder and Polyurethane Water-based Gloss Varnish.

Miscellaneous

Yarn and ribbons for staff.

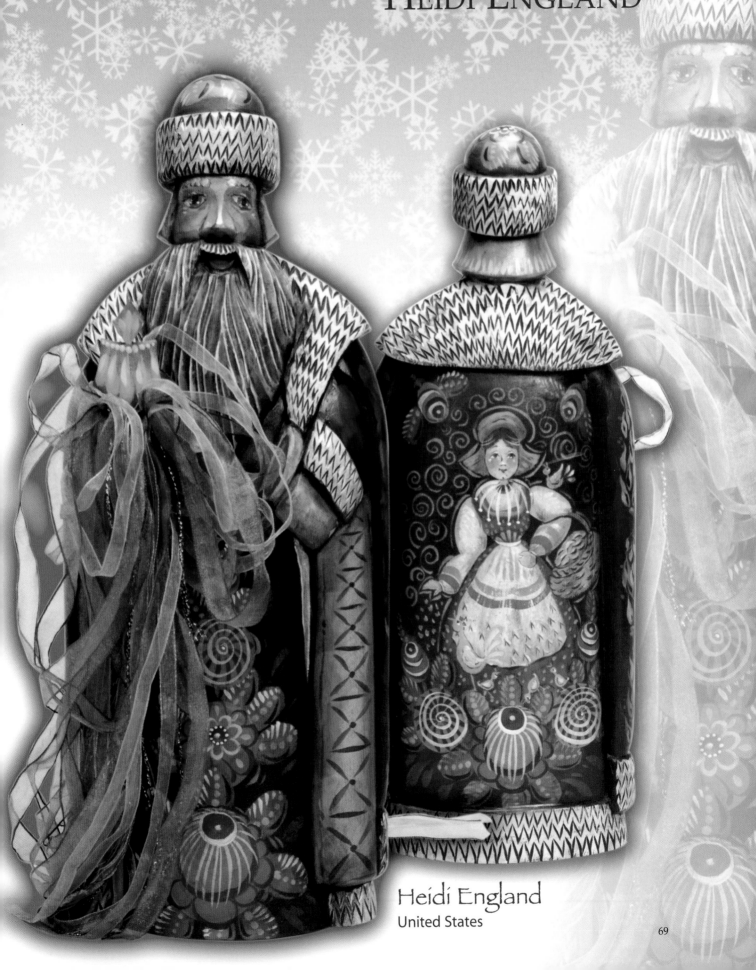

Heidi England
United States

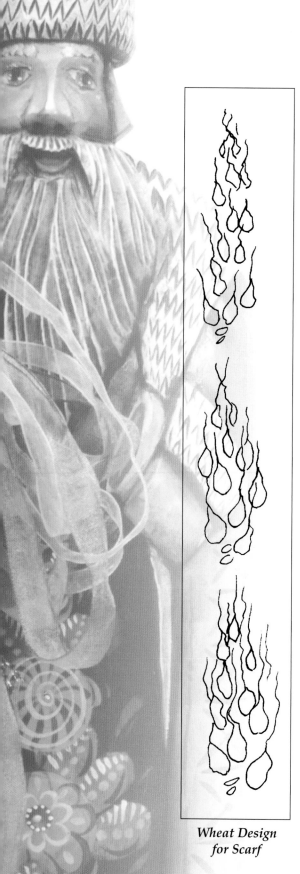

Wheat Design for Scarf

Dress

Cornflower shaded Harbour Blue. Accents are Tiger Lily and Poppy.

Kerchief

Tiger Lily with touches of Poppy.

Curlicues & Liner

Surround the figure with Mustard Seed liner and Marigold curlicues.

"Kalach" Christmas Bread, an intricate triple braided ring

Base Mustard Seed plus Blackberry. Highlight with Mustard Seed, Sunflower and a touch of Island Sand. Add Blackberry liner. Lastly, add Island Sand liner.

Basket & Wheat

On the basket use Marigold with Mustard Seed highlights. Add Blackberry liner. Paint the wheat with Mustard Seed commas. Add a few lighter ones by adding Island Sand and a few darker Blackberry ones.

Chickens

Mustard Seed with a touch of Sunflower. Add Tiger Lily legs and beaks. The wattle and comb is Poppy. Wings are the yellow mix plus Island Sand. Highlights and eyes are Island Sand. The pupils are Blackberry.

Flowers

Basecoat all flowers with a Poppy and Tiger Lily mix. All dark strokes are Claret Rose. All light strokes are Island Sand with a tiny touch of Mustard Seed.

Leaves

Paint with the Mustard Seed, Sunflower, Harbour Blue mix. The shaded c-strokes are Blackberry. The dots are Mustard Seed and the white accent strokes are Island Sand.

Final Finish

Seal the surface with Chroma's Clear Glazing Medium. Dry. Use the 3/8-inch oval glaze brush to apply the antiquing glaze. Use equal parts retarder, Cherry Wood Stain Gel and Raw Umber. Apply the glaze, wait a few minutes and blot with a lint-free paper towel. Use 3/8-inch oval glaze brush to blend. Dry. Apply two coats of Chroma's Polyurethane Based Gloss Varnish. Dry well.

Enjoy this piece the entire Christmas Season!

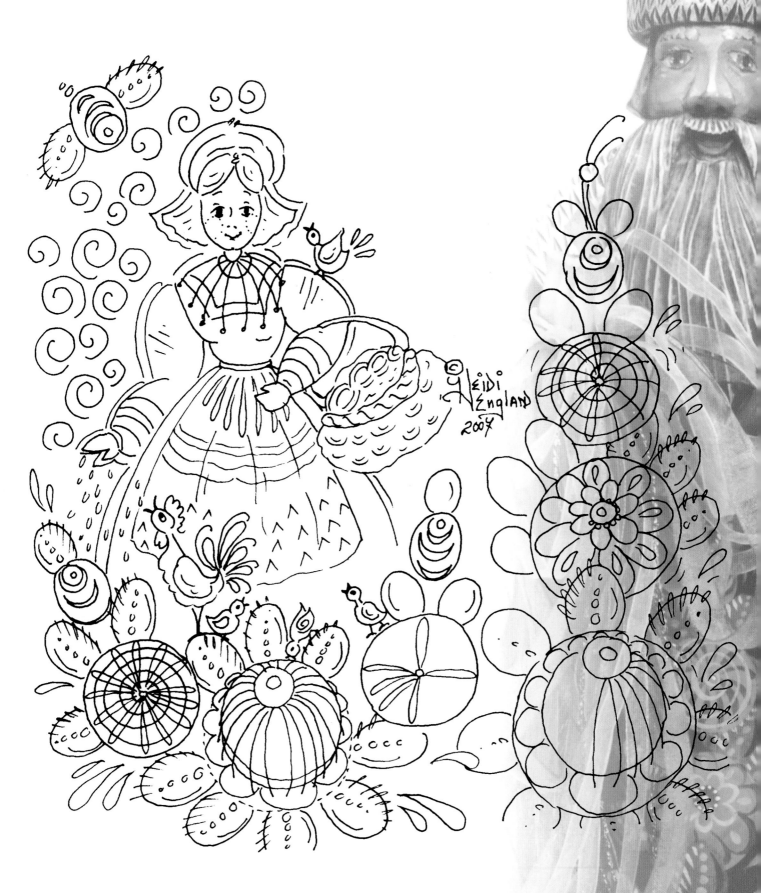

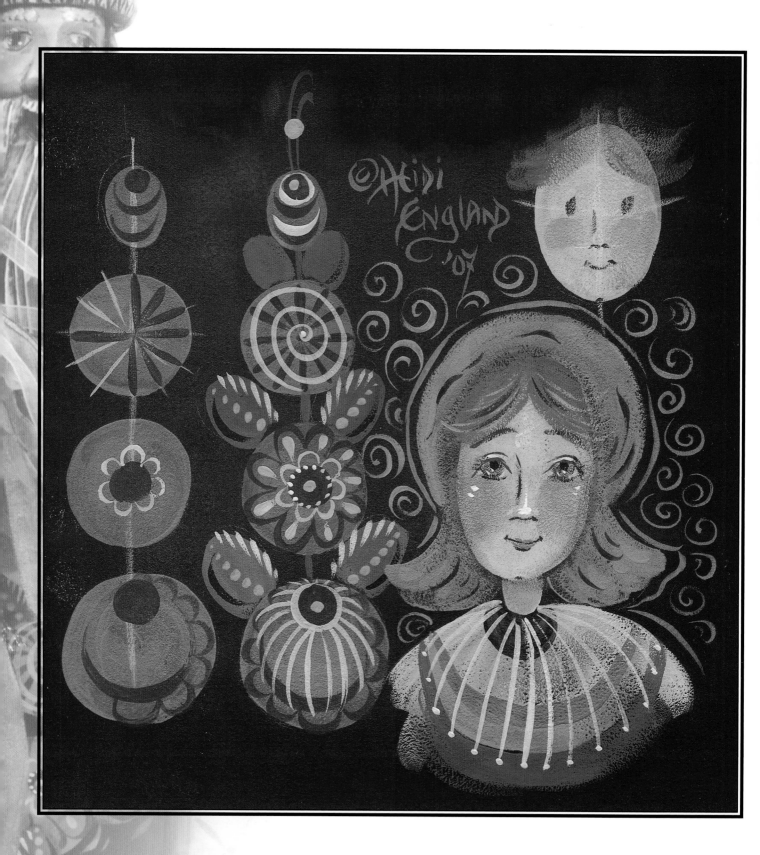

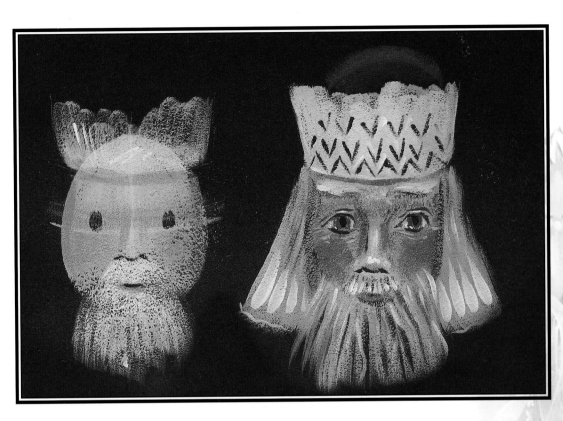

St. Nicholas of the Steppe

Preparation

Using the photograph as your guide, reconfigure the hat, face and hair of the figure and remove the carved herringbone fur pattern on the robe fur with an electric sander. If needed, use wood filler to adjust the facial features and fill the herringbone carving on the fur. Further hair and facial alterations may be made with an X-Acto knife. Resand entire figure by hand with fine grit sand paper. Seal the figure with two or more coats of UnderCover. Dry and resand. Remove dust with a tack cloth.

Using the photos as your guide, base paint the robes with Titanium White at the bottom and blue mix (Titanium White + Pure Black + Prussian Blue + touch Raw Umber) at the top. While still wet, blend where the colors meet. Dry and repeat until a smooth transition from light to dark is achieved.

Generously spray all surfaces with matte acrylic sealer. Dry well.

Trace and then transfer the reindeer design. Lighten the transfer lines as much as possible with a kneaded eraser.

Painting Procedure

This is a wet-in-wet technique, so choose paints and gel that have the greatest open time and always use a wet palette.

Keep acrylic gel in a small separate container. Gel makes paint transparent and acts as an extender; therefore, there is no correct amount of gel to use. Use more, or less, depending upon the amount of open time or transparency you desire.

Always paint gel over fur areas and areas to be blended before applying paint.

Paint and complete small areas at a time and establishing the highlights before the paint dries. As long as the existing gel/paint remains wet, more

MATERIALS

ACRYLIC PALETTE
FolkArt Artists' Pigments & Mediums

Fawn, Prussian Blue, Pure Black, Raw Umber, Red Light, Sap Green, Titanium White.

Blending Gel Medium.

OPTIONAL OIL PALETTE
Permalba Professional Oil Colors

Use similar colors to the acrylics. Res-n-Gel Oil Painting Medium

BRUSHES
Silver Brush, Ltd. Peggy Harris Fantastic Fur Set
- Series 1000S: #1 and #2 white bristle rounds
- Series 2502S: #2 bright
- Series 2528S: 1/8-inch filbert grass comb
- Series 2000S: #5/0 round
- Series 2407S: #20/0 script liner

Silver Brush, Ltd. Ruby Satin
- Series 2528S: 1/4-inch filbert grass comb
- Series 2502S: #4 bright

Silver Brush, Ltd. Ultra Mini
- Series 2404S: #12/0 angle

Silver Brush, Ltd. Wee Mop
- Series 5319S: 1/8-inch, 3/16-inch, 1/4-inch and 3/8-inch

Silver Brush, Ltd. White Oval Mop
- Series 5519S: 1/2-inch

Silver Brush, Ltd. Ultimate
- 1-inch varnish brush

Miscellaneous Brushes
- Usual prep brushes.

Brushes available through www.peggyharris.com

OTHER SUPPLIES
FolkArt: ClearCote Matte Acrylic Sealer (spray)

J.W., etc.: Wood Filler, UnderCover white acrylic primer, Right-Step Satin Varnish, Painter's Finishing Wax, #0000 white synthetic steel wool pad.

Electric sander and 200 grit paper, fine grit sand paper, #0000 gray steel wool, X-Acto knife with sharp #11 blade, tracing paper, mechanical pencil and stylus, gray transfer paper, kneaded eraser, Heat-It Craft Tool (or hair dryer), Masterson Sta-Wet Palette, soft paper towels, Q-tip cotton swabs, tack cloth. Three (3) shafts of dried wheat.

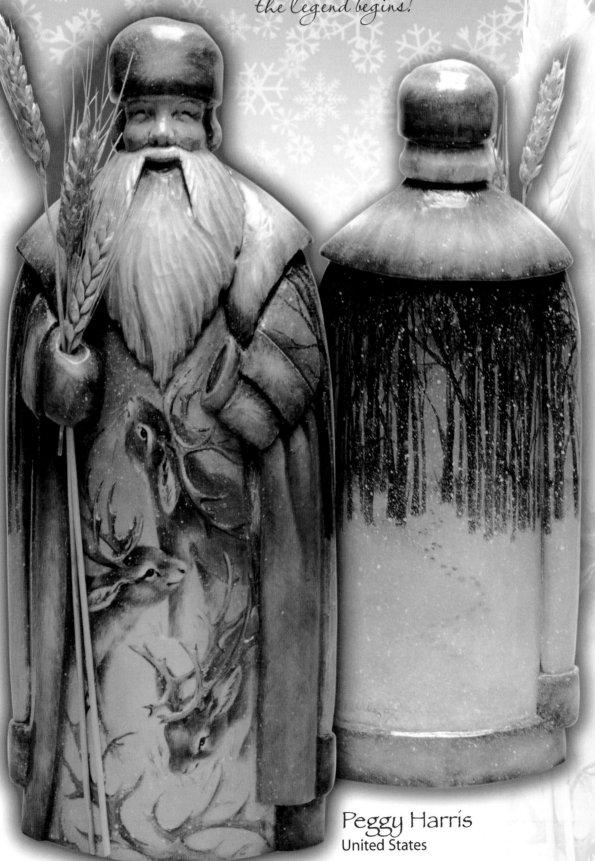

PEGGY HARRIS

The frozen north, a mystical saint, and reindeer said to fly, the legend begins!

Peggy Harris
United States

paint or gel may be added as you work. (Shading may be painted over dry paint later.)

Force dry gel/paint with a dryer before adding successive layers of gel and paint to prevent surprise lifting of paint that appears dry.

Once color has been applied, manipulate the gel and the paint with clean brushes. Frequently wipe clean and remoisten your brushes with gel as you work.

Use a feather touch. The bristles and hairs of your brushes should never bend as you manipulate the paint over the surface.

Use a clean, wet bright brush as an eraser to sharpen shapes or lift out mistakes.

Repeat the gel and paint layers infinite times to brighten highlights, deepen shading, add color glazes or simply add more fluff.

Keep layering until you've achieved the desired look. Build transparent layers gradually.

Forest Scene

Referring to the photos for design and color placement, freehand forest trees using brush-mixed Sap Green + Raw Umber. Vary the trunk and branch sizes using a #2 or #4 bright brush or a liner.

Indicate footprint trails leading to the forest with the 12/0 angular and some of the background blue mix.

Glaze the white snow with transparent Fawn + Gel. Dry. Moisten the glazed snow with

Gel. With a large mop and minimal Titanium White, pounce in freshly fallen snow over the glazed snow.

Reindeer Scene

With a 5/0 round brush, paint the eyes and nostrils Pure Black. Paint the inside of the ears with Fawn and Raw Umber.

Apply a thin layer of Gel to the ears and head of a reindeer. Pick up a tiny amount of Fawn with the bristle brush and stroke in rows of extremely short fur. Refer to the arrows on the pattern for the direction fur tips should appear to be pointing.

While the paint is still wet, lift out any highlights and stray paint in white fur areas with a wet Q-tip or bright brush. Blend highlight areas into the surrounding fur with a clean bristle brush. Wipe the brush clean frequently as you blend and continue to groom the fur. More gel and/or paint may be added with the bristle brush as you work.

Gel, paint and highlight the remainder of the reindeer, one area at a time. Dry with a dryer until no moisture glistens in the light. When cool, mist the reindeer with matte acrylic spray to prevent color lifting as you apply successive layers of Gel and paint.

Using the same technique, begin to refine the fur color. Apply gel to an area and blend in more Fawn, Raw Umber or Titanium White where needed with a filbert comb or a bristle brush. Dry with a dryer and mist with spray.

Using a series of glazes (Gel plus color) create even more realistic fur. Moisten the surface of the fur with Gel. With a soft, flat brush, stroke Fawn or Raw Umber into the Gel, avoiding highlight areas. Blend with a mop. This will greatly refine the appearance of the fur. Dry and repeat as needed. Spray with matte acrylic spray to seal the painting.

Stroke in white ear fur with Titanium White and an 1/8-inch comb. Perfect the eyes and noses with a 20/0 liner. Add sparkling Titanium White eye highlights with a 5/0 round brush.

Undercoat the antlers with Fawn. Highlight with brush-mixed Fawn + Titanium White and a filbert comb. Shade with Raw Umber. Add touches of fallen snow with Titanium White and a 5/0 round brush.

Face, Beard & Hair

Base paint the face with Titanium White + touch Red Light + touch Fawn. Dry. Apply a slick of Gel to the face and shade and highlight the features, using more or less white in the base paint mix to adjust the color values as you work. Blend with tiny mops. Dry.

Add rosy cheeks with a 12/0 angular brush and Red Light + Gel. Create delicate eyelashes and wrinkles with a liner and Raw Umber + Gel.

Moisten the hair and beard with Gel. Shade with brush-mixed grays of Titanium White + Pure Black + Raw Umber and a filbert comb, stroking in the direction the hair grows. Dry.

Apply a slick of Gel to the surface and stroke in Titanium White hairs with a filbert comb. Embellish with a liner. Repeat as needed. Glaze with Fawn and/or Raw Umber + Gel as desired for further shading and toning.

Fur Hat, Mittens & Robe Trim

These areas are meant to look as if they were made of fur.

Apply a slick of Gel to an area of fur. Using the photo as your guide, stroke in short, overlapping layers of fur with a #2 bristle brush and Fawn. Wipe the brush clean and continue to groom the wet fur. Dry.

Repeat to enhance the color.

Dry again and repeat using a filbert comb and Raw Umber to darken some areas of fur. Dry. In the same manner, lighten highlighted areas of fur with Titanium White.

Finishing

Seal the entire figure with a liberal spray of matte acrylic sealer.

Dry.

Heavily spatter both scenes with snow using thinned Titanium White and a bristle brush flipped across a knife. Lightly spatter snow on the remainder of the figure. Dry all spattered snow. Remove excess, or misshapened flakes with a wet Q-tip.

Varnish the figure with multiple coats of satin varnish. Do not sand between the early coats of varnish as you may abrade the delicate fur lines and color glazes. Sand all successive coats of varnish (including the final coat) with #0000 gray steel wool. Remove dust with a tack cloth.

Apply painter's finishing wax with a #0000 white synthetic steel wool pad. When dry, buff with soft paper towels to enhance the finish and bring out the beauty of the painting.

Insert three shafts of dried wheat through the right hand.

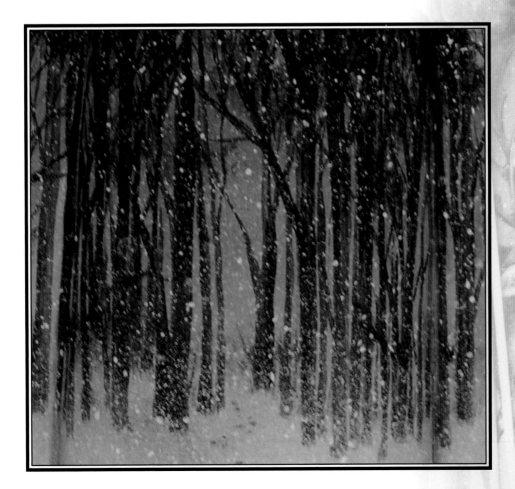

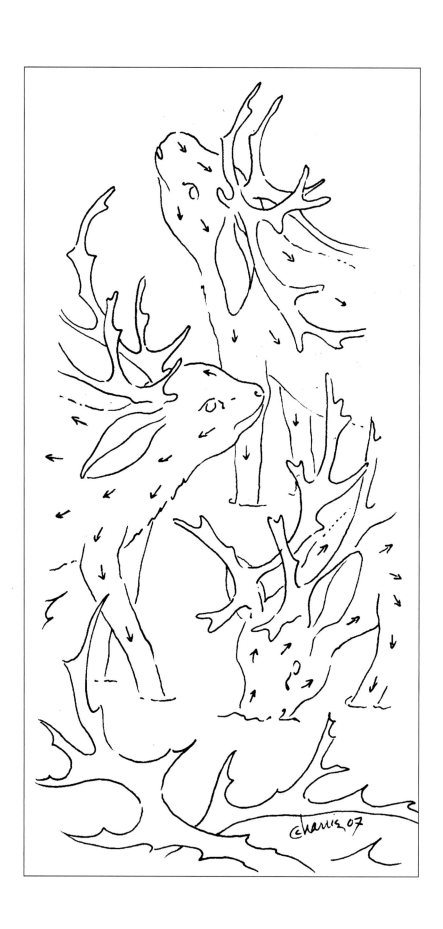

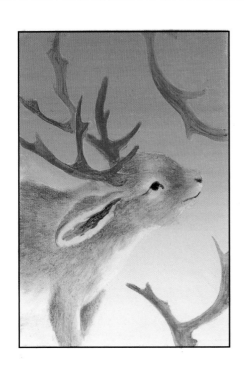

It's a Golden Christmas

"Christmas lives in each and every heart forever," says Priscilla, founder of the Society of Decorative Painters, an organization like the Decorative Arts Collection. Star of Public Television's *The Magic of Decorative Painting*, Priscilla has happily appeared through the years on HGTV, *The Carol Duvall Show*. She has taught all over the world and continues to write and teach at Priscilla's Little Red Tole House in Tulsa, Oklahoma, as well as her Studio by the Sea in Panama City Beach, Florida.

"It has been a joy and challenge I might add, of doing this entire Santa in water colors," says Priscilla. My choice of product is LuminArte' Twinkling H2O's.

I prepare the paints in a special way. The paint comes in solid form.

1. Apply 1/4-inch of water to the top of the colors you wish to use.
2. Put the lids on and let them sit for 6 hours.
3. Stir them with a palette knife to make a creamy paste.
4. Put them on a Masterson Sta-Wet Palette and paint with them much like acrylics.

Preparation

Sand Santa, if needed, then wipe with a tack rag.

Paint the entire Santa with a coat of White Opaque Primer using a large flat brush. Let dry and lightly sand.

Painting

Paint the face with two coats of Portrait. Let dry between coats.

The eyebrows are painted Heavenly White shaded with a teeny touch of Licorice.

Paint the iris Nutmeg; the pupil is Licorice highlighted with Heavenly White. The line work around the eyes is Nutmeg.

For the cheeks, apply a very thin wash of Hot Cinnamon.

Using your #1 wash brush, paint the front of the gown with three coats of Forest Green. Let the paint dry thoroughly between coats.

Paint the remainder of the garment with two coats of Hot Cinnamon. Let dry thoroughly.

Mittens are painted Heavenly White, shaded with a wash of Licorice.

When the garments are thoroughly dry, use a large wash brush and randomly apply Interference Gold; how-ever, first, practice on a sheet of painted paper, so that you don't apply too much Gold. It is a fascinating and beautiful high-lighting product.

Additional highlights on the red robe are stenciled or dabbed on using Solar Gold.

The dark shadows are created with a mix of Red Hot and Hot Cinnamon (1:1) brushed on here and there as desired.

Comma strokes to trim the top of the robe are painted with a small flat brush and Interference Gold.

Neatly trace and transfer the design using white Saral paper.

Undercoat the light leaves with 2 or 3 coats of Key Lime. Let the paint dry thoroughly between coats. Float the shad-ow with Nutmeg at the base of the leaves. Let dry. Highlight

MATERIALS

LUMINARTÉ TWINKLING H2O'S

Orange Peel, Hot Cinnamon, Heavenly White, Red Hot, Solar Gold, Key Lime, Nutmeg, Forest Green.

GOLDEN PAINT

Interference Gold Fine.

FOLKART ACRYLIC PAINT

Licorice, Portrait.

BRUSHES

Robert Simmons by Daler-Rowney
- Sienna Series SN60 Flats: #'s 2, 4, 6, 8, 10, 12
- Scroll Brush: #1
- Sienna Series 51 Liner: #10/0 for detail on Santa's face
- Sienna Series 55: 1-inch Wash Brush

MISCELLANEOUS SUPPLIES

Masterson Sta-Wet Palette and Paper, brush basin, soft absorbent 100% cotton rags or Viva Paper Towels, good palette knife, JW's Undercover White Opaque Primer, Scarlet red velvet fabric for hat, faux fur trim for hat and cuffs, lamb's wool for beard. Fine grade sandpaper, tack rag, minia-ture holly, Plaid Clear Acrylic Spray (matte or gloss), Golden Gel Medium Heavy Gloss, tracing paper, white Saral paper, Golden High Gloss Glue.

Santa's wire glasses were made by Judy Kimball.

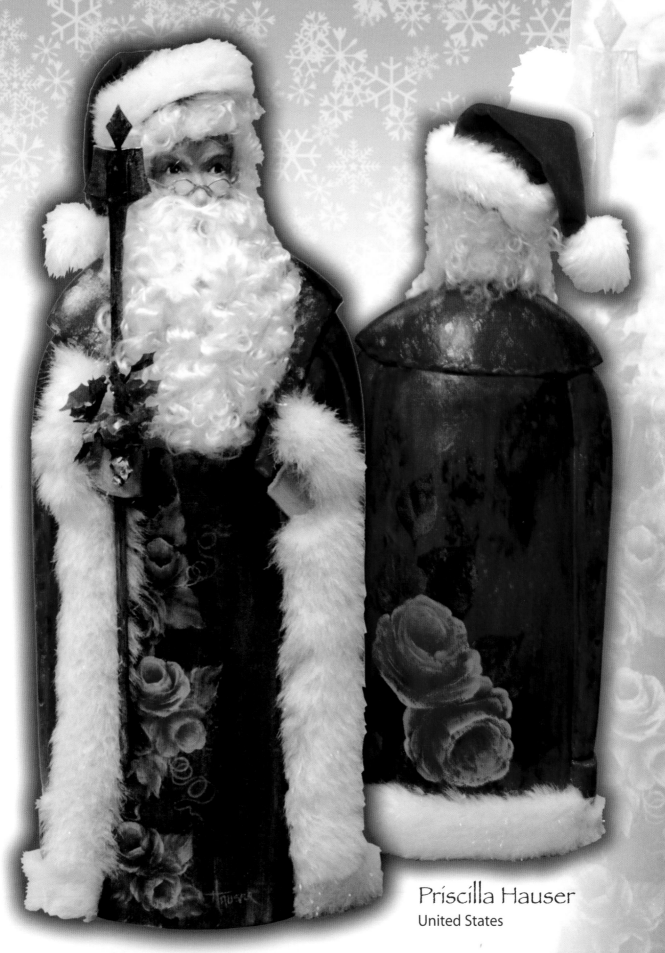

Priscilla Hauser
United States

by brushing on Interference Gold. Let dry.

The dark leaves are painted in the same way; simply undercoat with Forest Green instead and proceed as instructed as above.

Paint the rose step-by-step with the worksheet.

Undercoat the roses with two coats of Heavenly White. Let dry between coats.

Mix Solar Gold and Heavenly White (1:1) for the light value of the rose.

The dark value of the rose is Hot Cinnamon and Orange Peel (1:1).

Double load a #2 or #4 flat brush with the Solar Gold and Heavenly White mixture and the rich coral red mixture.

Apply the strokes as shown on the worksheet. Let dry thoroughly.

Spray with many light coats of clear acrylic spray. Do not use a brush or the water colors will lift. I used 6–7 light coats. Let dry between coats.

Finish

To glue on the hair and the artificial fur, use Golden High Gloss Glue.

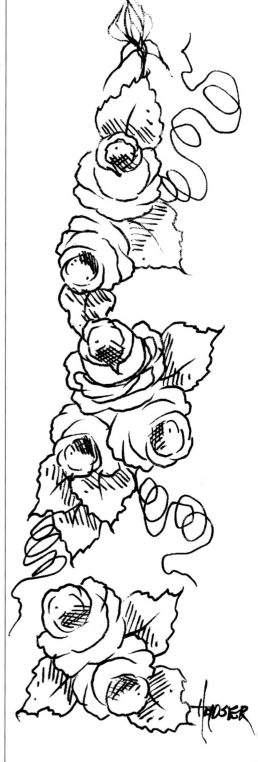

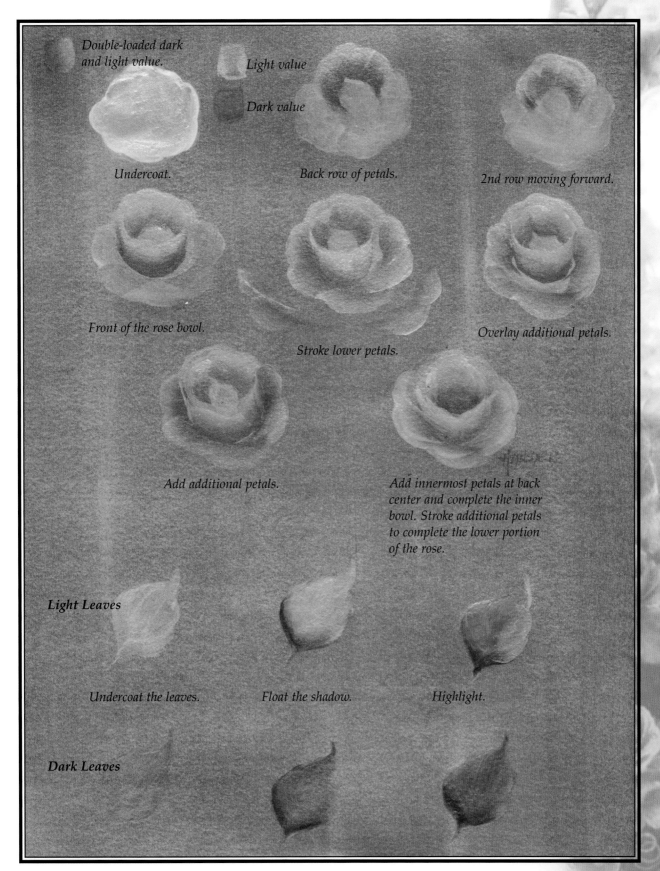

Double-loaded dark and light value.

Light value

Dark value

Undercoat.

Back row of petals.

2nd row moving forward.

Front of the rose bowl.

Stroke lower petals.

Overlay additional petals.

Add additional petals.

Add innermost petals at back center and complete the inner bowl. Stroke additional petals to complete the lower portion of the rose.

Light Leaves

Undercoat the leaves.

Float the shadow.

Highlight.

Dark Leaves

St. Nick with Fruit

Preparation

Sculpting the Hat, Pear, Fur Trim, Beard & Bag

To sculpt the hat, use the two-part epoxy wood filler. Mix the two parts together and knead them till completely mixed. Form a large ball and place it on the hat of the St. Nick figurine. Using your fingers, smooth the ball into place. Form another ball and roll the ball into a long cone. Add that on the hat and let it fall to one side. Smooth the bottom into the hat. Form a small ball and place it on the end of the hat. Study the finished photo for placement.

The textured fur is applied using fingers and a palette knife to get the textured look. You want to be sure to cover the zigzag carving.

The beard is formed by making several *ropes* of epoxy wood filler and placing them on the beard and then smoothing them into place. Be sure to apply the droopy moustache last.

The large pear is molded over the top of the staff. Form one large ball and one smaller ball. Place them on the staff and use your fingers to shape them into a pear. Add some additional material on the back to secure the pear onto the staff.

The bag was formed in two pieces. Cut the selvage edge of the burlap about 1-inch wide. Using a needle and thread, gather the bottom of the piece to pull and gather it. Secure the folds with Super Glue. Form the gathered strip into a loop that will form the top of the bag. Glue together and then trim the bottom to fit along the top of the mitten. When the glue is dry, attach the top of the bag to the figure with more Super Glue. Gather one corner of a large square of burlap using the needle and thread. Glue to secure. When the glue is dry, trim the gathered edge with an X-acto knife to conform to the bottom of the mitten. Glue the bottom in place and let dry. The bag was free-formed into shape. As you form the bag, glue it in place with Super Glue.

Paint the bag with about 5–6 coats of Linen. (This will stiffen the bag.) Basecoat the remaining parts of the figurine with two coats of Linen. Let dry completely and paint the figurine as follows.

Face

Flesh color made from Titanium White + Burnt Sienna + Red Light.

Hair & Beard

Gray made from Titanium White + Burnt Umber + Pure Black. Shade with Pure Black and highlight with Titanium White.

Fur Trim

Gray made from Titanium White + Black. Shade with Pure Black and highlight with Titanium White.

Front

Dull green made from Bayberry + a little Burnt Umber.

Red Areas

Lipstick Red. Shade with True Burgundy + a little Sap Green.

Mittens

Pure Black. Highlight with Titanium White.

Face

Shade the face with Burnt Sienna. Add cheek blush with

MATERIALS

FOLKART ARTISTS PIGMENT ACRYLICS

Titanium White, Yellow Light, Yellow Ochre, Red Light, True Burgundy, Sap Green, Burnt Umber, Burnt Sienna, Dioxazine Purple, Ice Blue Dark, Pure Black, Asphaltum.

FOLKART ACRYLICS

Lipstick Red, Bayberry, Linen.

WINSOR & NEWTON COTTMAN WATERCOLOR

Sepia.

BRUSHES

Silver Brush Ltd.
- Ruby Satin #8 filbert
- Golden Natural #8, 12, 14 flat shader
- Golden Natural #6 liner
- Golden Natural #2 script liner
- Golden Natural 3/4-inch wash brush

MISCELLANEOUS SUPPLIES

Epoxy wood filler (2-part), medium and fine grit sandpaper, burlap fabric, Super Glue, palette, palette knife, tracing paper, stylus, white transfer paper, needle and thread, X-Acto knife, oil-based polyurethane, old face cloth, small jar, liquid dishwashing soap.

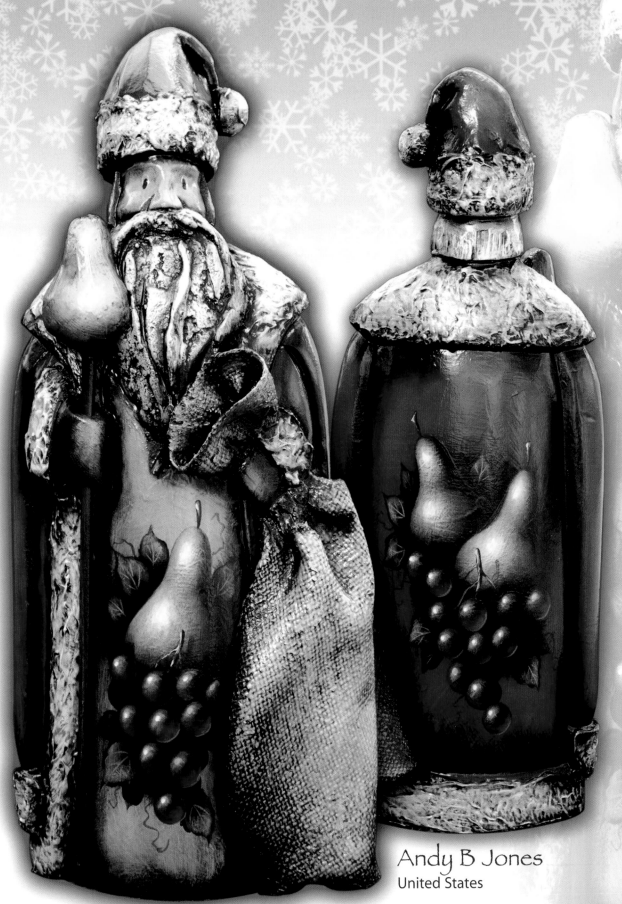

Andy B Jones
United States

True Burgundy. The eyes are painted with the script liner and are two ovals of Titanium White and then add Pure Black pupils.

Decorating St. Nick

He is painted in five (5) stages: Base coating, shading, highlighting, antiquing and detailing.

Stage 1

Base coat the design elements as listed:

Leaves: Use the #6 liner to base coat the leaves with Sap Green + Burnt Umber.

Pear: Use the #8 or #12 flat shader to base coat the pear with Yellow Ochre.

Grapes: Use the # 8 flat shader to undercoat the entire cluster of grapes with True Burgundy. You may add some Dioxazine Purple to the True Burgundy for a more violet grape.

Stage 2

Shade the design elements as listed:

Leaves & Grapes: They need no shading.

Pear: Shade with Asphaltum and then with Burnt Sienna + a little Burnt Umber.

Stage 3

Highlight the design elements as listed.

Highlight using a dry Ruby Satin Filbert (unless directed otherwise) and a scant amount of the color. As you build the highlights, remember, the highlights get lighter, they also get smaller. Always begin each highlight where you want the

highlight to be the brightest.

Pear: Yellow Ochre, Yellow Ochre + Yellow Light, Yellow Light, Yellow Light + White.

Add more Titanium White for the final highlights.

Add a blush of Red Light and then Lipstick Red or True Burgundy. Be sure the blush is applied using transparent color.

Leaves: Sap Green + Yellow Light, then continue to add Yellow Light as you build the highlights. Finally add a tiny amount of Titanium White to the final highlights.

Grapes: Begin to form the grapes using a side loaded flat brush and a mixture of True Burgundy + Ice Blue Dark. Form the light half of the grape with a half-circle stroke. Once all the light sides of the grapes are formed, load the liner brush with the same color and paint a line to form any dark edges that are visible.

Switch to a filbert brush and begin to build the highlights on the light side of the grape with the same color you formed the light edge with, then add Ice Blue Dark to the mix and then some Titanium White to the mix. Continue to build highlights in this way.

Stage 4

Antiquing

The antiquing process is a bit unusual, but it resembles the antiquing done by Peter Ompir but with much less effort.

Using Sepia watercolor, apply a thin, even coat to the box, one section at a time, using the 3/4-inch wash brush. I usually squeeze the watercolor into a

small plastic container with a tight-fitting lid so I can keep the watercolor fresh for the next time I want to use it. When applying the watercolor, it should be the consistency of thin syrup. You do not want this to be like dirty water. After you have applied the watercolor you want to be able to see the painted design just slightly. Do not worry. You will be able to remove the antiquing should you not like it. If the watercolor cisses or creeps, add a drop or two of liquid dishwashing soap to it. The soap will cause it to flow out smoothly.

When the watercolor is dry, you will begin to remove it. To do this, dampen an old face cloth and wring it out well. You want the cloth to be damp, not wet.

Fold the cloth into a soft pad and begin to wipe away the antiquing. The damp cloth will remove the watercolor. Change the cloth often in order not to redeposit the antiquing where it is not wanted. At this time you are trying to remove the color from the piece so it reveals the design but remains darker at the edges.

Using a fresh part of the cloth, wrapped around your index finger, begin to remove the antiquing from the highlighted area of the fruit and the background. Leave the antiquing darker in the shadow areas of the design. Be sure to change to a clean portion of the rag often as you remove the antiquing.

When you are satisfied with the antiquing, let it rest for a few minutes. If you removed too much antiquing, simply re-apply more Sepia. If you aren't

pleased with the results, wet the cloth and wash off all of the antiquing and try again.

Since the antiquing is done with watercolor and would wash off if you applied a water-based varnish, you must brush on a coat of an oil-based polyurethane varnish. Allow this to dry overnight.

Stage 5

Refine the design. Do not attempt to repaint the piece. Just freshen the highlights and add the details.

Pear: Yellow Light, Yellow Light + Titanium White, Titanium White.

Leaves: Veins are Titanium White + Sap Green + Yellow Light.

Grapes: Freshen the highlight with the blues and then add some True Burgundy or Red Light to the dark side of the grapes. Add some reflected lights with the liner brush and blue or green.

Stems: Burnt Umber + Black, then add Ice Blue Dark and then Titanium White.

Squiggles: Sap Green + Burnt Umber.

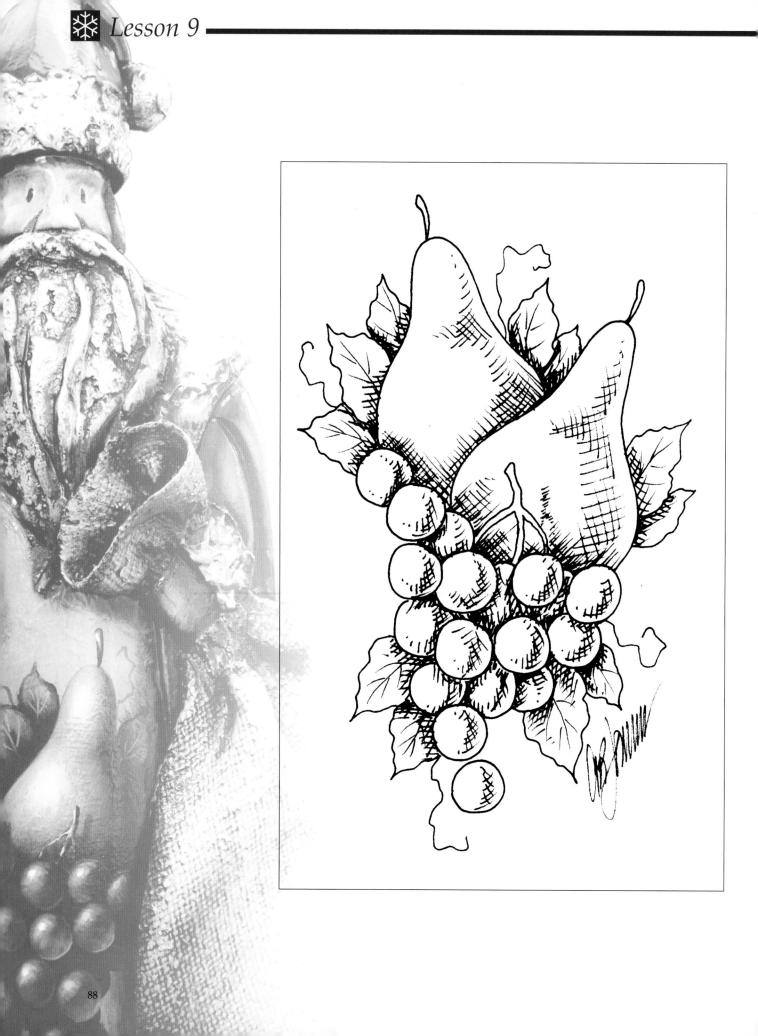

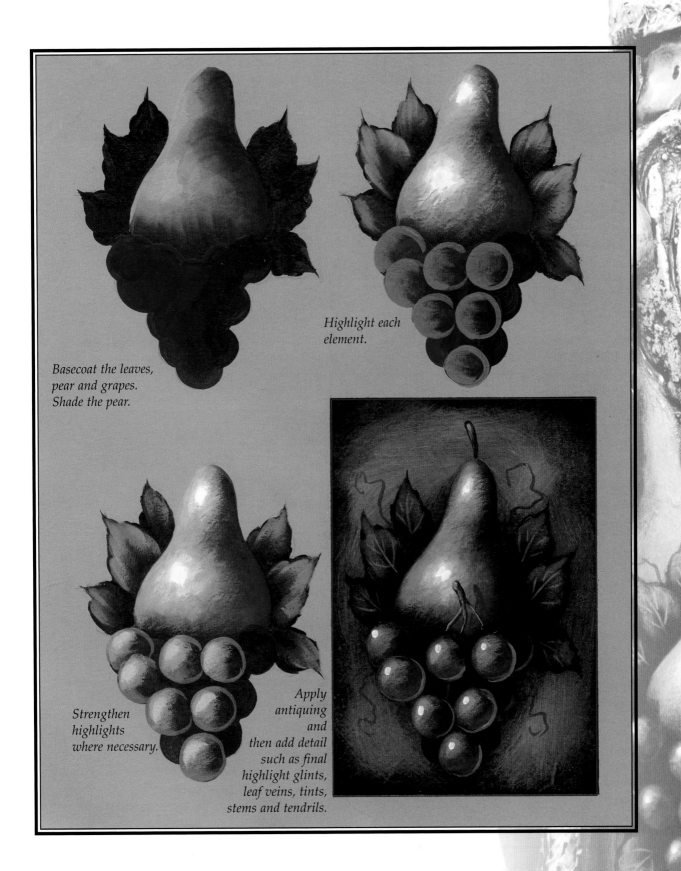

Basecoat the leaves, pear and grapes. Shade the pear.

Highlight each element.

Strengthen highlights where necessary.

Apply antiquing and then add detail such as final highlight glints, leaf veins, tints, stems and tendrils.

Damask Rose Santa

Wood Preparation

If needed, fill any cracks or holes with wood filler. After it dries, sand well and wipe with a cloth. Apply a wood sealer to the entire surface. If the background color is light, use Gesso as a sealer. Allow to dry, then sand lightly and wipe the surface again.

Basecoat

When basecoating, apply several coats, allowing each coat to dry before applying the next coat. If necessary, lightly sand and wipe away sanding dust between coats of paint. Continue basecoating until all areas are evenly covered.

Applying Design

Carefully trace the design onto the tracing paper. Place it on the surface and secure it with tape. Using the graphite paper, lightly transfer the pattern onto the surface. Check in the early stage of tracing to determine if the line is too dark or too light. Chose the right color graphite for the surface.

Painting Techniques

Side-loading

Use an angle brush that is in excellent condition. Dip the brush into clean water and blot on a paper towel until the shine disappears from the bristles. Dip the long side corner of the brush into the paint, then blend by stroking the brush in the same spot on the palette. Flip the brush and stroke again in the same manner until achieving a smooth gradation of the color. The short side corner should be free of color. Always reload the brush with fresh paint and clean water. When applying the color to the painting, the long side corner with the heavy color should always face to the darker side of the element.

Floating

Using clean water, moisten an area larger than where you expect to place shading and/or highlighting. If the area is very large, use Gel Blending Medium instead of water. Before the water or Gel Blending Medium dries, apply the color with either the filbert brush or angular brush to the desired area and soften with a suitably sized mop brush. Allow to dry and repeat as needed.

Linework

Thin the paint to the consistency of ink. Using a liner brush in good condition, fill the brush with paint and roll the brush to get sharp point.

General Instructions

When floating color, work a small area at any one time. To reapply the paint on an area you have already painted, wait until the previous paint dries completely. To create depth within the painting, layering colors one on top of each color is very important. When layering colors, each color change should cover a smaller area than the previously applied color. The lightest and/or the darkest value within a design element covers the smallest area within that element.

Basecoats

• Basecoat entire Santa with Touch O' Pink.
• Basecoat beard and moustache with Dark Burnt Umber. Then, dry-brush over the entire beard and moustache with Touch O' Pink.
• Basecoat face and hands with Fleshtone. Shade with Dark Flesh. Cheeks and top of nose are floated in with Adobe Red.
• Eyes are Dark Burnt Umber. Add White highlight dots to eyes, cheeks and nose. Eyebrows are Dark Burnt Umber dots, then White dots.

MATERIALS

DELTA CERAMCOAT

Touch O' Pink, Fleshtone, Dark Burnt Umber, Enchanted, Dark Flesh, Adobe Red, White, Lisa Pink, Sweet Pea, Lavender, Wild Rose, Quaker Grey, Hippo Grey, Burgundy Rose, Purple Dusk.

LOEW-CORNELL

• Series 7300: #4, #8, #16 shader
• Series 7400: 3/8-inch angular shader
• Series 7450: #8 chisel blender
• Series 7000: #2 round
• Series 7350: #0 liner
• Series 270: 1/4-inch, 3/8-inch Maxine's mop

MISCELLANEOUS

Delta All Purpose Sealer, Delta Interior Spray Varnish Satin, Gel Blending Medium, Delta Decorative Snow, Delta Stencils Petite Roses, gesso, palette knife, sanding disc or pager, stylus, tracing paper, grey transfer paper, wax paper palette, varnish of your choice.

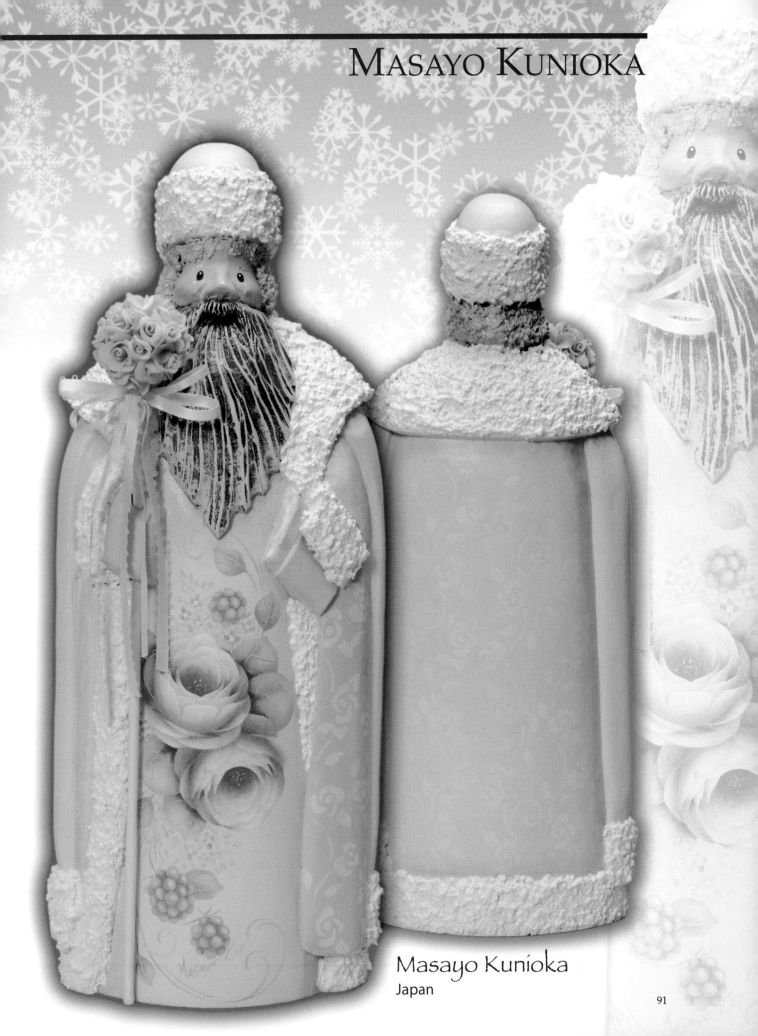

Masayo Kunioka
Japan

MASAYO KUNIOKA

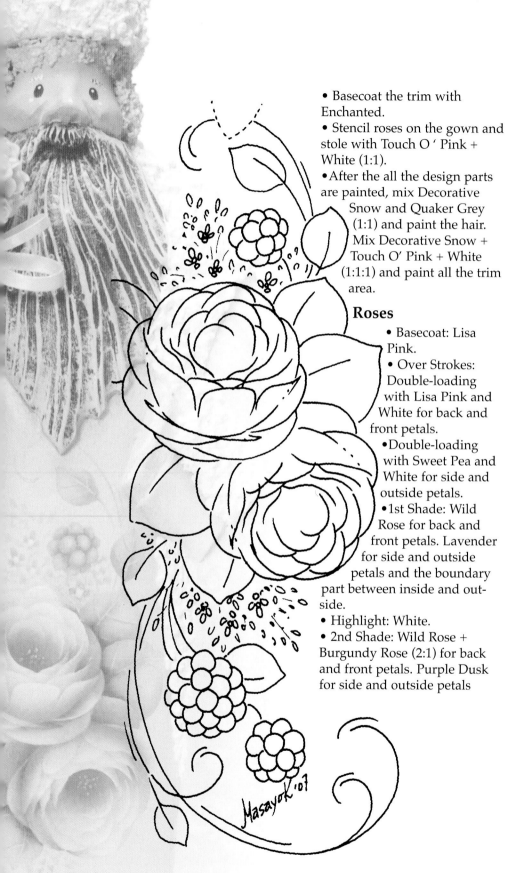

Masayok '07

- Basecoat the trim with Enchanted.
- Stencil roses on the gown and stole with Touch O ' Pink + White (1:1).
- After the all the design parts are painted, mix Decorative Snow and Quaker Grey (1:1) and paint the hair. Mix Decorative Snow + Touch O' Pink + White (1:1:1) and paint all the trim area.

Roses

- Basecoat: Lisa Pink.
- Over Strokes: Double-loading with Lisa Pink and White for back and front petals.
- Double-loading with Sweet Pea and White for side and outside petals.
- 1st Shade: Wild Rose for back and front petals. Lavender for side and outside petals and the boundary part between inside and outside.
- Highlight: White.
- 2nd Shade: Wild Rose + Burgundy Rose (2:1) for back and front petals. Purple Dusk for side and outside petals

- Tint: Lisa Pink on the outside petals and Hippo Grey for the remaining areas.
- Very front petal: Basecoat with Lisa Pink. Shade with Wild Rose. Highlight with White.
- Pollen dots: Dark Flesh, then Dark Flesh + White.

Leaves

- Basecoat: Quaker Grey + White (1:1).
- 1st Shade: Quaker Grey.
- Highlight: Touch O' Pink.
- Veins: Line with Pink, then line shade with Quaker Grey.
- 2nd Shade: Hippo Grey.
- Tint: Lisa Pink, Lavender.

Blackberries

- Basecoat: Sweet Pea.
- Outline: Lavender.
- 1st Shade: Lavender.
- Highlight: White.
- Tint: Quaker Grey + White, Lisa Pink.

Filler Flowers

- Flowers: Purple Dusk, Sweet Pea, White.
- Leaves: Quaker Grey, Quaker Grey + White.

Stem & Linework

Using the liner brush, paint with Quaker Grey + White (1:1). Shade and highlights are with Quaker Grey and Touch O' Pink.

Finishing

It is better to allow the paint to cure for a day before varnishing. Remove any remaining graphite lines. Following the manufacturer's instructions, varnish with several coats.

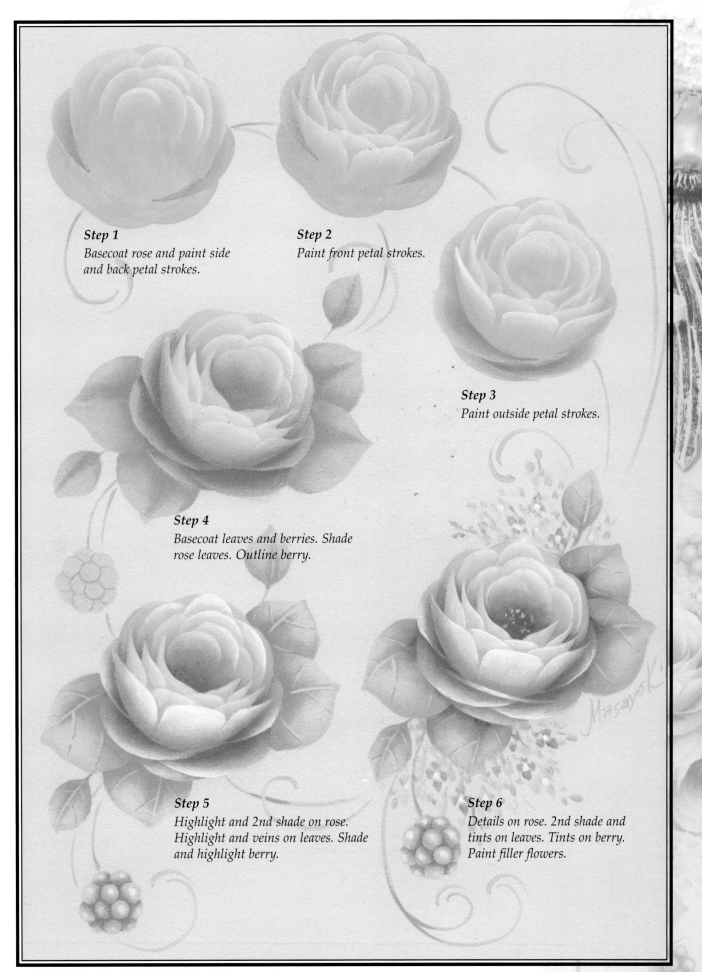

Step 1
Basecoat rose and paint side and back petal strokes.

Step 2
Paint front petal strokes.

Step 3
Paint outside petal strokes.

Step 4
Basecoat leaves and berries. Shade rose leaves. Outline berry.

Step 5
Highlight and 2nd shade on rose. Highlight and veins on leaves. Shade and highlight berry.

Step 6
Details on rose. 2nd shade and tints on leaves. Tints on berry. Paint filler flowers.

"S" is for Santa

Preparation

Following manufacturer's directions, seal with spray sealer and allow to dry.

Basecoats

Face	Base Flesh
Hair & Beard	Neutral Grey
Dress & Fur	Light Buttermilk
Bag	Honey Brown
Gloves	Soft Black
Coat, Stole & Top of Hat	True Blue + Ultra Blue Deep (1:1)

Allow ample time for basecoats to dry before transferring pattern. I interpreted a small area between the bag and dress to be part of the fur trim, so I carved it with a small utility knife to resemble the fur and then proceeded to basecoat accordingly.

Dress

When transferring the pattern with the darker graphite, trace only the basic design elements; the final overstrokes will be applied later. Refer to the photo for exact color placement or use your own ideas for placement of the three basic colors of the dress design: True Blue, Avocado and Santa Red. In general, the leaf and stem areas are green, the scrolls are blue, the hearts and berries are red and the stylized flowers contain both red and blue elements.

After the individual areas are basecoated, shading and highlighting can begin. This a slow process, but the final effect is worth the effort. Refer to the worksheet for examples.

Transfer the design details with the light graphite. Choose a smaller flat brush, appropriate to the size area you are working and, using a sideloaded method, float the shading on the red areas with Rookwood Red. A tad of Soft Black may be mixed with this, if needed.

Several layers of light floats are always preferable to a heavy float of color. You must be certain the area is dry before trying to deepen the color with another float; otherwise, the color will be lifted off.

Highlights on the red areas are floated with True Red.

Using the same sideloaded method, the blue areas are shaded with Ultra Blue Deep. Highlights are floated with a mix of True Blue + Snow (Titanium) White (2:1).

Areas of green are shaded with floats of Plantation Pine plus a tad of Soft Black, if needed, and highlighted with Celery Green.

The green comma strokes are painted with the #3 round brush or the detail liner, if you prefer. After rinsing and drying the brush, flatten it with your fingers and doubleload it with Celery Green on one side and Plantation Pine on the other. Stroke a few times on your palette to blend the colors, then proceed to the surface.

Begin with the comma stroke at the top of the design. Allow it to dry, then layer the next stroke over it.

Using the same colors, the small green leaves in the center of the solid red flowers are painted by creating an S-stroke with the small round or the detailer.

All elements of the dress design are outlined with Glorious Gold using the #2 detail liner. The small comma overstrokes and most of the dots are painted with Glorious Gold, as well. Some of the gold dots have an added dot of red or blue on top. This is applied after the first dot of gold has dried. The scroll design along the bottom edge of his dress is painted with the blue coat mix and Glorious Gold.

MATERIALS

DECOART AMERICANA ACRYLICS

Light Buttermilk, Base Flesh, Shading Flesh, Neutral Grey, True Blue, Ultra Blue Deep, True Red, Rookwood Red, Avocado, Celery Green, Plantation Pine, Soft Black, Snow (Titanium) White, Burnt Umber, Honey Brown, Glorious Gold, Santa Red.

BRUSHES

Jo Sonja's Sure Touch Brushes
- Series 1370: #'s 4, 6, 8, 10 flats
- Series 1350: #3 round
- Series 1325: #2 Kolinsky detail

MISCELLANEOUS SUPPLIES

DecoArt Americana Acrylic Spray Sealer/Finisher - Matte, Houston Art Gold Leaf and Adhesive Size, small scruffy brush, light and dark transfer paper, small utility knife.

Toni McGuire
United States

Face

Transfer the eyes and outline with Shading Flesh, filling in the tear ducts with this same color. Using a larger flat brush sideloaded with the Shading Flesh, float around the edges of the face and the eyes (see worksheet). When this is dry, float *blush* on the cheeks and tip of the nose with a mix of Shading Flesh + a small amount of Santa Red. Highlights on the upper cheeks and the nose may be drybrushed with Light Buttermilk using a scruffy brush. The lower lips, after being based with the Base Flesh is shaded along the outer edge with Rookwood Red.

Basecoat the eyes as follows:

Irises	True Blue
Pupils	Soft Black
Sclera (whites)	Light Buttermilk

Using a small flat brush, float shading along the top of the irises with Soft Black and along the top of the white areas with Burnt Umber. Together, these floats create the shadow on the eye created by the upper lid. Line the upper lid and the outer edges of the iris with a mix of Soft Black + Burnt Umber. Using this same mix, line the upper lashes, paying close attention to lash direction. The lower lid is lined with Burnt Umber and a scant amount of Burnt Umber lashes may be added along the lower lid, if desired. Highlights in the eyes are painted with Light Buttermilk. The eyebrows are lined first with Neutral Grey. Lines of Light Buttermilk are then applied in a feathery motion over the grey, followed by a few Snow (Titanium) White lines to add highlight to the brows.

Hair & Beard

Using the detail liner (or a rake brush if you prefer), line the hair with Light Buttermilk, establishing shape and direction. Add a few lines of Snow (Titanium) White as a top layer and float Neutral Grey underneath the hat to create a shadow on the hair. Wash thinned Light Buttermilk over the Neutral Grey beard. When dry, apply the same color, undiluted, to the raised carved ridges of the beard. For more contrast, apply Snow (Titanium) White over some of these same raised areas. Using a larger flat brush, float Burnt Umber around the outside edges of the beard and a few areas along the outer edge of the hair.

Bag

Using the liner brush, paint random squiggles of Glorious Gold on the bag to create a gold thread-like design. Use Burnt Umber to float around the edges of the bag and to create the folds.

Coat, Stole & Top of Hat

Transfer the pattern using light graphite. The linework and dots are painted with Glorious Gold to create a quilted look. The *S*–monogram and the stole design are this same color, also.

Santa Red lines are added for detail on top of the large monogram and the leaf is painted the same as the other leaves in the dress design.

Shading on the coat is floated with a larger flat brush, using Ultra Blue Deep. This shading is placed under the fur trim and along either side of the stole.

Gloves

Highlight by drybrushing with Neutral Grey.

Staff

The pole of the staff is painted Burnt Umber. The upper part is based with the same blue mix as the coat, and the *S*–monogram is Glorious Gold. At the very top of the staff, a diamond-shaped area is based Santa Red and detailed with Glorious Gold. The banding is gold with red detail.

Fur

I applied gold leafing to all fur areas of the coat. This was done over the Light Buttermilk basecoat, as opposed to the usual dark color over which leafing is generally placed. Carefully read and follow the directions on the adhesive and the leafing products.

Finishing

I sealed the entire piece with the matte spray sealer, even the gold leafed areas because I wanted to dull the leafing somewhat without antiquing it. Normally, gold leaf is sealed with a clear sealer to retain its luster. The choice of sealer is up to you.

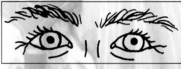

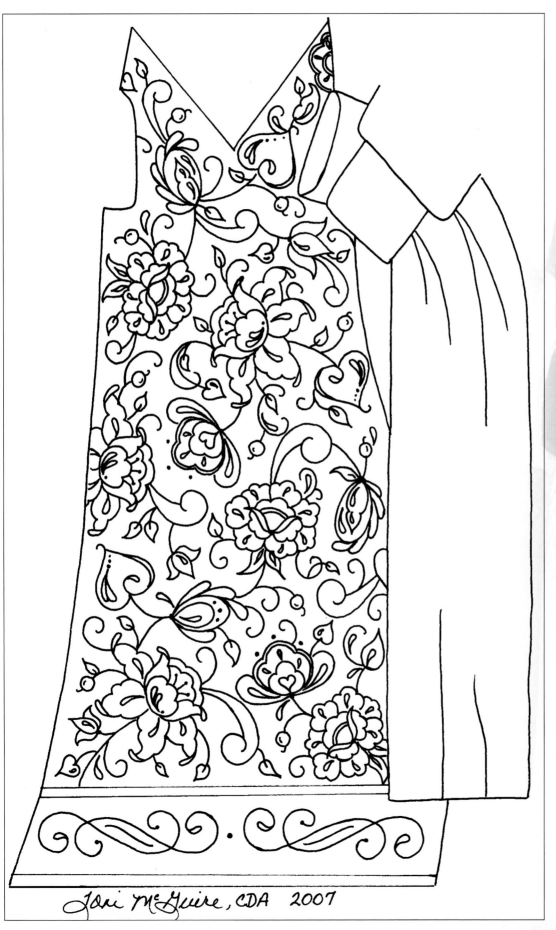

Toni McGuire, CDA 2007

TONI MCGUIRE, CDA

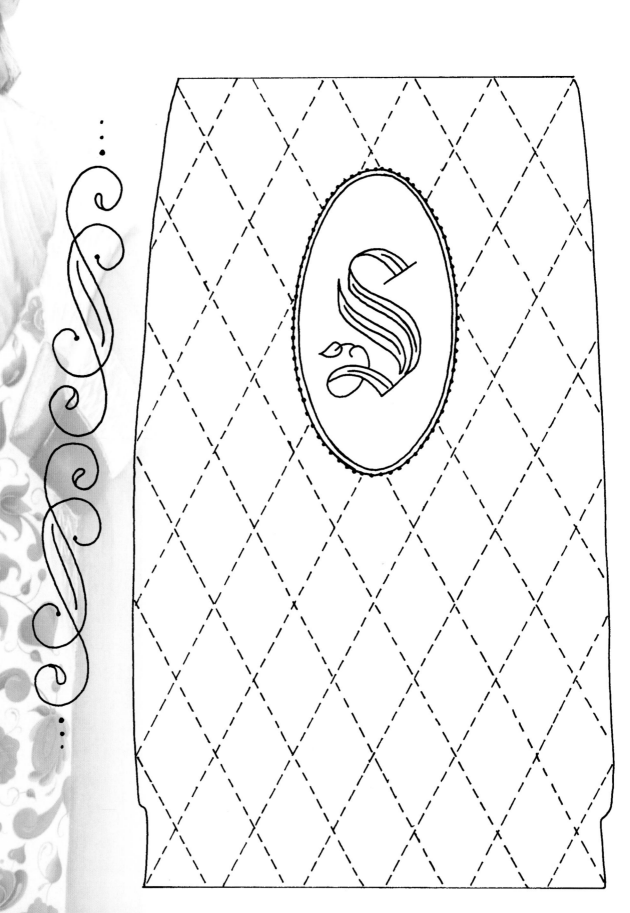

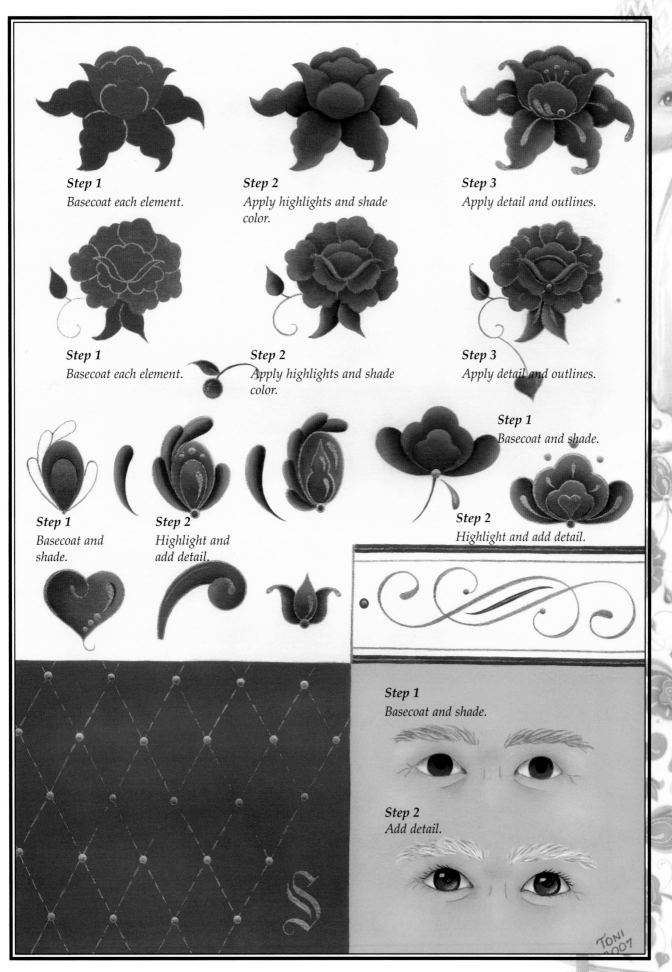

Step 1
Basecoat each element.

Step 2
Apply highlights and shade color.

Step 3
Apply detail and outlines.

Step 1
Basecoat each element.

Step 2
Apply highlights and shade color.

Step 3
Apply detail and outlines.

Step 1
Basecoat and shade.

Step 2
Highlight and add detail.

Step 1
Basecoat and shade.

Step 2
Highlight and add detail.

Step 1
Basecoat and shade.

Step 2
Add detail.

A Regal Santa

Preparation

Lightly sand the figurine. Wipe with a soft cloth to remove dust and apply a coat of wood sealer. Let dry. Sand lightly again, remove any dust and apply Shale Green acrylic to the undergown and the muffler. Apply Deep Burgundy on the back and on the front of the robe and to the top of the hat. Spray lightly with Matte Finish.

Begin by painting the apple design on the front and back. Next, paint the beard and hair and finally the face. The gold leafing was applied last using the gold leaf pen. Two coats of gold were applied.

Let everything dry and then add antiquing as follows:

• The front of the undergown is antiqued along the edges of the robe and beard with Mars Black + a little Burnt Umber + a touch of linseed oil.

• The center of the undergown around the painted design was highlighted with very little Naples Yellow Hue + a touch of Titanium White. Soften with a dry brush.

• Shade under the design on the undergown with Mars Black + a little Burnt Umber + a touch of linseed oil.

• The back and front of the robe are shaded dark around the edges with Mars Black + a little Burnt Umber + a touch of linseed oil. It is highlighted with a little Permanent Alizarin + a touch of Cadmium Scarlett.

• The antiquing under the design on the back of the robe was done with Mars Black + a little Burnt Umber + a touch of linseed oil. Soften lightly with a dry brush.

• The muffler, beard and hair (when dry) were also antiqued lightly with Black + a little Burnt Umber + a touch of linseed oil.

• The lower section of the scepter was stained using Burnt Umber. The center section is painted with Shimmering Silver. The top is painted with the gold leaf pen.

• All small scroll designs around the base of the figurine and on the scepter are done with Mars Black + Titanium White.

Apples

Dark Value: Purple Madder + Permanent Alizarin
Medium Value: Cadmium Scarlett + Permanent Alizarin
Light Value: Cadmium Scarlett + Cadmium Yellow Medium, Cadmium Yellow Light + Naples Yellow Hue
Shade: Purple Madder
Highlight: Naples Yellow Hue + Titanium White, Titanium White
Tint: Titanium White + Ultramarine Blue
Streaks: Permanent Alizarin, Naples Yellow Hue

Leaves

Dark Value: Cadmium Yellow Light + Mars Black + Ultramarine Blue
Light Value: Dark Value + Titanium White
Shade: Mars Black
Highlight: Titanium White

MATERIALS

DECOART AMERICANA ACRYLICS

Deep Burgundy, Shale Green, Shimmering Silver.

ARCHIVAL OILS BY CHROMA

Burnt Sienna, Burnt Umber, Cadmium Yellow Light, Cadmium Yellow Medium, Cadmium Scarlett, Mars Black, Naples Yellow Hue, Purple Madder, Permanent Alizarin, Raw Sienna, Titanium White, Ultramarine Blue.

BRUSHES

Red Sable Short Brights
• #'s 2, 4, 6, 8
• #1 round
• Large flat synthetic brush for applying base coat colors.

MISCELLANEOUS SUPPLIES

Krylon 18 KT Gold Leaf Pen, palette, odorless brush cleaner, tracing paper, transfer paper, sandpaper, Liberty Matte Finish, Krylon Satin Varnish, JW First Step Wood Sealer, linseed oil.

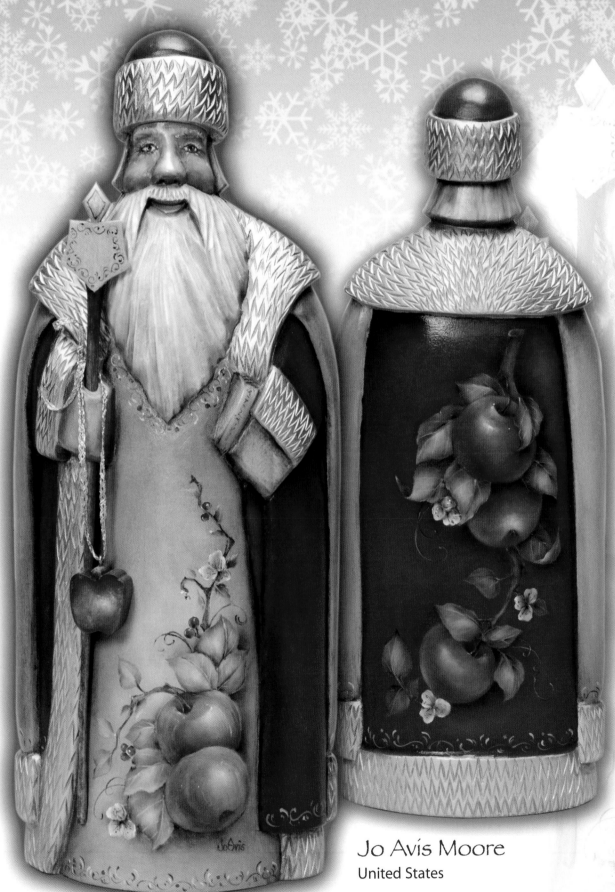

Jo Avis Moore
United States

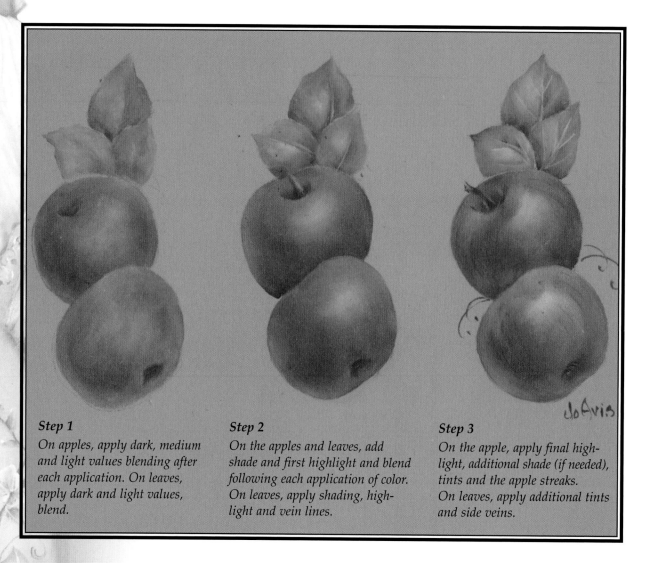

Step 1
On apples, apply dark, medium and light values blending after each application. On leaves, apply dark and light values, blend.

Step 2
On the apples and leaves, add shade and first highlight and blend following each application of color. On leaves, apply shading, highlight and vein lines.

Step 3
On the apple, apply final highlight, additional shade (if needed), tints and the apple streaks. On leaves, apply additional tints and side veins.

Tints: Cadmium Scarlett, Titanium White + Mars Black + Ultramarine Blue

Berries

Basecoat: Cadmium Scarlett
Shade: Mars Black
Highlight: Cadmium Scarlett + Cadmium Yellow Light

Blossoms

Basecoat: Titanium White
Shade: Mars Black
Highlight: Titanium White
Dots: Titanium White

Branch

Basecoat: Burnt Umber + Raw Sienna
Highlight: Naples Yellow Hue + Titanium White

Santa's Face

Basecoat: Titanium White + Burnt Sienna
Shade: Burnt Sienna
Cheeks: Cadmium Scarlett + Burnt Sienna + Titanium White
Eyes: Outline with Burnt Umber + Burnt Sienna + Titanium White. The iris is Burnt Sienna; the pupil is painted with Mars Black with a final highlight of Titanium White.
Hair & Eyebrows: Mars Black + Titanium White
Mouth: Burnt Sienna + Titanium White

Finish with several coats of Krylon Satin Varnish.

The Birds of Russia

Surface Preparation

Seal Santa with wood sealer. Let dry and sand well. Spray with Liberty Matte Finish to seal over any sanding marks. Make the following stains from your oil paints, using approximately 1/4-inch of paint from the tube mixed with a drop of cobalt siccative and sufficient odorless thinner to make the mixture soupy but not runny.

Mix the following stains and apply in the order given using a 1/2-inch synthetic brush.

• Rusty stain for cloak: Burnt Sienna.
• Green stain for robe: Ivory Black + Sap Green (1:1).
• White stain for fur areas, beard and hair: Titanium White.

Rub off excess with wood grain using a pad of cotton cheesecloth. When all stains have been applied and wiped down, allow to dry overnight. Spray with Liberty Matte Finish.

Now, create yet another stain in the same manner, using Raw Umber + Raw Sienna (2:1). Use this stain to glaze (antique) all but the most *open* areas of the Santa, particularly crevices, the detail on the fur, etc. Wipe down to remove excess with cheesecloth pad. Allow to dry and respray with Liberty Matte Finish.

Transferring the Design

Use the inked design to transfer to the painting surface. Use dark graphite of a kind that is soluble in thinner/oil paint. Lay gray graphite paper over the prepared painting surface. Lay inked design on top of graphite. Lay a piece of tracing paper on top of design to pro-tect original during transfer and to help determine accuracy of transfer. Use ballpoint pen, NOT a pencil or marking pen to transfer. Transfer all bird detail and branches completely and carefully. Check during process of transferring to be sure design is coming off on surface clearly. If too faint, change graphite.

Understanding the Painted Placement Sheet

The painted worksheet is to be used as a guide along with the written instructions. Read the written instructions carefully, then work in the sequence given, referring to the sequence painted on the worksheet. Use this worksheet to determine color placement, amount of blending to be done and so forth.

Instructions are written in the sequence in which I painted the piece; work in that order and finish each element before going on to another.

Step 1 shows how the basecoat areas should appear.

Step 2 normally indicates the first blending, as well as application of additional darks and lights.

Step 3 is the finished painting showing the final blending, strongest highlights and detail.

Brush-loading & Blending Basics

Colors should be loaded onto the flat brushes from a loading zone, a strip of sparse paint pulled from the patty of paint down onto palette.

Mixes are made by moving from one loading zone to another, working back and forth, to achieve a mix of two or more colors. Wipe brush on paper towel after applying paint to surface, but before beginning to blend.

Blend colors where they meet, with a dry brush and a short stroke. Do not blend randomly over the entire area; just on the line where the colors come together thus creating a new value and hue with the process of blending in that area. To blend overall causes loss of value distinctions and color clarity.

MATERIALS

WINSOR & NEWTON ARTIST'S OILS

Ivory Black, Titanium White, Raw Sienna, Burnt Sienna, Raw Umber, Sap Green, Cadmium Yellow Pale, Winsor Red, French Ultramarine.

BRUSHES

• Sherry C. Nelson Signature Red Sable Brights, Series 303, #'s 0, 2, 4, 6.
• Sherry C. Nelson Signature Red Sable Liner, Series 312, #0 round.

MISCELLANEOUS SUPPLIES

Artist's graphite paper, ball point pen, odorless thinner, cobalt siccative (optional), palette pad for oils, paper towels, Liberty Matte Finish, (to spray background before applying design), Krylon Spray Varnish, No. 7002 (for final finish), sandpaper, stylus, cheese cloth, wood sealer.

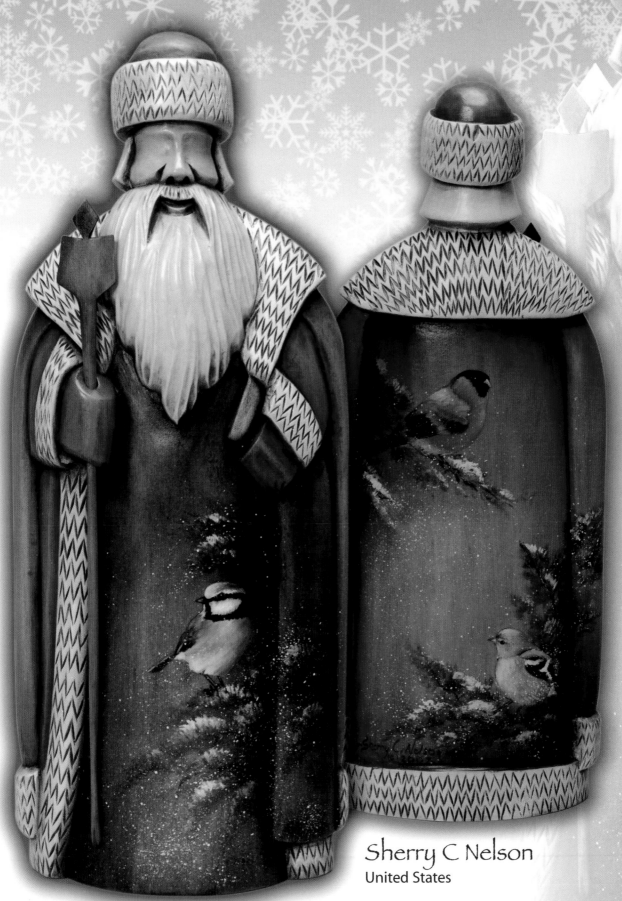

Sherry C Nelson
United States

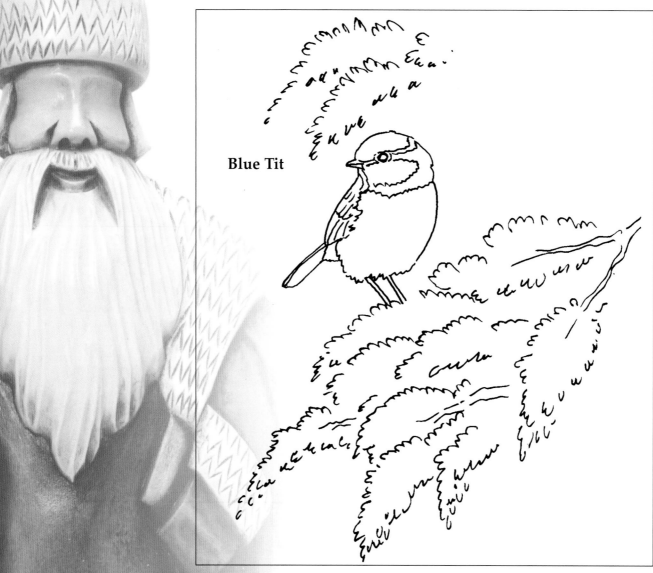

Blue Tit

Brush Sizes

Use the smaller brush sizes, #'s 0, 2 and 4 for the smaller areas of the design, choosing the largest size that is comfortable to achieve the detail necessary. The #6 is appropriate for needed clean up. I use it dampened with odorless thinner; I find the larger bristle base gives better pressure for removing any messy paint, or graphite lines around the edges of the design. Use the round brush for placement of highlights in eyes and other tiny details.

Blue Tit

Tail

Base Ivory Black + Raw Umber and highlight Titanium White on the edge.

Wing

Dark areas are Ivory Black + Raw Umber. Light areas are French Ultramarine + Titanium White + Ivory Black.

Lay in feather lines with the chisel edge using dirty brush + Titanium White.

Legs

Base with Ivory Black + Raw Umber. Highlight with dirty brush + Titanium White.

Breast & Undertail Coverts

Base dark area with Cadmium Yellow Pale + Raw Sienna. Base the light area with Titanium White.

Blend where values meet. Shade the breast with Burnt Sienna. Shade undertail with Raw Umber + Titanium White.

Beak & Black Areas

Base with Ivory Black and highlight with dirty brush + Titanium White on beak.

Eye

Base with Ivory Black. Lay a tiny line of Titanium White in front and behind eye.

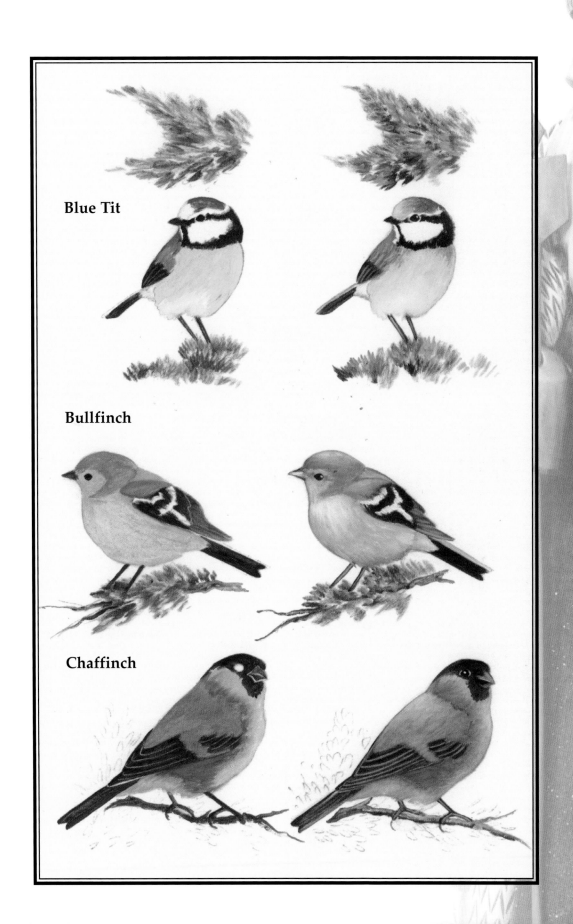

Blue Tit

Bullfinch

Chaffinch

Bullfinch

- © 2007 *Sherry C Nelson*

White Areas
Base with Titanium White.

Crown
Base with French Ultra-marine + Ivory Black and highlight with Titanium White.

Forehead
Base with Titanium White. Blend where the values meet.

Bullfinch

Tail
Base with Ivory Black + Raw Umber. Streak with a few lines of dirty brush + Titanium White.

Dark Wing Feathers
Base with Ivory Black + Raw Umber. Draw in feather lines with stylus. Streak in feather lines with the chisel using the dirty brush + Titanium White.

Back & Shoulder, Undertail Coverts
Base with Titanium White + Ivory Black + Raw Umber. Shade with Ivory Black + Raw Umber. Highlight with Titanium White.

Legs
Base with Ivory Black + Raw Umber. Highlight with dirty brush + Titanium White.

Breast
Dark area is Winsor Red + Raw Sienna + Burnt Sienna. Light area is Titanium White + Raw Sienna. Blend where values meet. Shade with Winsor Red. Highlight with light mix + more Titanium White.

Head
Base beak, eye and other dark areas Ivory Black + Raw Umber. Highlight beak with dirty brush + White. Place a tiny outline of Titanium White in front and behind eye. Highlight just a bit on top of crown with very dirty White.

Chaffinch

Chaffinch

Tail

Base with Ivory Black + Raw Umber. Lay narrow band of Titanium White along top edge of tail.

Undertail Coverts, Breast & Throat, Back, & Area Around Eye

Base with Raw Sienna + Titanium White. Shade with Raw Umber. Highlight with Titanium White.

Eye & Beak

Base with Ivory Black + Raw Umber. Highlight with dirty brush + Titanium White on beak and with a dot of pure Titanium White on the eye.

Primaries

Base with Titanium White + Raw Umber + a bit of Ivory Black. Streak with dirty Titanium White.

Rest of Wing

Dark area is Ivory Black. Light area is Titanium White. Connect areas with slightly irregular line.

Gray Areas

Base with Titanium White + Ivory Black + a bit of French Ultramarine. Shade with Raw Umber. Highlight with Titanium White.

Branches

Base with Raw Umber. Highlight with chisel edge chops of dirty brush + Titanium White.

Evergreen Needles

Base with choppy chisel marks of Sap Green + Ivory Black. Highlight some of the topmost needles with Sap Green + Raw Sienna + Titanium White, using same choppy stroke.

Complete painting and allow to dry. Using Titanium White on a #2 chisel, place small heaps of snow along the tops of the needles. Allow some of the needles to show through, and put snow between and within some clusters. If dirty white is needed, add a little Raw Umber.

Make snowflakes using the remaining white paint thinned to a very soupy consistency. Use a tiny corner of paper toweling to lay over each bird's face before spattering so you don't have to remove extra highlights from their eyes! Spatter snowflakes on all areas of greenery and birds using an old toothbrush. Pull the edge of the palette knife gently across the bristles so that the flakes do not get too big.

Final Finish

Spray with several coats of Krylon Spray Varnish, No. 7002.

Norsk Santa

My woodman, Paul Brooks, did additional carving to change Santa's appearance to be more conducive to the Telemark style. I used some metallics in the paint. The bird I found at the gift shop at the Tillamook Cheese Factory, Tillamook, Oregon. I repainted it to fit the décor. The mangle board came from Vesterheim Norwegian-American Museum in Decorah, Iowa, and I cut it down so it would be in proportion to Santa.

Palette

I like to use a wet paper towel inside a folded piece of deli paper. Make sure the deli paper sticks down to the paper towel; smooth out the air, no wrinkles. This keeps the paint wet a long time. Dampen the paper towel if the paper starts to curl and dry. Cover when not in use.

Color Mixtures

Red
DK = Burnt Umber + Brown Madder (1:1)
M = Napthol Red Crimson + touch of dark mix
LT = Napthol Red Light

Yellow
DK = Raw Sienna + a little dark red mix
M = Raw Sienna and/or Rich Gold
LT = Raw Sienna + Smoked Pearl (Use for base coating inside robe and fur.)
Detail Light = Raw Sienna + Pearl White + about 1/3 Kleister

Flesh
DK = Gold Oxide
M = DK + Smoked Pearl
LT = M + Smoked Pearl

Blue
DK = Prussian Blue + Burnt Umber (1:2)
M = DK + Smoked Pearl - Use for base coating hat and robe.
LT = M + Smoked Pearl or Pearl White

Green
DK = Teal Green + DK Blue
M = Green Oxide + Teal Green
LT = M + Pearl White (two values of light)

Detail

Red Objects
Carbon Black + DK Red for the dark detail.

Stems & Fill-in Detail
Pearl White + Raw Sienna (two values). Use darker value for stems and fill-in detail.

Use LT Green + Pearl White on greens.

Rich Gold + Kleister.

Background Preparation

Sand and wipe free of sanding dust. Add All-Purpose Sealer to the paint used for basecoating.

Robe
Medium/DK Blue

Inside Robe
Napthol Red Crimson

Inside Clothing & Fur
Smoked Pearl + Raw Sienna. Fabric under left arm: Teal Green.

Flesh
M and LT Flesh

Beard & Hair
Smoked Pearl

When the above is dry, sand lightly. Apply a second coat. Add a little flow medium if too thick for a smooth, even coat.

Antique or Stipple

Apply Retarder before applying the antiquing color. Apply the DK Blue on blue and green areas, DK Red mix on red areas, Raw Sienna on the Smoked Pearl areas. Stipple, texture or treat as antiquing.

MATERIALS

JO SONJA'S ARTISTS' COLOURS

Smoked Pearl, Raw Sienna, Gold Oxide, Napthol Red Light, Napthol Red Crimson, Brown Madder, Burnt Umber, Green Oxide, Teal Green, Prussian Blue, Carbon Black, Rich Gold, Pearl White, Warm White.

MEDIUMS

All-Purpose Sealer, Retarder, Clear Glaze, Flow Medium, Kleister, Polyurethane Matte or Satin Finish.

BRUSHES

Loew Cornell or Jo Sonja
- Filberts: LC 5700 or use JS 1385 sizes 2, 4, 6.
- Round: JS 1355 detailer size 2 or 3, or use Raphael Quill, 16684, size 3.

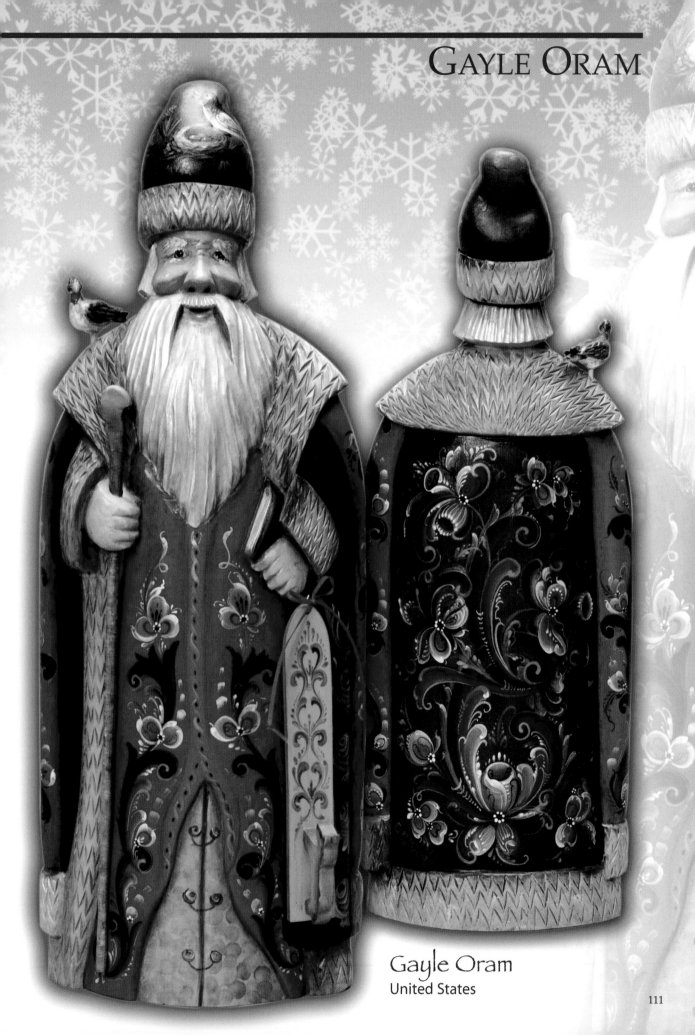

Gayle Oram
United States

Repeat the previously used technique on the fur but use the dark yellow mix.

On the dark flesh on the skin areas, use a mix of gray by adding more Burnt Umber to the blue mix to neutralize.

Beard and Hair: Apply light-medium gray. Highlight with some Smoked Pearl. When dry lighten again with Pearl White.

Apply one coat of Clear Glaze to protect the surface.

Transfer a minimum amount of design as needed or preferably sketch your own using a piece of white chalk.

Face

Repaint flesh on the face, side loading into dark around the edges. Use a lighter value on the top of the cheeks. Side load into red and add some blush to the underside of the cheeks and lips. Using a liner, sketch in the eyes with Gold Oxide. Paint in the pupil with Burnt Umber. Highlight lower side. Use touches of gray on the corners. Paint some flesh for the eyelid above the eye.

Adds some dark flesh wrinkles at the corners of the eyes and

strengthen the dark, if needed, by adding some dark red mix to flesh. Use this dark inside the nose and mouth.

Highlight cheeks, nose and below eyes with Smoked Pearl (add some Warm White if more light is needed).

The eyebrows can be painted with Smoked Pearl and a touch of light gray.

Scrolls (Back of Robe)

Paint the large C-scrolls first using medium and dark red. Inside scrolls are medium and light red. On the very inside ones, side load into Raw Sienna or Rich Gold.

Where the scrolls intertwine, paint over the first scroll and clean off the wet paint so the second scrolls stays behind. Otherwise, stop and start at the scroll. Make sure all scrolls flow gracefully in C-shapes or S-shapes and directions.

Flower Forms

Start with the red scroll shape first, working into the yellow. Use a dirty brush. Balance color within the flower form and in the entire design. Use the basic strokes. Paint the reds and

yellows on each flower while the paint stays wet. Side load into some of the Smoked Pearl + Pearl White mix when painting the light sides and oval strokes.

Leaves

Paint the green scrolls and leaves to balance everything out. Side load into light green on the light side of the leaves.

Detail

Use the darkest value of the color you are painting on to detail the dark values on each object. You may need to add some black to dark red. Use the photograph for a guide as to what and how to detail. Let your personality come out in the line work and detail. Don't worry about following what I did. Make sure the lines and strokes gracefully flow from the root of the design to the flower's root and beyond. Use the light value for the light overstrokes on the flowers, leaves and scrolls. Use Rich Gold for the stems and most of the detail on the dark side; use Pearl White with some Raw Sienna. Tip the brush in the color you are painting on when

using the light detail. That will help the light values to soften in.

Repeat the same methods for the design on the inside robe (red background areas). Use values of green for the scrolls, side loading into Raw Sienna on the inside scrolls. Use Raw Sienna and LT Yellow for the oval strokes. Detail the scrolls and flowers, then paint the stems and fill-in detail using light or dark stems.

Drape

Use Rich Gold tipped in Pearl White to paint the rose buds and S-strokes on the drape, or do your own thing.

Hat

Bird Nest

Use a liner with values of Burnt Umber and gray for the nest, branches and cones. Eggs and bird are values of blue. Add a touch of red to the bird's throat. Side load in the LT Blue + Pearl White for the light areas on the bird. Use values of green for the pine needles.

Mangle board

Base with LT Yellow mix. Antique with the DK Yellow mix. Paint the scrolls with Raw Sienna and add DK Yellow detail.

Staff

Paint with values of gray or Burnt Umber.

Finish

Dry thoroughly. Apply several coats of finish and enjoy.

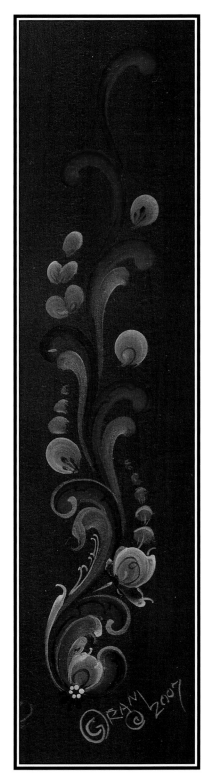

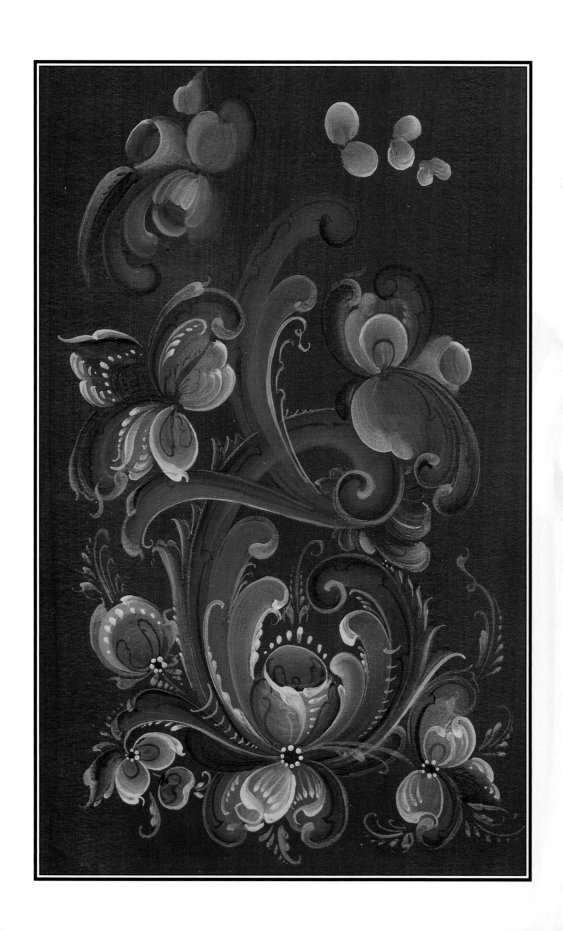

A Floral Christmas

Preparation

1. Sand any rough spots with fine grit sanding sponge. Dust.

2. Seal with any water based wood sealer.

3. Basecoat as follows:
- Coat, collar, hat trim and dress with Camel
- Face with Light Flesh
- Beard and hair with Titanium White
- Mitts with Wrought Iron
- Bag with Burnt Umber
- Float Wrought Iron in folds, and between coat and dress and under collar.

4. Transfer pattern using grey transfer paper.

Painting Instructions

Follow these steps as pictured on the worksheet using acrylic colors:

1. Undercoat flowers with Titanium White.

2. Basecoat with acrylic color: Rose Chiffon, Buttercrunch and Sterling Blue for the flowers and Olive Green for the leaves.

3. Float in dense shadows of Alizarin Crimson. (Study areas on flowers and leaves.)

4. Float Payne's Gray to deepen shaded areas.

Set up your oil palette and use for the following steps. Include a small cup of Painting Medium.

Before beginning the wet-into-wet overstrokes, study the flower shapes, the direction of the strokes and the highlighted areas. Each leaf or flower should be covered with a very thin coat of Painting Medium to allow the strokes to flow and

to add transparency to them.

Dust in wet Alizarin Crimson, and then Paynes Gray over the already shaded areas. As you pull your overstrokes, they should move through this wet color, dirtying the brush, thus changing the color of the next stroke.

Begin to pull in overstrokes loading your brush with the appropriate color (listed below). Follow the same direction and shape as indicated in the white undercoat. Once you begin in a leaf or flower, continue to stroke (in the flowers, from the bottom, moving up the sides and around the back) without reloading your brush in-between strokes.

Overstroke Colors:
- Cadmium Yellow over the Buttercrunch flowers.
- Crimson Alizarin plus

Titanium White over the Rose Chiffon
- Prussian Blue plus Titanium White over the Sterling Blue
- Sap Green over the Olive Green leaves

6. Finish the bottom, fronts of the flowers first, then move up the sides and around the back. Add Cadmium Yellow and/or Titanium White to lighten these colors and sideload your brush to pull shorter, fewer, highlight strokes for the *second* layer. Add more white and sideload again, adding only a few strokes for the final (third layer) highlight.

7. Proceed to pull overstrokes in the front of the flower with a side-loaded highlight color.

8. Dot in centers with Cadmium Yellow and Crimson Alizarin. Add thin, broken lines

MATERIALS

FOLKART ACRYLIC
Buttercrunch, Titanium White, Light Flesh, Rose Chiffon, Payne's Gray, Alizarin Crimson, Camel, Olive Green, Wrought Iron, Burnt Sienna, Sterling Blue, Burnt Umber.

DALER-ROWNEY GEORGIAN OIL COLORS
Prussian Blue, Cadmium Yellow, Sap Green, Payne's Gray, Crimson Alizarin, Titanium White, Burnt Umber.

DALER-ROWNEY
Painting Medium for oils.

BRUSHES
Daler-Rowney, Robert Simmons Expression Series
- E67, #8 filbert
- E67, #6 filbert
- E60, #12 flat shader
- E55, 3/4-inch flat wash
- E52, 1/4-inch oval mop
- Heather Redick Liner 5/0

MISCELLANEOUS SUPPLIES
Masterson Sta-Wet Palette for acrylics, stylus, tracing paper, gray transfer paper, suitable oil palette.

Daler-Rowney Low Odor Thinner, Daler-Rowney Water Washable Oil Brush Cleaner, Heather's Choice Final Coat Gloss, fine grit sanding sponge, water-based wood sealer.

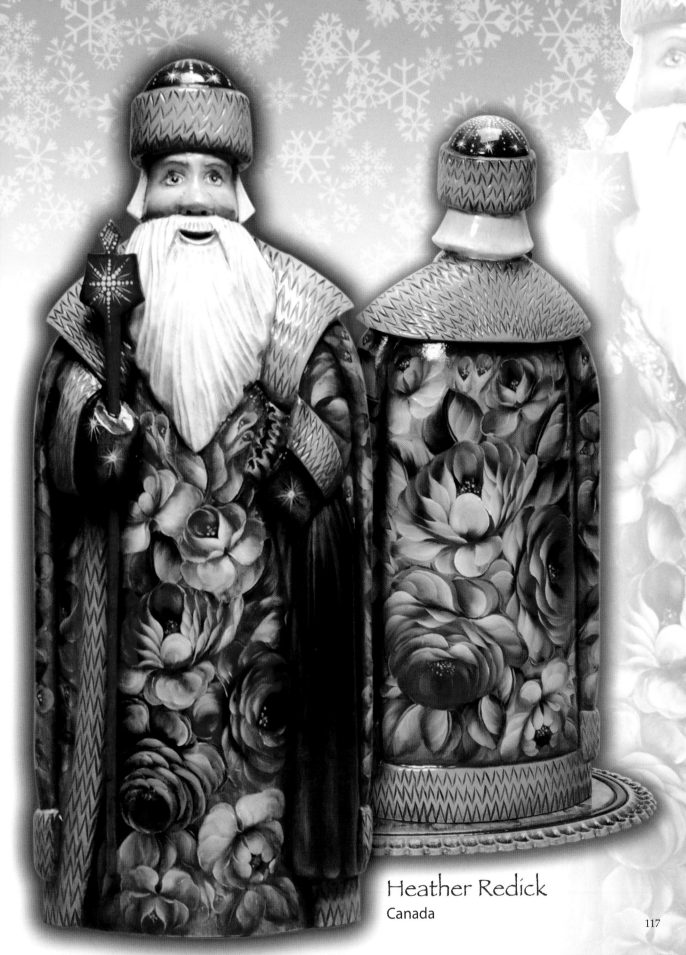

Heather Redick
Canada

to define shapes of petals if needed.

9. Using acrylic color, float a faint shadow of Burnt Sienna under the eyebrow and eye. Paint the eyes. Fill in the white, Payne's Gray pupil and brush mix a blue color (or color of your choice) for the eye.

10. Outline the eye with Burnt Sienna.

11. Add a fine light line around the pupil; add a couple of small dots to highlight; pull fine eyelashes out from the center of the eyes.

12. Add white dotted stars to mitts, hat and staff. Fill in eyebrows.

13. Float Burnt Sienna around the face. Lighten Crimson Alizarin with Light Flesh and float rosy cheeks.

14. Paint the bag with Burnt Umber acrylic color. Outline the top open area of the bag and ruffle highlight with white. Fill in center opening with Payne's Gray.

15. Go over with Burnt Umber oil color. Add Payne's Gray to indented areas. Highlight ruffles with U-shaped strokes of Burnt Umber lightened with white.

16. Dust a light highlight of white over front/center of mitts and center of collar and coat trim.

FINISHING

When dry, varnish with two coats of Heather's Choice Final Coat Gloss.

Antique with Burnt Umber oil color using your favorite technique.

When dry, re-varnish with several wipes of Gloss varnish.

EMBELLISHMENTS

The small boxes and tree are from Bear With Us, Inc. I used the same pattern, downsized and painted the tree in a similar fashion to that of the Santa. The boxes have just one flower on each side. The ribbons are made of lightweight watercolor paper, cut into strips, painted, formed into loops and hot-glued to the boxes.

The floor is from Coyote Woodworks and again painted with the same pattern, filling the space with extra flowers.

SUPPLIERS
- Bear With Us
 www.bearwithusinc.com
- Coyote Woodworks
 www.coyotewoodworks.net
- Daler-Rowney
 www.Daler-Rowney.com
- Plaid Enterprises
 www.Plaidonline.com
- Heather Redick
 www.HeatherRedick.com
- Masterson Art Products
 www.mastersonart.com

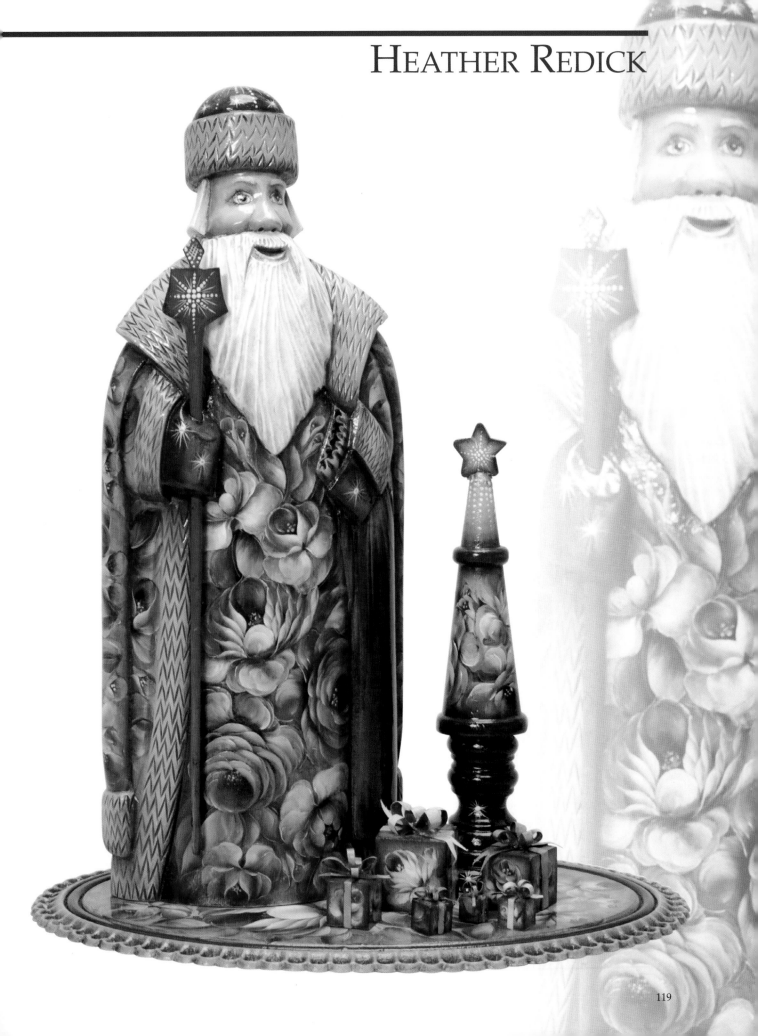

HEATHER REDICK

Back of Santa's Gown

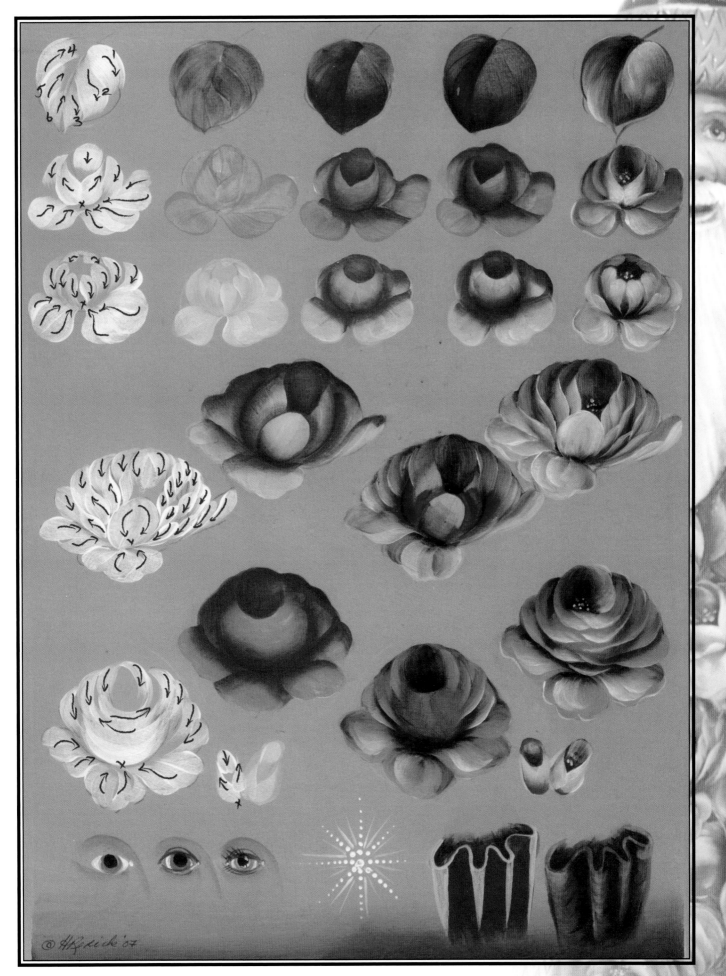

Winter Whispers "Peace"

Preparation

Basecoat as smooth as possible with a coat of Soft Grey acrylic. Let dry thoroughly and sand.

Basecoat with acrylics as follows:
- Hat & Coat: Lavender Lace
- Hat & Coat Trim: Blue Haze
- Borders on Coat & Dress: tape off and then basecoat with Blue Velvet
- Face: Santa's Flesh
- Hair & Beard: Dolphin Grey
- Santa's Sack: Deep River
- Mittens & Staff: Blue Velvet
- Let Dry! Lightly sand and basecoat again.
- Highlight the beard, hair and coat trim with floats of Soft Grey.
- Highlight the sack with a float of Festive Green.

Let's Paint

Create basic oil mixes as follows:
- Black: French Ultramarine + Burnt Umber
- Warm White: Titanium White + Cadmium Yellow Pale
- Yellow Tint: Warm White mix + more Cadmium Yellow Pale
- Blue Violet: French Ultramarine + Black mix + a dot of Alizarin Crimson
- Sky values: Blue Violet mix plus White and then mix another lighter one with more White.
- Take part of the lightest sky value and add French Ultramarine.

Sky

Start under the trim on the coat and from under the beard with Blue Violet mix, blending down into the next lighter value. Build in the top of the clouds using the lighter blue violet mixes and Warm White for the puffy tops.

Leave the sleeves a smooth blend of values. Mop to soften out the brush marks.

Trees

Mix an assortment of greens for trees. French Ultramarine + Black mix + a little Cadmium Yellow Pale will give you a very dark green (like Deep River). To make lighter values, add more Cadmium Yellow Pale and Titanium White in various amounts.

For background trees, take the lightest green value and the lightest blue value and mix them together. Stipple the trees in with Cheri's smallest mop. Add a few vertical lines for tree trunks with Warm White.

Brush on snow with Warm White mix plus light green mix using a horizontal stroke.

As you work forward, use more and more color. Doing this will give you the strongest contrast in the foreground.

RIVER

For the river use the Blue Violet mix plus Warm White mix to create a zig zag river, being sure to keep the river strokes horizontal to the bottom of the edge. Use all the Blue Violet mixes. Slice in highlights of Warm White using the chisel edge of a #2 blender.

PINE TREES

For the pine trees, thin the medium green mix with a drop of Winsor & Newton Blending & Glazing Medium. Load onto the script liner and draw on the tree trunk. Use a #6 blender to slap on very dark green mix for branches, smallest at the top, wider and broader at the bottom.

MATERIALS

WINSOR & NEWTON OIL OR ALKYD

Titanium White, Cadmium Yellow Pale, Raw Sienna, Bright Red, Alizarin Crimson, French Ultramarine, Burnt Umber.

DELTA CERAMCOAT ACRYLICS

Blue Velvet, Deep River, Dolphin Grey, Soft Grey, Lavender Lace, Santa's Flesh.

DECOART AMERICANA ACRYLIC

Blue Haze, Festive Green.

DECOART TWINKLES

Silver.

ACRYLIC BRUSHES

Langnickel 3010, Size 12 for base coating.

CHERI ROL OIL BRUSHES

Blenders #'s 0–10
Mops #'s 0–3
Droplets #'s 1 & 2
Liner #10/0

MISCELLANEOUS SUPPLIES

Wood Sealer, Zinsser's Bulls Eye Seal Coat, Universal Sanding Sealer, #320 sandpaper, tack cloth, Winsor & Newton Blending & Glazing Medium, 3M Magic Tape, Krylon Satin Varnish, #7002.

Cheri Rol

United States

Snow on Trees & Snow Banks

Wipe the brush, then pick up Titanium White, blend into the dirty brush making a white that looks grey green, then add as snow to the top of each branch. Highlight with Warm White on top of the boughs. Add touch of Raw Sienna to indicate the trunk.

Snow banks are values of Blue Violet. Add Warm White to the tops. Shade the bottom bank into a dark blue violet so it disappears into the Blue Velvet trim on the shirt.

Pull twigs and grasses using values of green and Raw Sienna on the liner. Add a little Blending & Glazing Medium to thin the paint.

Deer

The deer uses values of brown. Burnt Umber is dark; Burnt Umber + Raw Sienna is medium; Raw Sienna + Titanium White is the light value. Use Warm White for the lightest spots on the deer: for example, on his throat, the muzzle, around the eyes and in the ears. Black mix can be added for the darkest parts such as the edges of the ears and the eyes. Shade the left side of the deer and highlight on the right side.

Complete the front landscape with cast shadows from the deer's feet in the snow, to the left with streaks of Blue Violet plus Warm White mix.

Santa's Face

Mix values of flesh with Bright Red + Cadmium Yellow Pale + a touch of French Ultramarine, adding Titanium White to make two lighter values.

Basecoat the face with medium value. Shade under the hat and around the whole outer edge of the face with a float of dark value. Rouge the cheeks and nose with Bright Red using a #2 mop. Highlight with Warm White.

Use a droplet brush to detail the eyes: white for the eye ball, Black + French Ultramarine for the iris. Highlight with Warm White and medium sky blue.

Shade around the eye with a float of dark flesh mix.

Add eye lashes and eye brows with values of grey (Black + Titanium White).

Lips are base coated with dark flesh, rouged with Bright Red, then highlighted with Warm White.

Church

The church is built with grey values, Black + Titanium White, adding more Titanium White to make three values.

Block in the sides of the church and steeple with light grey on the right and medium grey on the left. The under eave is basecoated with dark grey mix. Highlight the board siding with Warm White on the right and light grey on the left. Add streaks of light blue on the left side.

Windows are painted with a thin layer of Cadmium Yellow Pale, shaded with Raw Sienna and highlighted with Warm White. Trim with a contrasting lighter grey.

The doors are base coated with Raw Sienna + Burnt Umber, shaded with Burnt Umber and highlighted with Raw Sienna + White.

Roof

The church roof is covered with snow. Use the light grey-green from the base color, Warm White and Blue Violet shades for the shadow cast by the pine tree.

The steeple roof is base coated on the right with Raw Sienna + Burnt Umber, highlighted with Raw Sienna + White. The left side of the steeple roof is base coated with Burnt Umber, highlighted with a sky blue mix.

Use a 10/0 script liner to pull the cross with medium grey value. Shade the left with a line of Burnt Umber and the right with Warm White.

Final Trees & Road

Add pine trees around the church being sure to vary their heights and widths. Bushes are added the same as the background trees but using darker, stronger values of green.

The bare tree is pulled on with a mix of Burnt Umber + Raw Sienna + a little Titanium White. The main trunk is painted with the chisel edge of a #2 blender. Slice highlights of Raw Sienna + Titanium White on the right and Burnt Umber on the left to shade. Add sky blues on the left also.

Pull out the branches from the trunk using a 10/0 liner and a drop of Blending & Glazing Medium to thin the previously used brown colors. Remember that your light source is on the right.

The road is made with values of grey and a little Raw Sienna,

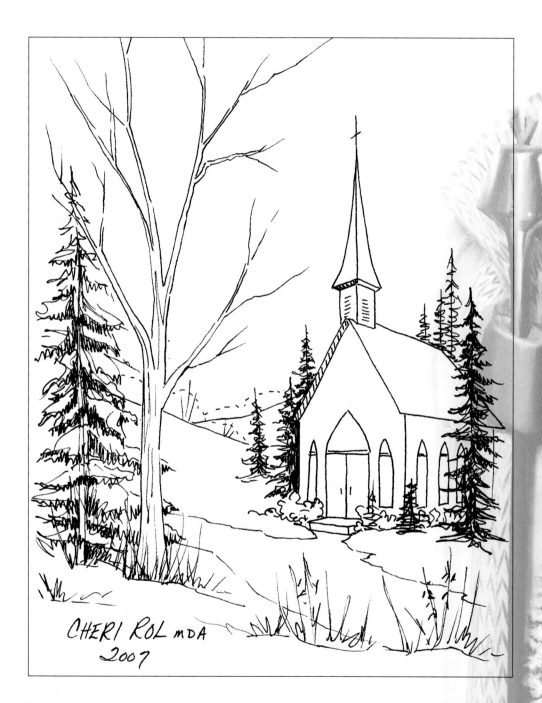

CHERI ROL mDA
2007

keeping the application horizontal. Across the bottom use the script liner to pull up weeds and then add snow drifts with a flat brush or palette knife using light grey mix or Warm White.

BRAID & FRINGE
Transfer the line drawing on the Blue Velvet areas of the robe. Paint this metallic-like braid and fringe with values of grey adding tints of Yellow Tint and Warm White.

Basecoat with 10/0 liner and dark grey. Add Blue Violet, then lighten the dark grey threads on the upper right sides with medium grey.

Highlight the top right with light grey, then add highlights of Yellow Tint and Warm White mixes.

Staff

Over the basecoat of Blue
Velvet, add dark grey streaks.
Build on top of the dark grey to
medium, then light grey getting
smaller in area with each appli-
cation of color. Sparkles of
Yellow Tint and Warm White
are added last in small streaks
and dots.

Sign Your Name!

Varnish

When dry, varnish with many
thin coats of Krylon Satin Spray
Varnish, #7002. Be sure to read
the label on the can for specific
instructions. Add some random
glitter sparkle on the trim with
DecoArt Twinkles Silver or
Warm White.

126

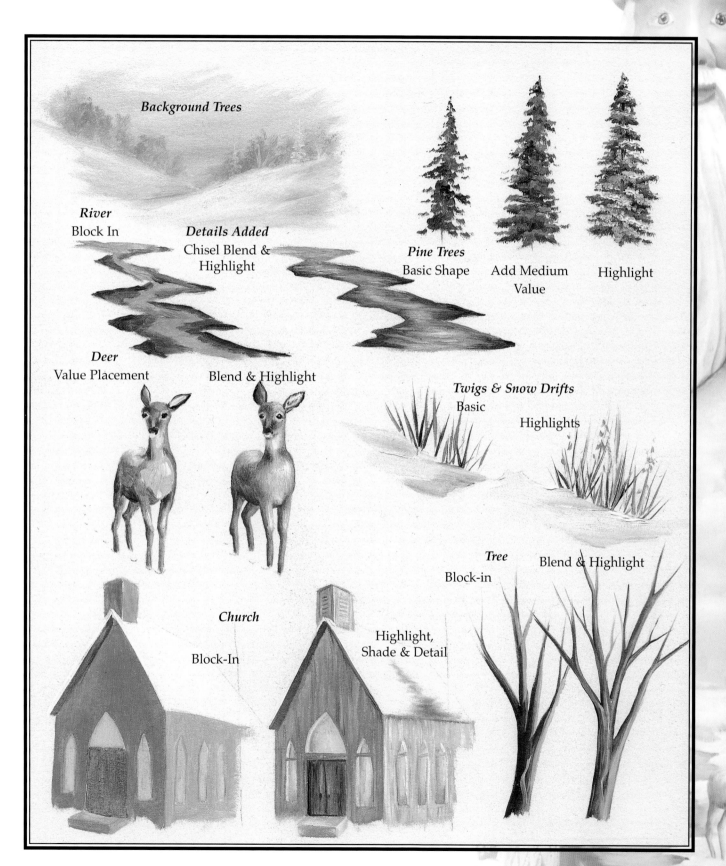

Background Trees

River
Block In

Details Added
Chisel Blend &
Highlight

Pine Trees
Basic Shape

Add Medium
Value

Highlight

Deer
Value Placement

Blend & Highlight

Twigs & Snow Drifts
Basic

Highlights

Tree
Block-in

Blend & Highlight

Church

Block-In

Highlight,
Shade & Detail

The Nutcracker Santa

Inspiration for the design comes from E.T.A. Hoffman's story of *The Nutcracker*.

Wood Preparation

Stain and seal the entire Santa with All Purpose Sealer + a touch of Raw Umber + a touch of Retarder Medium. This is a very light value stain. Dry.

Blend a brush mix of Raw Umber + Unbleached Titanium (1:4) onto the front and back areas avoiding the fur trims. Dry and sand lightly as needed. Transfer the pattern.

Painting Techniques

- Wet-into-wet (over lightly retarded surface).
- Dry brushing final highlights.
- Glazing for added shadows and accent colors.
- Raw Umber is the toner for all other pigments. Use as desired.

Painting the Design

Lightly retard areas ahead of painting procedure. Add Retarder to paints for liner work and translucency. Use the dirty brush painting method, leaving the previous color in the brush and going to the next step.

Floor Tiles

Dry brush Smoked Pearl + a touch of Retarder to casually fill in every other square, making an overall check pattern.

Owl

Base in Purple Madder + a touch of Raw Umber. Shade around the owl's body with base color + Carbon Black. Highlights on the owl's face and wings start with the base color + a touch of Marigold to Jaune Brillant.

Form acanthus leaf-style scrolls to represent the feathers. On the leaves, a liner of Jaune Brilliant + a touch of Smoked Pearl is stroked over the vein lines and along edges.

Eyes: Iris is based Marigold. Pupils are Raw Umber + a touch of Carbon Black.

Mice

Base with Raw Umber + Purple Madder. Highlights Marigold + a touch of Purple Madder to Jaune Brillant to bring up the shapes out of the background.

Castle

Roof: Base is Purple Madder; shade is Purple Madder + Dioxazine Purple. Glaze with Burgundy. Highlight in Burgundy + Poppy. Heart is strokes of Burgundy + a touch of Unbleached Titanium; then, the previous mixture + more Unbleached Titanium. Scrolls and strokework are Brilliant Green + Tree Frog Green.

Walls are based in Raw Umber + a touch of Nimbus Grey. shade in Raw Umber + a touch of Carbon Black. Highlight in Nimbus Grey + touch Raw Umber and then with the same mixture + a touch of Smoked Pearl.

Linework around stones is Raw Umber + a touch of Dioxazine Purple.

Flags are Raw Umber + a touch of Trans Magenta or Brilliant Green + Retarder to equal a faint color.

Goat

Base with a mix of Raw Sienna + a touch of Burgundy + a touch of Amethyst. Shade with Dioxazine Purple + a touch of Carbon Black. Highlight in Amethyst and then a touch of Jaune Brillant. Spots are Dioxazine Purple. Accent is liner of Aqua + a touch of Titanium White. Eye is based in Titanium White. Pupil is a dot of Black.

Collar and bell are based in Purple Madder, highlight of Marigold, then Marigold + Jaune Brillant.

Horns are based in Raw Umber. Shade Dioxazine Purple liner and highlights of Jaune Brillant + Yellow Light + a touch of Titanium White liner.

Horse

Horse is based in Raw Sienna + a touch of Burgundy. Shade in Purple Madder + Dioxazine Purple. Highlight with base + a

MATERIALS

JO SONJA ACRYLIC

Titanium White, Unbleached Titanium, Smoked Pearl, Nimbus Grey, Raw Umber, Carbon Black, Yellow Light, Turners Yellow, Marigold, Raw Sienna, Jaune Brillant, Poppy, Trans Magenta, Burgundy, Tree Frog Green, Brilliant Green, Aqua, Blue Violet, Amethyst, Purple Madder, Dioxazine Purple, Raw Umber.

JO SONJA MEDIUMS

All Purpose Sealer, Clear Glaze Medium, Retarder Medium, Satin Varnish

BRUSHES

Jo Sonja's #2 detailer, #0 liner, #2 short round brush, #2 or #3 filbert, #6 round, 1-inch prep brush.

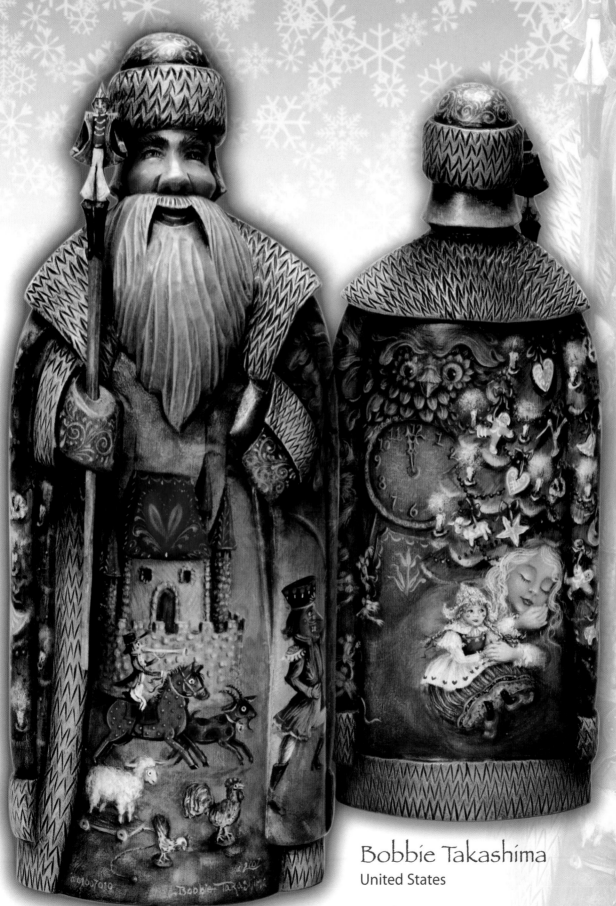

Bobbie Takashima
United States

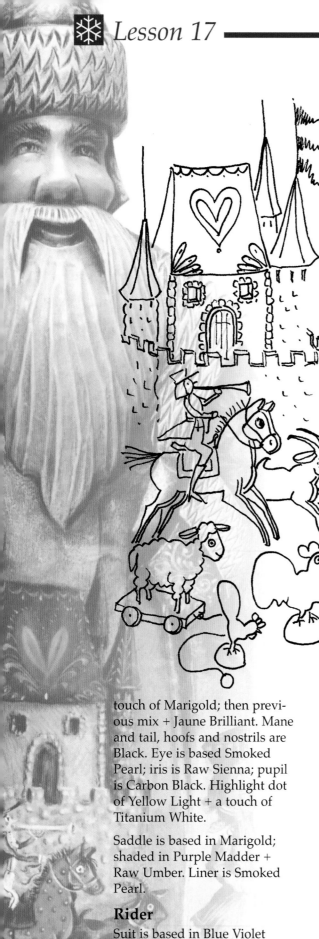

Highlight is Titanium White + a touch of Aqua.

Boots are based in Carbon Black. Highlight is Titanium White + a touch of Aqua.

Horn is based with Turners Yellow. Shade is Purple Madder. Highlight is Turners Yellow + White.

Chicken

Chicken is based in Turners Yellow + a touch of Titanium White. The feathers are strokes of Burgundy + a touch of Raw Umber. Comb and wattle is based in Poppy + a touch of Jaune Brilliant. The eye is a Black dot.

Rooster

Rooster is based in Turners Yellow + a touch of Titanium White. Shade is Purple Madder liner. A glaze of Brilliant Green + a touch of Blue Violet is stroked over the body. Comb and wattle are based in Burgundy and highlighted with Poppy and Jaune Brilliant.

Toys

All toy bases are based Brilliant Green, shaded Blue Violet with Tree Frog Green highlights.

Sheep

He is based in Marigold, shaded with Marigold + a touch of Dioxazine Purple.

Highlights are built up from Marigold to Jaune Brilliant to Yellow Light + a touch of Titanium White.

Platform is based Raw Umber highlighted in Marigold.

Wheels are Marigold shaded Dioxazine Purple with Black liner.

Clock

Hands and numerals are based in Raw Umber, then over stroked with Black liner.

Background Swirls

Dark and light swirls are painted over a lightly retarded surface. Dark swirls are Raw Umber + touch Purple Madder. Light swirls are Unbleached Titanium.

Christmas Tree

Green Mixes
- Medium green base mix = Brilliant Green + Blue Violet (1:1/2).
- Light green mix=Tree Frog Green + Brilliant Green (2:1).
- Dark green mix=Brilliant Green + Blue Violet (1:1:1/2).
- Highlight mix=Brilliant Green + Aqua + Tree Frog Green (1:2:2)
- Highlight liner=Yellow Light + a touch of Tree Frog Green + touch of Unbleached Titanium

Shade between the rows of branches in dark green mix. Base the top surface of branches in medium green mix, stroking from the branch edge toward the shading. Front edge is based with the light green mix and highlighted in Yellow Light + Titanium White mix.

Ornaments
Cookies are based in Marigold + a touch of Dioxazine Purple. Highlights are Jaune Brilliant + Unbleached Titanium.

touch of Marigold; then previous mix + Jaune Brilliant. Mane and tail, hoofs and nostrils are Black. Eye is based Smoked Pearl; iris is Raw Sienna; pupil is Carbon Black. Highlight dot of Yellow Light + a touch of Titanium White.

Saddle is based in Marigold; shaded in Purple Madder + Raw Umber. Liner is Smoked Pearl.

Rider

Suit is based in Blue Violet + a touch of Unbleached Titanium. Shade is Blue Violet + a touch of Dioxazine Purple.

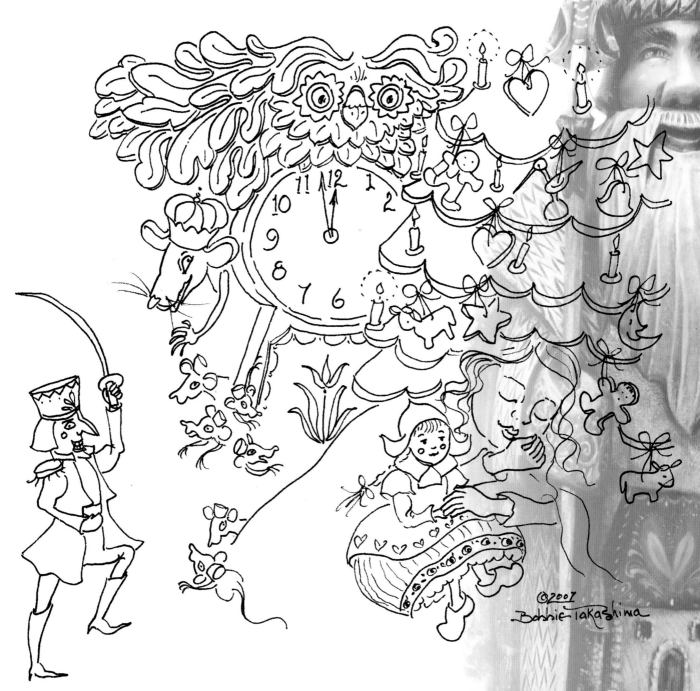

©2007
Bobbie Takashima

Berries and ribbons are based in Burgundy with Poppy to Jaune Brilliant highlights.

Candles are based in Nimbus Grey, shaded with a touch of Black and highlighted in Unbleached Titanium drips. Flame is based in Turners Yellow + a touch of Titanium White. A tiny Poppy brush-stroke is placed at the base of the flame. The halo is stippled over the flame in Yellow Light + a touch of Titanium White.

Little Girl

Clara, the girl, is based in Marigold + a touch of Dioxazine Purple. Highlights are the base mix + more Marigold + a touch of Jaune Brilliant; then to more Jaune Brilliant to Yellow Light + a touch of Titanium White.

A glaze of Amethyst shading is stroked next to hairline and around facial features, eyes nose and mouth. Blush color of Poppy, then Trans Magenta along the lower cheek edge.

Eyelashes, eyebrows are liner of Purple Madder.

Mouth is based in Purple Madder with highlights of Poppy to Jaune Brilliant on the lower lip.

BOBBIE TAKASHIMA

Hair is built in layers of liner beginning with Marigold to Turners Yellow + a touch of Unbleached Titanium to Yellow Light + a touch of Titanium White.

Sleeve is transparent Unbleached Titanium with dabby dots of Titanium White along edges.

Blanket is based Purple Madder, shaded Purple Madder + a touch of Raw Umber. Highlight with Amethyst + a touch of Marigold to Jaune Brilliant.

Doll

Face is based in Marigold, highlighted in Jaune Brilliant + a touch of Titanium White + Yellow Light. Eyes and liner is Purple Madder. Blush is Poppy. Hair is based in Purple Madder with Jaune Brilliant to Yellow Light + Titanium White highlights.

Hat, blouse and stockings are based in Nimbus Grey + a touch of Carbon Black. Highlights are Smoked Pearl to Unbleached Titanium. Bodice is based in Burgundy, shaded in Burgundy + a touch of Blue Violet. Highlight in Poppy to Jaune Brilliant.

Skirt bottom band is based in Tree Frog Green, highlighted with Yellow Light + Titanium White.

Black band through center of green band is dabbed with tiny red roses and green leaves.

Yellow stripes are based in Raw Sienna + Turners Yellow and highlighted in Turners Yellow + a touch of Unbleached Titanium.

Base blue stripes in Blue Violet, highlighted in base color + more Unbleached Titanium to Aqua + Unbleached Titanium.

Nutcracker

Shirt is based Amethyst, shaded Dioxazine Purple + a touch Blue Violet. Highlight Jaune Brilliant + Yellow Light + Titanium White.

Coat is based in medium blue made of Blue Violet + Titanium White. Shade with base + a touch of Carbon Black. Highlight is Aqua + Titanium White.

Epaulets are Turners Yellow with Yellow Light + Titanium White highlights.

Waistband is based Trans Magenta, highlighted in Poppy to Jaune Brilliant.

Pants are Nimbus Grey + a touch of Carbon Black. Shade Raw Umber + a touch of Carbon Black. Highlight with Smoked Pearl to Unbleached Titanium.

Hat is based Carbon Black with Burgundy details highlighted in Poppy to Jaune Brilliant. Strokes and dots are Titanium White + a touch of Yellow Light.

Boots and sword are based in Carbon Black with Nimbus Grey to Unbleached Titanium highlights.

Hair and eyebrows are Purple Madder to Carbon Black liner. Base eyes in Unbleached Titanium. Iris is Titanium White + a touch of Blue Violet for a medium blue mix. Shine dot is Titanium White + a touch of Yellow Light. Teeth are based in Nimbus Grey, highlighted Smoked Pearl.

Lips, cheek and cheek dots are Poppy with a shadow stroke of Purple Madder. Highlight in Jaune Brilliant to Yellow Light + Titanium White. Accent is Amethyst.

Carved Santa

Base the face with Marigold + a touch of Purple Madder. Highlight nose, forehead and cheeks with base + a touch of Smoked Pearl. Add brighter and lighter highlights of Jaune Brilliant + Smoked Pearl. Shine dots are soft, dabby brush strokes of Jaune Brilliant + Yellow Light + Titanium White. Burgundy blush is glazed on cheeks, nose, lip and forehead.

Eyes are based in Unbleached Titanium. The iris is based with medium blue mix, highlighted with Titanium White + a touch of Aqua. The pupil is Raw Umber + a touch of Carbon Black. Shine dot is Titanium White + a touch of Yellow Light. Eyeliner, eyebrows are Raw Umber to Carbon Black.

Textured fur trim is based in Raw Umber + a touch of Carbon Black. Highlights of Marigold to Smoked Pearl are dry brushed over the top surfaces, not into the grooves. Accents of Amethyst are randomly dry brushed on the fur trim.

Nutcracker staff is painted in the same steps as the toy nutcracker.

Finish

Dry thoroughly. Apply one coat of Clear Glaze Medium. When dry, apply several coats of Jo Sonja's non-yellowing Satin Varnish to protect your masterpiece.

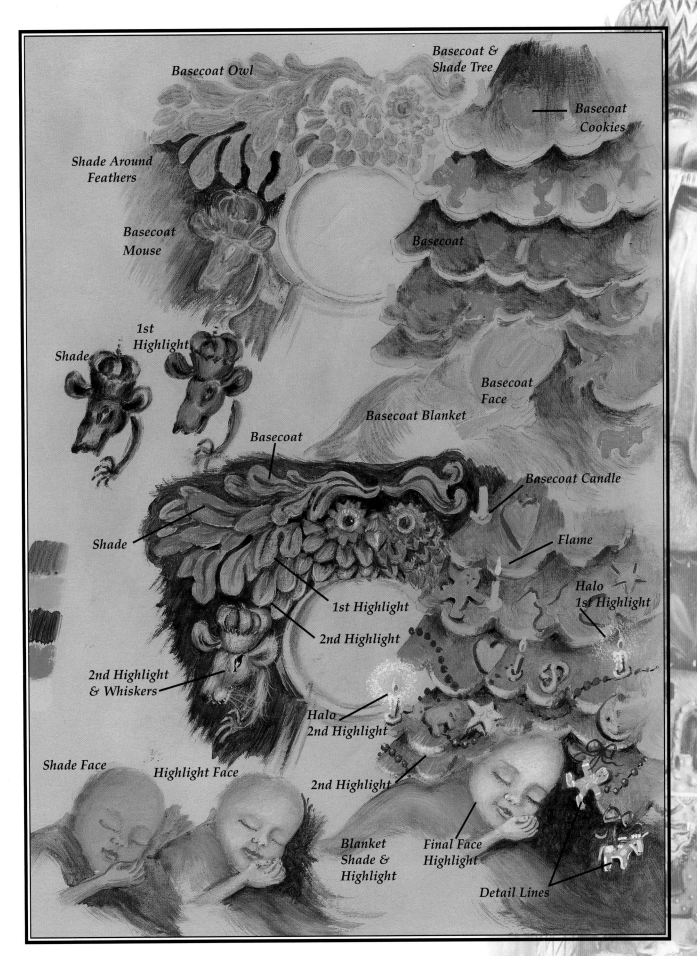

Basecoat Owl

Basecoat & Shade Tree

Basecoat Cookies

Shade Around Feathers

Basecoat Mouse

Basecoat

Shade

1st Highlight

Basecoat Face

Basecoat Blanket

Basecoat

Basecoat Candle

Shade

Flame

1st Highlight

2nd Highlight

Halo 1st Highlight

2nd Highlight & Whiskers

Halo 2nd Highlight

Shade Face

Highlight Face

2nd Highlight

Blanket Shade & Highlight

Final Face Highlight

Detail Lines

A Bountiful Santa

Preparation
Seal the entire figure. Don't omit this step as the wood is fairly soft and the paint will soak into the surface, not allowing for good clean edges. Dry. Sand lightly and wipe residue off with a damp cloth or sponge.

Textured Bag
Apply Decoupage Medium generously, using a foam brush, over the bag area that extends under the arm. Wad up the tissue paper and open, allowing some good size wrinkles to remain. Press it to the wet surface, moving the tissue around to form folds or wrinkles that could occur in an empty bag. When the look wanted is achieved, quickly pat on more Decoupage Medium. Allow the surface to dry thoroughly.

Painting Techniques
When instructed to shade (float color) with more than one color, sideload the lightly blotted filbert into the first color, blend on the dry palette, then sideload the same side into the next color, blend again and use a pat and pull or *sweeping* motion on the surface. Repeat, if necessary, until the desired color is achieved being sure the last application has dried before applying the next.

Face & Hands
Using the #12 filbert, basecoat with Medium Flesh. Shade around all edges with Medium Flesh + Burnt Sienna; dry, then apply Burnt Sienna + Burnt Umber using the #12 filbert.

Eyes
Using the round brush, basecoat the entire eye White. The balls of the eyes are Payne's Grey.

Using the #2 filbert, place a sheer highlight float of Payne's Grey + White on the left and lower side of each ball.

With the liner brush, mix a lighter flesh (Medium Flesh + touch of Ivory) and paint eyelids.

Shade behind the eyelids and under each eye with the same shading colors using the #6 filbert. Float these same shading colors along the bridge of the nose and around the backside of the nostrils on the cheek area. Apply shading colors in each nostril with the #2 filbert.

Apply Payne's Grey linework on lids and iris.

Apply scant eyelashes using the liner brush with thinned Black Green.

Add highlights in each eye using the liner brush with White.

Eyebrows
Delta's Freshly Fallen Snow was used to make dimensional eyebrows. I used the small tip of a stylus but they could be painted on as well. Paint first with Hippo Grey, then over stroke with White using the #2 filbert.

Face Highlight & Rouging
Using the #6 filbert, highlight the upper cheeks with floats of Medium Flesh + Ivory. Dry.

Apply a smooth coat of Extender over the entire face. Using the #2 filbert, pick up a bit of Medium Flesh + Ivory. Blend most all color out of the brush and lighten the center area of the nose and the outer edges of the nostrils. If needed, add a bit more highlight to

MATERIALS

DELTA CERAMCOAT
Black Cherry, Black Green, Burnt Sienna, Burnt Umber, Chocolate Cherry, Drizzle Grey, Freshly Fallen Snow (optional for eyebrows), Hippo Grey, Ivory, Empire Gold, English Yew, Medium Flesh, Moroccan Red, Payne's Grey, Quaker Grey, Raw Sienna, Spice Tan, White.

GLEAMS
Kim Gold.

BRUSHES
Loew-Cornell
• Series 7500, #'s 2, 6, 12 filberts
• Jackie Shaw Liner, #1
• Series 7000, #3 round
• 1-inch Tilford Phylbert Brush

MISCELLANEOUS SUPPLIES
Delta Ceramcoat
All Purpose Sealer, Decoupage Medium, Interior/Exterior Varnish, Matte Finish.

J.W. Etc.
Open Time Extender/Retarder

Small piece 3-inch x 9-inch white tissue paper and a yellow, round synthetic hydra sponge.

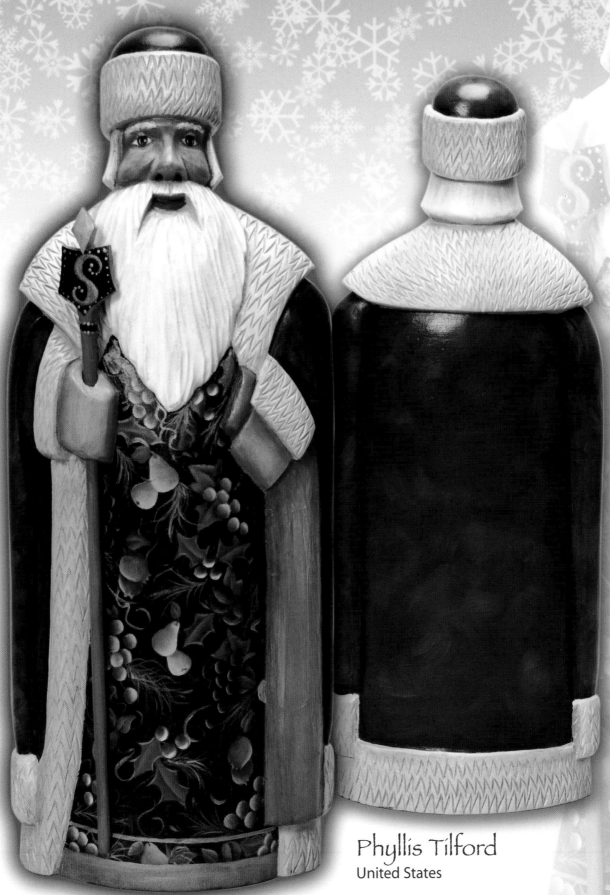

Phyllis Tilford
United States

upper area of the cheeks with the same color. Dry. Apply Extender again. Add cheek color using floats of Burnt Sienna + touch of Moroccan Red on the #6 filbert. Change to the #2 filbert and basecoat the lip with the cheek colors.

Hair

Basecoat all hair with Quaker Grey using the #12 filbert, then over stroke from the bottom up, with Quaker Grey + White, to more White, to just White. Keep this brush fairly wet when applying the White highlights so all the darker grey background is not lost. Shade on the hair, under the hat, under cheeks and bottom of hair and around the lip with floats of Quaker Grey using the #12 filbert. If this is not dark enough, add a bit of Hippo Grey to the Quaker Grey.

Coat & Hat

Using the 1-inch Phylbert, paint Chocolate Cherry. Dry. Using the round sponge, apply a smooth application of Extender. Again, with the 1-inch Phylbert, pat into a bit of Chocolate Cherry, blend, then Black Cherry, blend, then a touch of Drizzle Grey, blending again. Slip-slap this on the coat to give the surface a crushed velvet look. The more variation of color, the better. If necessary, mop the areas to soften. The lighter color should blend in on the edges; not look like spots sitting on the surface.

Bag

Be sure the tissue previously applied to the bag is dry. Paint the bag with Raw Sienna using the #12 filbert. Shade all edges

and under the hand with Burnt Sienna, then Burnt Sienna + Burnt Umber. Dry. Final shading is Burnt Umber. Paint the inside of the bag opening with Burnt Umber. When dry, apply extender and dry brush on a bit of Raw Sienna + Empire Gold in the center of the bag for highlight and float the same around the opening of the bag.

Fur

Scrub the paint into the carving; therefore, use a large older, worn brush and paint the fur areas with Drizzle Grey. Dry. Using the sponge, apply a smooth coat of Extender, then pick up just a tad bit of Drizzle Grey + Hippo Grey in the sponge. Blot on palette to soften and antique the fur. Be sure to allow the darker paint to remain in the carved areas only wiping lightly to remove it from the top surface. Dry.

Apply Extender and lightly add some White. Dry brush highlight to various areas of the fur with the #12 filbert. Be careful. You don't want the fur to be as white as his hair and beard. Using the #12 filbert, add floats of Drizzle Grey + more Hippo Grey on the fur behind the beard, under the hairline and where one fur area meets another to separate them.

Gown

Paint the entire gown insert with two coats of Payne's Grey for an opaque coverage using the large or #12 filbert.

Transfer the design.

Fruit Techniques

Painting all like fruits at the same time, and in the following

order will keep them more consistent and speed up the process greatly. When more than one basecoat color is noted, the colors are brush mixed, not palette knife mixed.

Refer to the worksheet for shading and highlight placement which is very basic and consists of just floated color, generally with two or more colors at the same time. Using a dirty brush will speed this up even more so.

To use a dirty brush, on the last opaque basecoat, while the surface is still wet, flatten the dirty brush with the color still in it by blending on the palette to retain a good chisel edge, and side load one side into the shading or highlight color. Blend slightly on the palette to soften the color and apply to either the shaded or highlighted area. All fruits and leaves are painted, shaded and highlighted using the #2 filbert.

Pears

Basecoat Spice Tan and shade Spice Tan + Burnt Sienna, then shade Burnt Sienna. Highlight Spice Tan + Empire Gold then strengthen with dirty brush colors + more Empire Gold + touch White.

Stems and blossom ends are painted Burnt Umber + touch Payne's Grey, using the liner brush.

Pomegranates

Basecoat Black Cherry + Drizzle Grey + touch of Payne's Grey. Highlight with the above dirty brush + more Drizzle Grey. Shade with the base colors + more Payne's Grey.

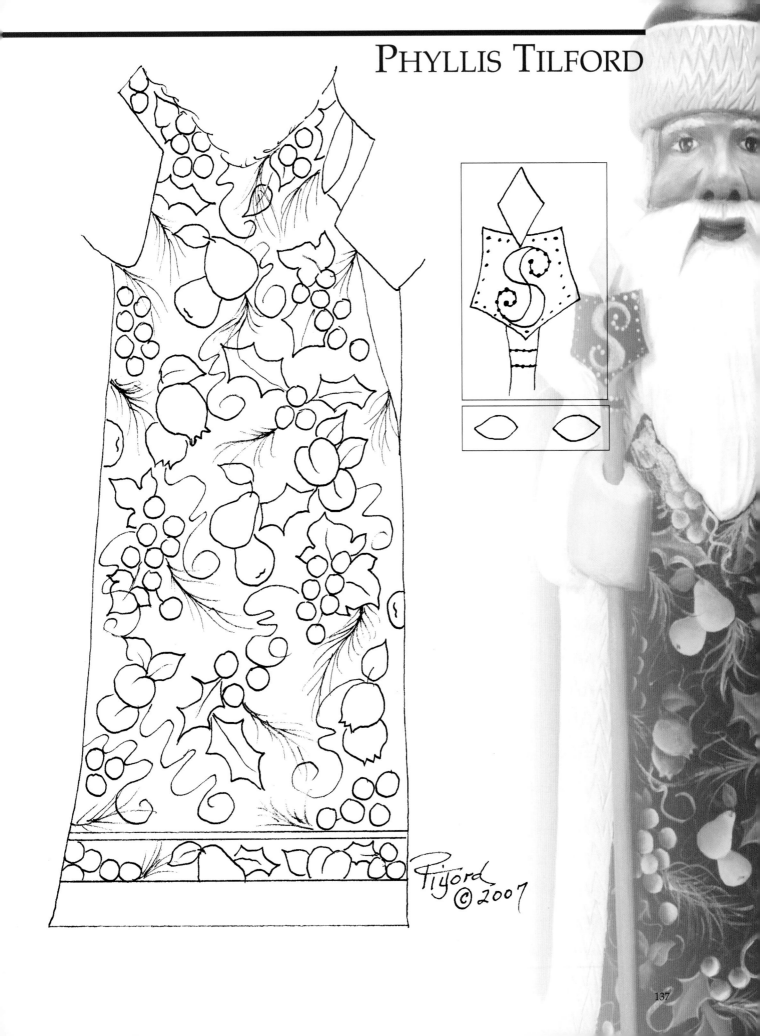

Tilford
© 2007

Pink Grapes

Basecoat with Black Cherry + Drizzle Grey. Highlight with the dirty brush + more Drizzle Grey. Shade with the base colors + just a touch of Payne's Grey.

Pink Berries

Basecoat with Black Cherry + Drizzle Grey. Highlight with the dirty brush + White. Shade with the base colors + bit more Payne's Grey than the grapes.

Plums

Basecoat Payne's Grey + touch of Black Cherry + touch Drizzle Grey. Highlight with the dirty brush + more Drizzle Grey. Shade with Payne's Grey + Chocolate Cherry.

Purple Grapes

Basecoat Payne's Grey + Black Cherry. Highlight with the dirty brush + White. Shade with Payne's Grey + Chocolate Cherry.

Green Grapes

Basecoat English Yew + touch Drizzle Grey. Highlight with the dirty brush + White. Shade with English Yew + touch of Black Cherry.

Leaves

Basecoat with English Yew + a touch of Empire Gold. Shade, forming center veins and shading one side with the dirty brush + English Yew + Payne's Grey. Highlight with the base colors + more Empire Gold.

Stems

Add any stems that are visible on the fruit or for filler vines using the liner loaded with English Yew + Burnt Umber.

Pine Branches

Change to the liner for these. Blend well, and keep paint very thin. Paint from the stem end out toward the tip and keep them graceful; not stiff.

Paint with English Yew. Overstroke with the dirty brush + Drizzle Grey. Add more Drizzle Grey for a few highlights on various needles but not to all needles.

Gold Embellishments

Paint the borders on the gown with Kim Gold, using the liner and the #6 filbert. Paint the delicate scrolls in the gown with thinned Kim Gold and outline each holly leaf with the same. More scrolls and even pine may be added for fill and to pull it all together if needed.

Staff

The handle is painted with the same colors as the bag. The background on the top of the staff and the small band is Payne's Grey, and all dot trim, lettering and side edges are Kim Gold.

Since the acrylic may tend to make the wood swell, it may be necessary to lightly sand the handle so it isn't forced into his hand.

Be sure to check all small areas, edges and crevices. Sometimes it is necessary to use the tip of a liner or round to get into these tiny areas, so look at him from all directions, including upside down rather than just straight on.

Finish with at least four applications of varnish, using the large 1-inch Phylbert. In order to avoid varnish buildup in the carved areas, caution is needed and light pressure should be used there with a well-blended brush.

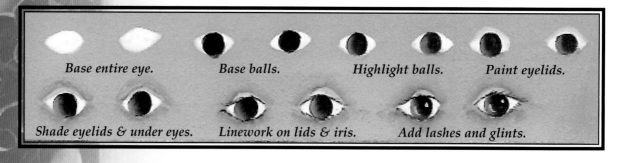

Base entire eye. *Base balls.* *Highlight balls.* *Paint eyelids.*

Shade eyelids & under eyes. *Linework on lids & iris.* *Add lashes and glints.*

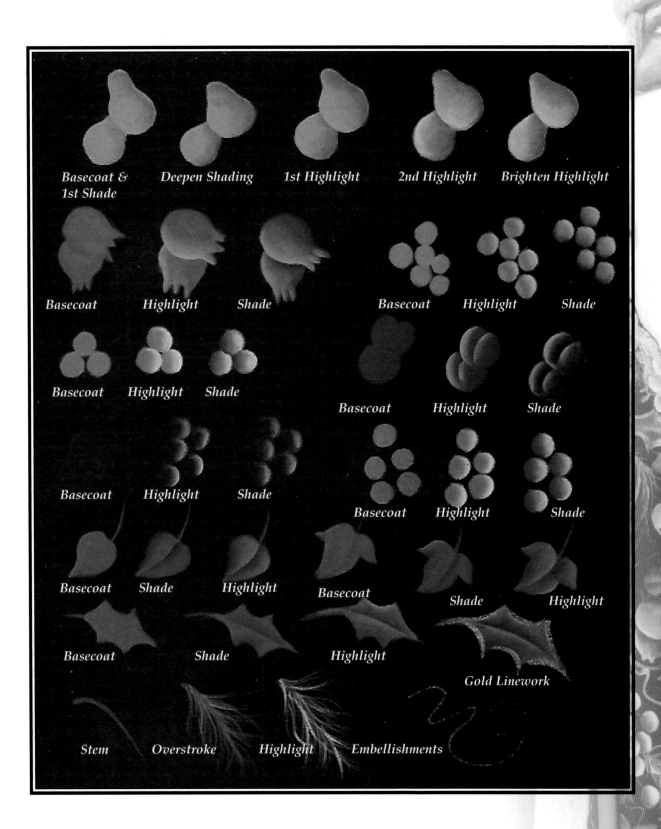

Basecoat &
1st Shade

Deepen Shading

1st Highlight

2nd Highlight

Brighten Highlight

Basecoat

Highlight

Shade

Basecoat

Highlight

Shade

Basecoat

Highlight

Shade

Basecoat

Highlight

Shade

Basecoat

Highlight

Shade

Basecoat

Highlight

Shade

Basecoat

Shade

Highlight

Basecoat

Shade

Highlight

Basecoat

Shade

Highlight

Gold Linework

Stem

Overstroke

Highlight

Embellishments

Gifts for Winged Friends

Preparation

Basecoat Santa as follows using the 3/4-inch angular Series 155:
- Face: Medium Flesh
- Fur Areas & Beard: Titanium White
- Hair: Driftwood
- Mitten: Payne's Grey
- Bird Seed Bag: Red Violet
- Wood Wheel in the Hat: Dioxazine Purple

Basecoat the bird feeder as follows:
- Roof Parts, Seed Dish, Dowels: Golden Straw
- Disk Below Food Dish: Tangerine
- Large Wood Bead: Honey Brown
- Birds: Dove Grey

Face & Hair

Use the 1/4-inch angular to float Terra Cotta by the fur hat and hair, under the brows and around the base of the nose.

Mix Cadmium Red and Medium Flesh for the cheek color. Float this above the moustache and on the tip of the nose. Also paint the lip.

Eyes are Titanium White. Float Payne's Grey lightly across the tops of the white. Irises are Payne's Grey, pupils are Lamp Black. Outline the eyes with thinned Burnt Umber. Eyebrows are Titanium White strokes.

Use Prudy's Best Liner to line the hair with thinned Titanium White. Float Neutral Grey around the top to shade using Prudy's Best Floater.

Mix Driftwood with a touch of Dioxazine Purple. Wash this over the beard, then wipe lightly with paper towel so that this color stays in the crevices.

Fur & Mittens

Wash Payne's Grey over the fur areas, then wipe with a paper towel so that it stays in the carved pattern.

Float Payne's Grey around the beard and hair to shade.

Use Prudy's Best Pouncer to pounce Payne's Grey and Titanium White to add texture to the mittens.

Coat & Hat

Use Prudy's Best Floater to pit-pat Cadmium Orange and Cadmium Red over the coat, hat and the hat's wood ball.

Use Prudy's Best Stroke Brush to paint the stroke design on the back of the coat and sleeves with Peony Pink.

Wash Cadmium Orange over the top of the design to tint, and Dioxazine Purple over the bottom area.

Shade the edges by floating with Dioxazine Purple and then Black Plum.

Use Prudy's Best Liner to paint the design with Dioxazine Purple, adding a touch of Titanium White to the brush occasionally.

Bird Seed Bag

Line horizontally and vertically with Country Blue. Shade around the edges with Black Plum.

MATERIALS

DECOART AMERICANA

Antique Teal, Black Green, Black Plum, Burnt Umber, Cadmium Orange, Cadmium Red, Canyon Orange, Country Blue, Dioxazine Purple, Dove Grey, Driftwood, Golden Straw, Hauser Light Green, Hauser Medium Green, Honey Brown, Lamp Black, Medium Flesh, Neutral Grey, Payne's Grey, Peony Pink, Plantation Pine, Red Violet, Tangerine, Terra Cotta, Titanium White.

BRUSHES

Prudy's Best Liner, Prudy's Best Floater, Prudy's Best Pouncer, Prudy's Best Stroke Brush.

Scharff Brushes: Series 155 3/4-inch angular and 1/4-inch angular.

MISCELLANEOUS SUPPLIES

Bird Feeder

1/8-inch diameter dowel, 3/4-inch wood bead, 1/2-inch diameter circle disk, one plate 1 and 1/2-inches diameter, one plate 2 and 1/2-inches in diameter, 1/2-inch diameter wood wheel, 1/4-inch diameter wood peg. Available from Bear With Us, www.bearwithusinc.com.

Hat

1/2-inch wood wheel, 3/8-inch wood ball, small wood birds. Available from Bear With Us, www.bearwithusinc.com.

Additional supplies include wire, bird seed and wood glue.

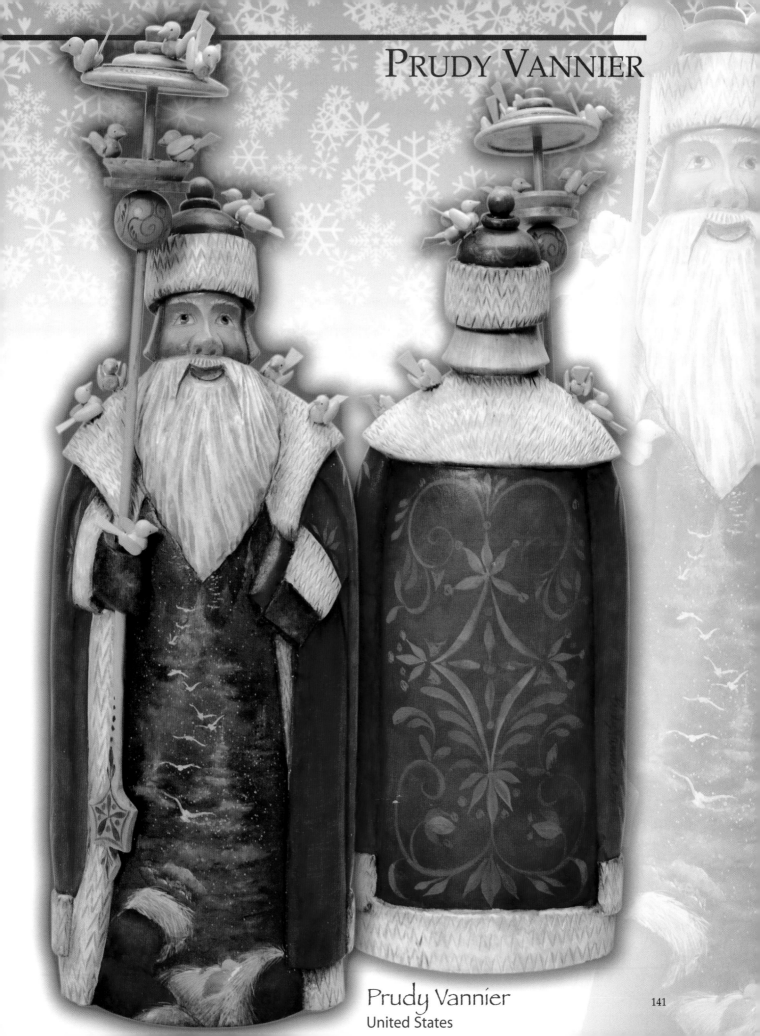

Prudy Vannier
United States

Scene

Transfer the pattern. It is painted sketchily with Prudy's Best Pouncer and then the trees are defined a little more by floating Black Green shading around them.

The sky is Payne's Grey and Antique Teal. The back trees are Hauser Medium Green, Antique Teal and a little Hauser Light Green. The front trees are Hauser Medium Green, Plantation Pine and much lighter with additional Hauser Light Green.

Spatter lightly with Titanium White and paint the birds with Dove Grey using the Best Liner.

Santa's face is Medium Flesh with a Cadmium Red + Medium Flesh cheek and lip. The eyebrow is Titanium White. The beard is Neutral Grey with Titanium White lines.

The coat and hat are Cadmium Red with much Red Violet shading on the shoulder and then Payne's Grey shading around the cuff, bend in the sleeve and along the base.

The fur is Payne's Grey + Titanium White. Paint Titanium White lines over it, and then shade with Payne's Grey.

Birds & Bird Feeder

The beaks are Golden Straw. The eyes are Lamp Black dots. Wash over some with colors in your palette, if you like.

The patterns on the bird feeder are painted with the Best Liner using thinned Burnt Umber.

Float Canyon Orange to tint around some of the wood embellishments and on the dowel.

Finish

Varnish all pieces. Drill holes if necessary and assemble referring to the photos, attaching the birds with wire and glue.

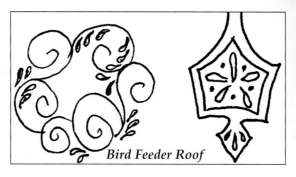

Bird Feeder Roof

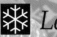

Have You Heard the News?

PREPARATION

Seal and sand the wood. Paint the entire piece with two or three coats of Gold Metallic being sure to cover the surface well. When dry, use the Bronze Paper Effects to dot the fur area of the coat and hat thus giving a more interesting texture. When the dots are dry, paint all the fur with English Red Oxide. Apply gold leaf to the fur areas allowing some of the red to show through as it undoubtedly will when you push the leaf into the incised lines of the carving. Seal it with a coat of the leafing Medium and Sealer.

Apply the design for the front of the robe. The line drawings generally extend out further than required to allow for difficulties in applying them.

PAINTING THE DESIGN

Outline the elements with Carbon Black and then fill in the background between them with the same black leaving the stems, leaves and flowers the gold color of the base coat. Paint the fine details Carbon Black and, finally, paint the decorative curls and commas with English Red Oxide.

Use the script liner to paint the stems first making sure you have long, graceful lines. Paint to one side of the pattern line paying careful attention to where other stems branch off so you can leave a gold space for them. Cotton tips will quickly clean up any mistakes if you get to them before they dry. Next, paint to the other side of the pattern line thus leaving a narrow gold stem between the black lines. Don't stick slavishly to the line drawing if it means your stems won't be gracefully curved. Next paint in the large flowers and then the leaves; you may have to alter the leaves slightly to avoid stem lines. Paint the groups of trumpet-shaped flowers last as these can easily be adjusted to fit the remaining spaces. Carefully paint a Carbon Black background between all elements, then use a fine brush and black to paint in the details on leaves and flowers. Use a good round brush and English Red Oxide to paint curls and commas running smoothly along stems and into V-shaped areas to fill any obvious empty spaces. Remove any transfer lines and give the painted area a coat of Glazing Medium to protect it while you paint the rest of the Santa.

Apply the design of the angels and flowers on the back centering the line drawing. Use Carbon Black and the liner to paint the main lines of the flowers at the bottom. Fill in the black background and add the detail lines with black. Use the script liner, the liner and the small round brush, as it suits you, with black to paint the angels. Apply the trims with lines and dots of black.

Take the designs for the rest of the cloak and transfer them, one side at a time, from the angels around the side to where they finish on the front of Santa. Include the sleeves.

This will be difficult to paint but, once again, start with the stems keeping them graceful and keeping any stem junctions

MATERIALS

DECOART PAPER EFFECTS
Bronze, Gold.

DECOART ACRYLICS
Copper Metallic, Oyster Pearl Metallic, True Red, Asphaltum, Titanium White.

DECOART HOT SHOTS
Sizzling Pink.

JANSEN TRADITIONS PAINTS
Gold Metallic, English Red Oxide, Carbon Black.

DECOART
Multi-Purpose Sealer, Faux Glazing Medium and DuraClear Gloss Varnish.

MISCELLANEOUS
Mona Lisa Gold Leaf, Leafing Medium and Sealer. Sandpaper, cotton swabs, paste wax and polishing cloth, graphite, tracing paper, stylus.

BRUSHES
Loew-Cornell La Corneille Golden Taklon
- Series 7150 Wash/Glaze, 1/4-inch
- Series 7350 Liner, #6/0
- Series 7050 Script liner, #1
- Series 7040 Round Stroke, #2, #0
- Series 7400 Angular Shader, 1/4-inch
- Series 410 Deerfoot Stippler, 1/4-inch

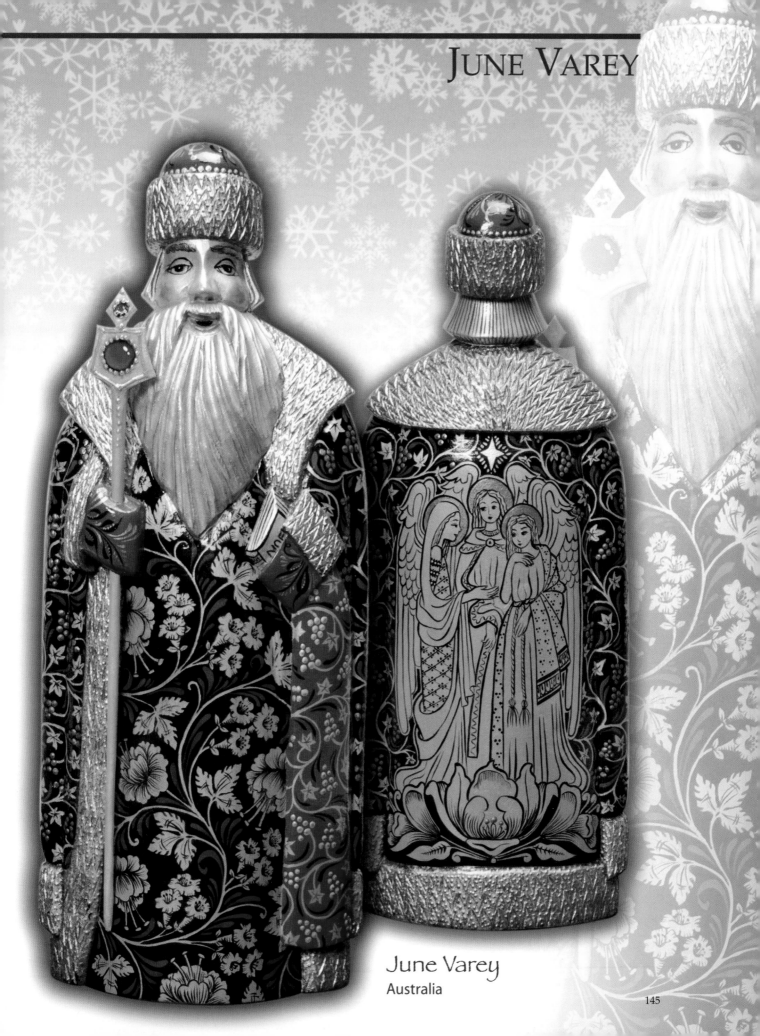

JUNE VAREY

June Varey
Australia

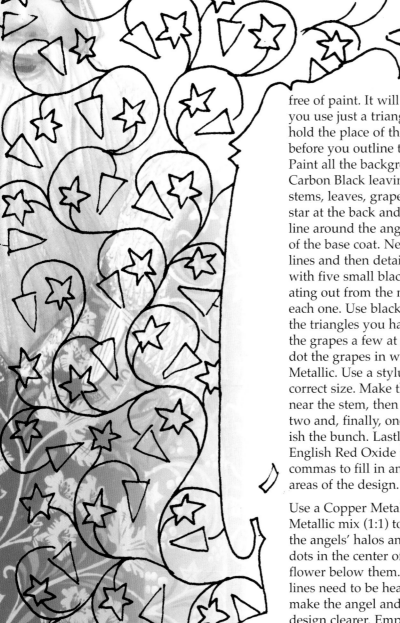

free of paint. It will be easier if you use just a triangle shape to hold the place of the grapes before you outline the leaves. Paint all the background Carbon Black leaving the stems, leaves, grape areas, the star at the back and a narrow line around the angels the gold of the base coat. Neaten all the lines and then detail the leaves with five small black lines radiating out from the middle of each one. Use black to paint out the triangles you have left for the grapes a few at a time and dot the grapes in with Copper Metallic. Use a stylus of the correct size. Make three dots near the stem, then two sets of two and, finally, one dot to finish the bunch. Lastly, use English Red Oxide to paint commas to fill in any empty areas of the design.

Use a Copper Metallic + Gold Metallic mix (1:1) to paint in the angels' halos and to put dots in the center of the middle flower below them. Some of the lines need to be heavier to make the angel and flower design clearer. Emphasize the outside lines of the flowers to separate them from the angels. Also strengthen the lines around the halos, around the outside of the wings and a few selected vertical lines. If you feel you have selected the wrong lines or made them too heavy clean them off immediately with a cotton tip.

Color the star with Oyster Pearl and paint some short radiating lines from it with Gold Metallic.

Apply any part of the grape pattern to the turn back of the cloak on the front right. Paint it in the same manner as the main part of the cloak but the outlining and back grounding is English Red Oxide, the grapes are Gold Metallic and the commas are Carbon Black. Don't put too many black commas in or the area will be too dark.

Paint the gloves and the crown of Santa's hat English Red Oxide. The design on the gloves is painted with variations of gold and black commas. See the step sheet. Paint the free hand design on the hat (see the step sheet) and embellish with some gold Paper Effects dots. Put a line of gold Paper Effects dots around the crown of the hat next to the fur.

Paint Santa's eyes and eyebrows with lines of Carbon Black. Put a gleam of Oyster Pearl at the lower left of the gold iris and a dot of Gold in the black pupil of each eye. Paint lightly over the eyebrows with the Copper + Gold mix to soften them and, when dry, paint over with tiny hair strokes in Carbon Black. Use a very dry brush to lightly rouge some English Red Oxide on the cheeks and the tip of the nose. Use the large flat brush dry and wisp just a touch of English Red Oxide over the raised parts of the beard. When dry add a much smaller touch of Oyster Pearl.

Left Side Bottom

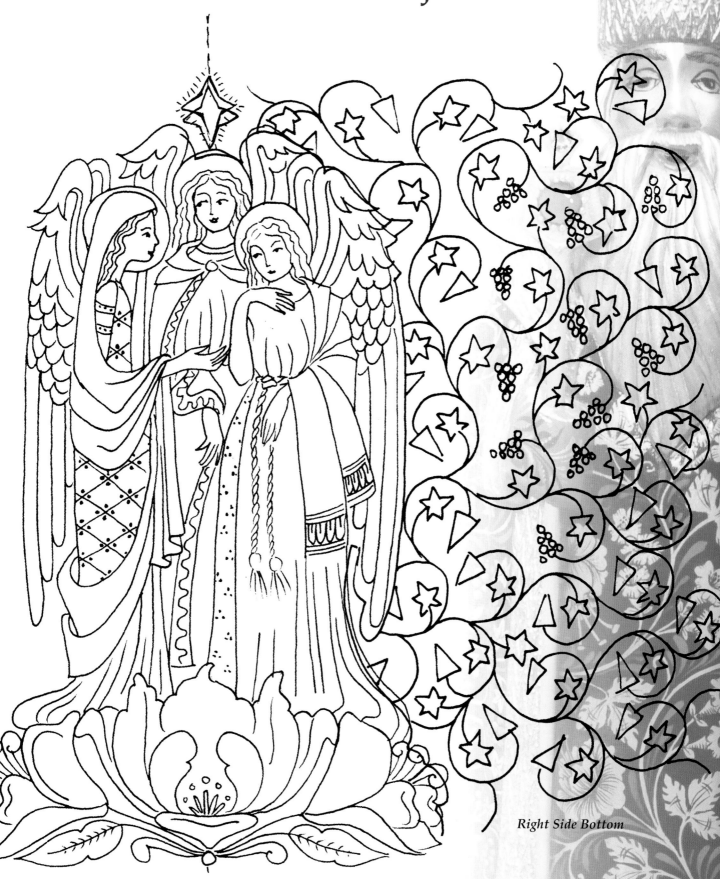

Right Side Bottom

Paint the hair using fine, straight strokes of English Red Oxide. Use Carbon Black and the liner to paint the cover and page edges of the book in his hand. I have written *Noel* on the cover but you may leave it blank.

Paint the large and small jewels on the top of his gold staff with circles of True Red. Use the angle shader and Asphaltum to lightly shade around each circle on the gold. Paint one or two more coats of True Red to tidy the edges and get a good coverage. Float diffused light around the lower left of the jewels with Sizzling Pink and add highlights to the upper right with Titanium White. Use the gold Paper Effects to lightly dot around the jewels, to make a line around the edge of the shape containing the large jewel and to run some dots down the shaft of the staff.

Use a dry Deerfoot brush to lightly stamp and rub a mix of English Red Oxide and Carbon Black into the creases of the gilding, around the bottom of the fur and on the hat near the gilded edge. Do not make this too strong or it will just look dull and dirty.

Remove any pattern lines, then varnish and wax.

Front of Santa
Beard Area

Artist Information

Arntzen, Eldrid
319 Thomaston Rd.
Unit #84
Watertown, CT 06795

Cagle, Gretchen
Gretchen Cagle Publications, Inc.
PO Box 2104
Claremore, OK 74018-2104
www.gretchencagle.com

Hauser, Priscilla
Priscilla's Little Red Tole House
1914 S. Harvard Ave.
Tulsa, Ok 74114
www.priscillahauser.com

Barrick, Helan
5805 East 78th Place
Tulsa, OK 74136
www.helanbarrick.com

Clark, Margot
2921 Amroth Place
Cassleberry, FL 32707
www.margotclark.com

Iwaski, Kaz
4505 Paseo Tortogas
Torrance, CA 90505

Bateman, Nancy
776 Red Oak
Lancaster, OH 43130
www.nancybateman.com

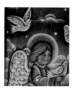

G. DeBrekht Artistic Studios
10 Hughes A-103
Irvine, CA 92618
www.gdebrecht.com

Jackson, Louise
1341 Yankee Vineyard
Centerville, OH 45458
http://home.woh.rr.com/louise
jackson/

Beard, Trudy
Trudy Beard Designs
21 Calvin Park Blvd.
Rockford, IL 61107
www.trudybearddesigns.com

Edwards, Ginger
523 Wimbledon Blvd.
Alexandria, LA 71303

Jansen, Jo Sonja
2136 Third St.
Eureka, CA 95501
www.josonja.net

Binam, Sharyn
10841 East Placita de Pascua
Tuscon, AZ 85730
www.sharynbinam.com

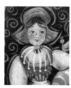

England, Heidi
2006 Laurel Hill Dr.
Kingwood, TX 77339-6126
www.heidiengland.com

Jones, Andy B
1121 Knott Street SE
Atlanta, GA 30316

Blanco, Mabel
Mosconi 874
Haedo 1706
Buenos Aires, Argentina
www.blanco.com

Fabretti, Vilma
Ortiz de Ocampo 4365
Cordoba, Argentina
X5009DPC
www.pinturadecorativa.com/
fabretti.html

Kingslan, Ann
9851 Louis Drive
Omaha, NE 68114
www.kingslan.com

Bringle, Ronnie
1345 West 530th Ave.
McCune, KS 66753
www.ronniebringle.com

Harris, Peggy
3848 Martins Chapel Rd.
Springfield, TN 37172
www.peggyharris.com

Kresal, Yvonne
18197 Pumpkin Ridge Rd.
North Plains, OR 97113
www.pumpkinridgedesigns.com

Kunioka, Masayo
3-11-13-901 Tarumi-cho
Suita City, Osaka 564-0062
Japan

Pennycook, Bob
35 Lorraine Crescent
Brampton, ON L6S 2R6
Canada
www.bobpennycook.com

Thomas, Maxine
PO Box 613
Camas, WA 98607
www.countryprimitives.net

McGuire, Toni
4081 Jeffery Lane
Paducah, KY 42001

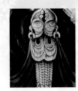

Rader, Golda
15157 Forest Lane
Conroe, TX 77306
www.raderizms.com

Tilford, Phyllis
617 Sheridan Woods Drive
West Melbourne, FL 32094
www.tolemill.com

McNaughton, Maureen
RR#2
Belwood, Ontario
Canada NOBJO
www.maureenmcnaughton.com

Redick, Heather
19 Goshen Street North
Zurich, ON, NOM 2TO
Canada
www.HeatherRedick.com

Vannier, Prudy
279 Maplewood St.
Northville, MI 48167
248-380-0220
www.prudysstudio.com

Moore, Jo Avis
4005 E 80th St.
Tulsa, OK 74136

Rol, Cheri
Rol Publications
3600 Amy Lane NE
Greenville, IN 47124
www.cherirol.com

Varey, June
32 Central Ave.
Bayswater Nth.
Victoria 3153, Australia

Nelson, Sherry C
PO Box 16530
Portal, AZ 85632
www.sherrycnelson.com

Shaw, Jan
400 Houghlahans Creek Rd.
Booyong via Lismore
2480NSW Australia

Wetterman, Della
Della & Company
5208 Lake Charles Dr.
Waco, TX 76710-2720
www.dellaandcompany.com

Norris, Tina Sue
11170 Caroline Acres Rd.
Fort Mill, SC 29715
www.tinadesigns.com

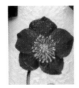

Sims, Tracy
3121 Old Elympie Rd
Mt. Mellum, Qld 4550
Australia

Wise, Linda
PO Box 4523
Springfield, MO 658808
www.lindawisedesigns.net

Oram, Gayle
36757 Immigrant Rd.
Pleasant Hill, OR 97141
www.gayleoram.com

Takashima, Bobbie
340 West 26th St., Suite D
National City, CA 91950
www.BobbieArtStudio.com

Wiseman, Mary
12856 Whitfield
Sterling Heights, MI 48312
www.wiseman.com

Index

Index

painted TREASURES

Projects & Inspiration from the Masters of Decorative Painting

Celebrating 25 Years of the DECORATIVE ARTS COLLE

Other Publications from the *Decorative Arts Collection*

A Sentimental Collection of *Roses*

The Decorative Arts Collection, Inc.
393 N. McLean Blvd. • Wichita, KS 67203 • 316.269.9300
www.decorativeartscollection.org

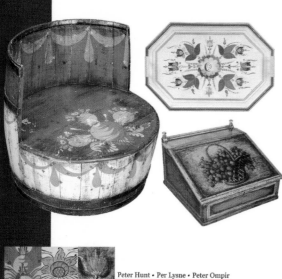

The Fathers of American Decorative Painting

Peter Hunt • Per Lysne • Peter Ompir

PO Box 18028
Atlanta, GA 30316
404-627-3662
www.decorativeartscollection.org

155

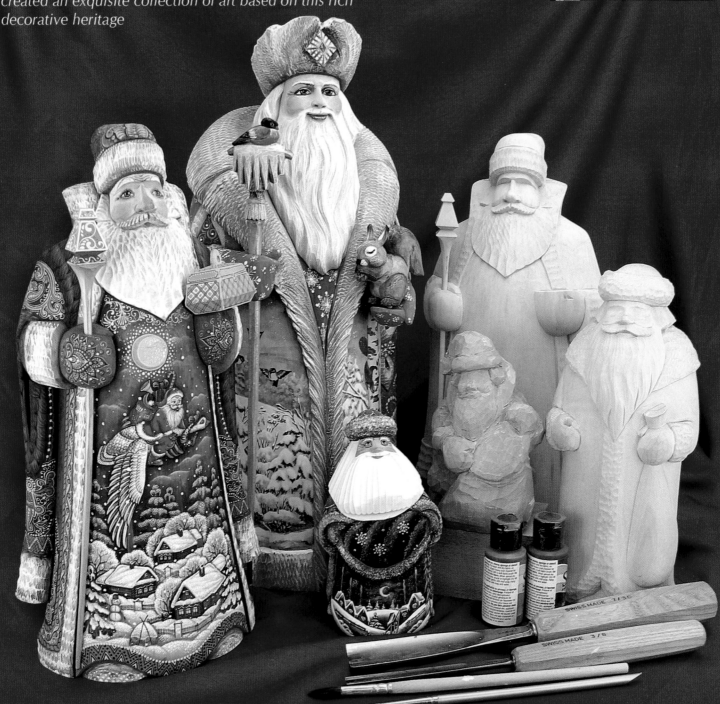

Experience the Finest in Decorative Art...

Over the centuries, unique decorative art has been preserved by talented artisans handing down their traditions and techniques from one generation to the next.

For over three decades, the talented artists of G.DeBrekht Artistic Studios have created an exquisite collection of art based on this rich decorative heritage

G.DeBrekht Artistic Studios®

phone 800-787-7442 *(intl.* 949-768-5533) fax 800-787-7427 *(intl.* 949-768-5538)
sales@gdebrekht.com www.gdebrekht.com

G.DeBrekht®
Artistic Studios
www.gdebrekht.com

...and the Beauty of
G.DeBrekht Distinctive Style

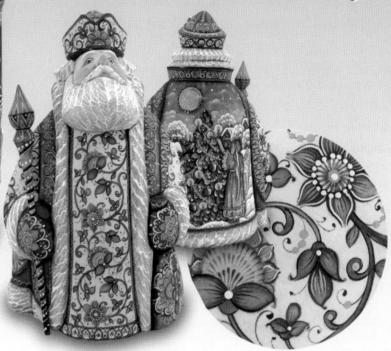

*we capture and share what
we love... beauty.*

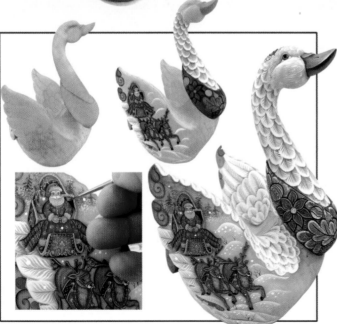

...Since that time, G.DeBrekht has focused on making quality handcrafted art available to collectors, art connoisseurs and home décor enthusiasts worldwide. G.DeBrekht has set itself apart, developing a hand-crafted style that is instantly recognizable and has remained committed to Old World craftsmanship, resisting the trend to automate the creative process. G.DeBrekht is home to the best and the brightest international artists, hand-carvers, and freehand painters.

Each decorative art piece is crafted from the hands of skilled artisans. The collections are created in very limited editions, that are limited by the amount of time it takes to hand-carve and hand-paint each and every work of art. Each piece is one of a kind as there are no two alike.

Hand-carved Figurines are available to art instructors for painting demonstrations and to Decorative Artists for individual creations. Original G.DeBrekht hand-painted figurines are made available to Art Enthusiasts or Collectors for their enjoyment and to Fine Galleries for worldwide distribution.

DECORATIVE ARTS COLLECTION MUSE

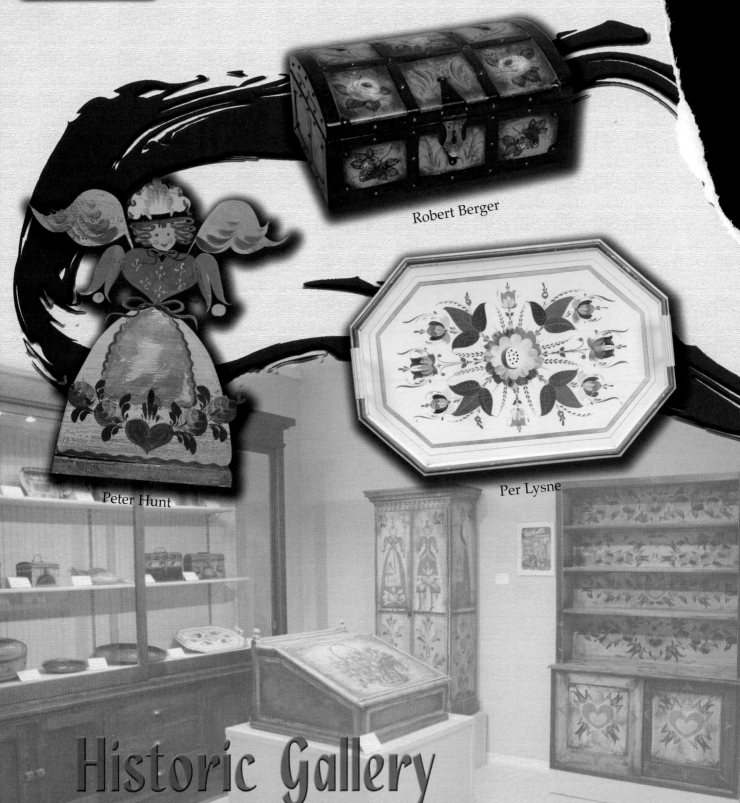

Robert Berger

Peter Hunt

Per Lysne

Historic Gallery

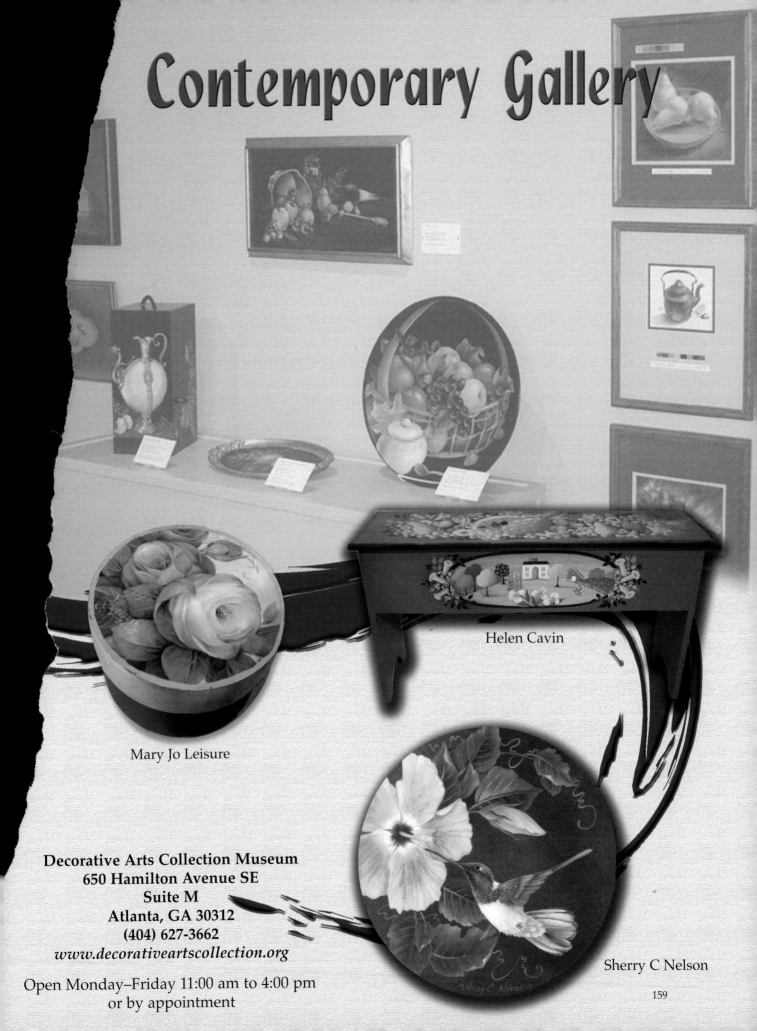

Contemporary Gallery

Mary Jo Leisure

Helen Cavin

Sherry C Nelson

Decorative Arts Collection Museum
650 Hamilton Avenue SE
Suite M
Atlanta, GA 30312
(404) 627-3662
www.decorativeartscollection.org

Open Monday–Friday 11:00 am to 4:00 pm
or by appointment

159

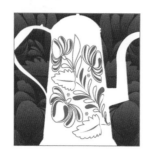

Become a Friend of the Decorative Arts Collection Museum

The Decorative Arts Collection is the premiere repository of decorative painting. This her must be cared for and preserved. Your participation is vital to the success of our mission we welcome your support and partnership in this worthwhile endeavor. This is the art forn love–that is important to you. Join us in making certain that future generations will also be to see the treasures of our collection. Seriously consider becoming a Friend of the DAC toda today and for tomorrow.

Show your support for the Decorative Arts Collection by becoming a Friend of the Museum. For your contribution, you will receive our replica crookneck coffeepot pin as a token of thanks. Additionally, you will receive four issues of *Museum News*, a 10% discount on DAC merchandise and free admission to the museum.

The Museum is supported by individuals like you who have a love for decorative painting. Annually renew your support and receive our porcelain renewal pins featuring artwork from the museum. Your gift is tax-deductible.

❑ I want to become a **Friend** $ 40.00
 ❑ **NEW** ❑ **RENEWAL**
❑ I want to be a **Contributor** $ 100.00+
❑ I want to be a **Sponsor** $ 250.00+
❑ I want to be a **Patron** $ 500.00+
❑ I want to be a **Benefactor** $ 1000.00+

Name _____

Address _____

City _____ **State** _____

Zip _____ - _____

Phone (_____) _____

Payment

❑ Check #_____ ❑ VISA ❑ MasterCard
Card Number_____
CIN Number on card back_____
Billing Address_____
City_____
State_____Zip_____ Expiration_____
Signature_____
Please photocopy this page and return it
with your support today!

Decorative Arts Collection & Museum
PO Box 18028
Atlanta, GA 30316
(404) 627-3662

www.decorativeartscollection.org